BRITISH WILDLIFE

PHOTOGRAPHY AWARDS

COLLECTION 5

Editor: Donna Wood

Designers: Nick Johnston and Tracey Freestone

Image retouching and colour repro: Jacqueline Street-Elkayam

Produced by AA Publishing

© AA Media Limited 2014

Published by AA Publishing (a trading name of AA Media Limited, whose registered
office is Fanum House, Basing View, Basingstoke RG21 4EA; registered number
06112600).

A05205

ISBN: 978-0-7495-7643-1

A CIP catalogue record for this book is available from the British Library.

The contents of this book are believed correct at the time of printing. Nevertheless,
the publishers cannot be held responsible for any errors or omissions or for changes
in the details given in this book or for the consequences of any reliance on the
information provided by the same. This does not affect your statutory rights.

Caption information has been supplied by the photographers and the publishers
accept no responsibility for errors or omissions in the details given.

Printed and bound in Italy by Printer Trento SRL.

theAA.com/shop

TREVOR REES > HIGHLY COMMENDED

A Jewel of an Anemone
(Jewel anemone, *Cornactis viridis*)
Plymouth, Devon, England
See page 169

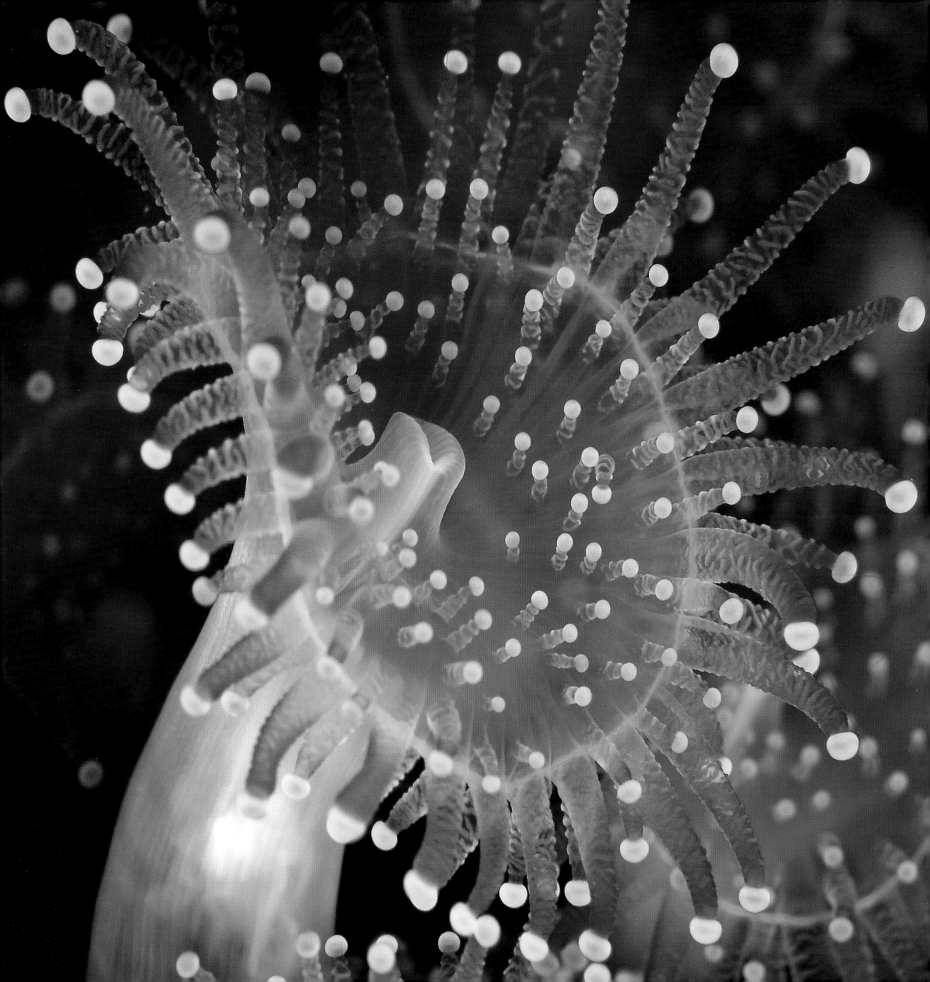

CONTENTS

KEITH THORBURN > HIGHLY COMMENDED

King of Rannoch Moor and Glencoe
(Red deer, *Cervus elaphus*)
Glencoe, Scotland
See page 29

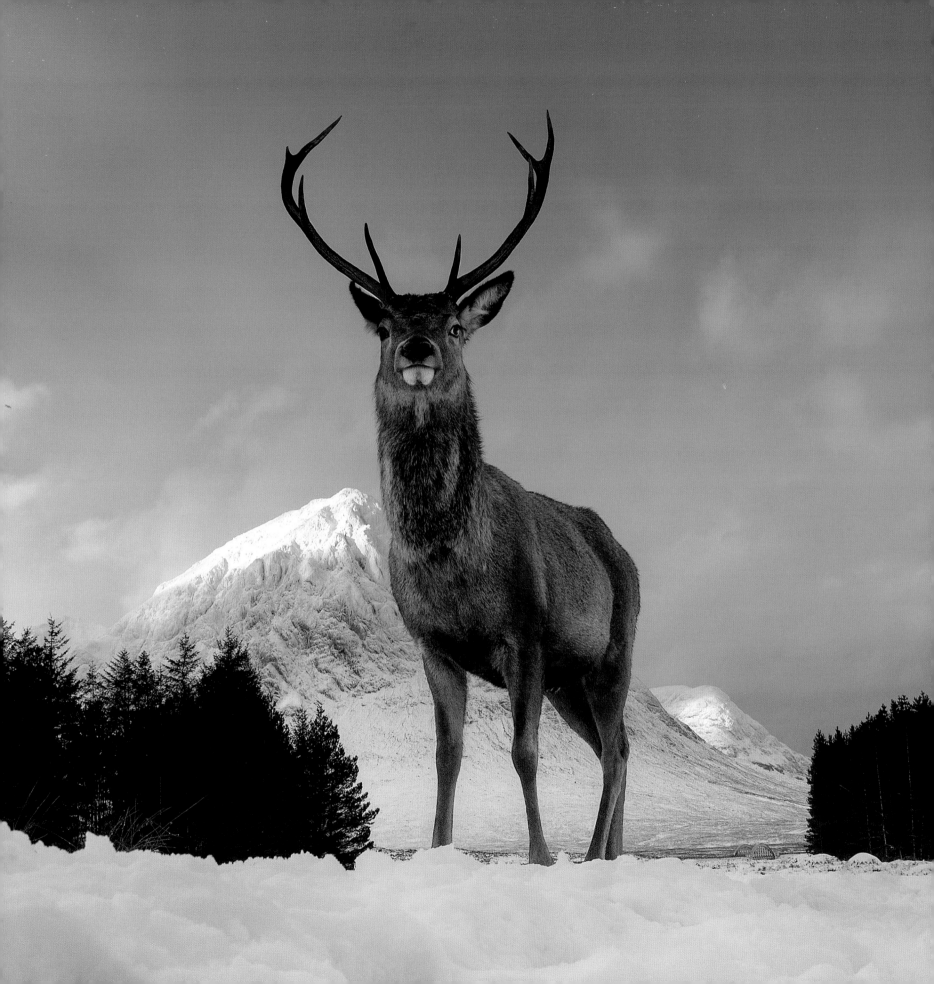

THE BRITISH WILDLIFE PHOTOGRAPHY AWARDS

MAGGIE GOWAN
BWPA DIRECTOR

The British Wildlife Photography Awards were established to recognise the talents of photographers practising in Britain, while at the same time highlighting the great wealth and diversity of Britain's natural history. The driving motivation to set up the Awards evolved through the nation's growing awareness of the local environment and the need for its protection. With a nationwide touring exhibition of the best entries, the Awards aim to:

- celebrate British wildlife, in all its beauty and diversity, through a collection of inspirational photographs
- recognise the talents of photographers (of all nationalities) practising in Britain
- showcase the very best of British nature photography to a wide audience
- engage all ages with evocative and powerful imagery
- raise awareness about British biodiversity, species and habitats

With thanks to the BWPA team:

Matthew Chatfield,
 Website Manager, Facilitator and
 Chairman of the Judging Panel
Carl Crawley, Website Lead Developer

Victoria Skeet, Assistant Judge and Administrator
Clare Webb, Technical Adviser and Manager
Venetia Khan, Exhibitions Manager
Chris Hart, Designer

THE CATEGORIES

Animal Portraits

Images that capture the character or spirit of the subject in an imaginative way, giving a sense of the animal's 'personality'.

Animal Behaviour

Images showing any aspect of wildlife behaviour or action, or depicting something familiar in a new light. The judges sought images that made them look again at what they thought they knew.

Urban Wildlife

Wherever we live, wildlife can be found alongside us in our towns and cities, parks, gardens and backyards. The judges looked for an original image that shows wild animals or plants within an urban environment.

Hidden Britain

Images in this category reveal the secret universe that is life in the undergrowth – a life that is all around us but rarely seen.

Coast and Marine

Imaginative photographs that reveal the behaviour of marine animals or create a sense of place or occasion. This includes marine animals near the sea, underwater, at the sea shore and within the coastal zone.

Wild Woods

The judges looked for a winning image celebrating the splendour of British woods. Entries could be portraits of woodland wildlife, wooded landscapes, seasonal scenes, details of plants, or show the relationships between species and habitats that occur within our woods and forests.

Habitat

Imaginative images that portray the importance of the environment and ecosystems that sustain wildlife. This can include animals, plants, and the relationships between them; for example a butterfly feeding on wild flowers or a barn owl hunting over rough grassland.

Botanical Britain

This category focused on botanical subjects photographed in Britain, including trees, plants, flowers, fungi and algae, whether close-up, macro or as part of a wider scene.

Close to Nature

A category that explores the beauty of nature close up and its ability to create extraordinary designs, symmetry, form and patterns. Subjects could include a study of shells, wild flowers, an insect's wing, or patterns made by rock, ice and water.

British Nature in Black and White

Any images of British wildlife and landscapes were eligible. The judges were looking for creativity and innovation in the use of the medium.

British Seasons

A portfolio of four images portraying British wildlife in each of the four seasons; or a portfolio of four scenes from just one season. Each image should capture the essence of the season along with the wildlife subject.

Documentary Series

A sequence of up to six images on any British wildlife, conservation or environmental issue, showing innovation in storytelling.

Wildlife in HD Video

An inspirational and dynamic sequence (up to 90 seconds) illustrating the unique power of HD video as a medium for capturing British wildlife. Some stills from the film are featured in this book. The whole film and commended entries can be viewed at www.bwpawards.co.uk

Outdoor Photography Editor's Choice

Each month of the competition, the editor of *Outdoor Photography* chose his favourite image for publication in future magazines.

Young People's Awards

Striking and memorable images of any British wildlife species taken by under-12s and 12–18 year olds.

School British Wildlife Photography Award (up to 18 years of age)

Awarded to the school whose portfolio was judged to be the most imaginative and original. Any aspect of British wildlife was eligible, and all species were considered, for example animal portraits, wildlife behaviour or action, urban wildlife or a conservation topic.

For further information about the annual competition and touring exhibition, please visit **www.bwpawards.co.uk**

BRITISH WILDLIFE PHOTOGRAPHY AWARDS

FOREWORD
CHRIS PACKHAM

At the moment of choice we photographers have a pretty narrow view of the world. A tiny rectangle of light beneath which some figures flicker is the portal that our cameras have opened for a fraction of a second in the entire history of our universe. If we are using a telephoto lens it's fair to say that we are looking down a straw in both space and time, thus what we capture in that moment has to be quite special to be successful. To be able to communicate to others something powerful or beautiful enough to make them look – maybe marvel, love, cry or laugh – is a big ask, a particularly big ask when the photographer is not only grappling with the chaos of reality but also with creatures invested with their own free will. Good, very good or exceptional wildlife photography is not easy, it's about as hard as it gets.

Of course, on our side we have nature's masterpieces on which to focus – things that are as close to perfect as we'll ever see; things of unparalleled beauty and wonder. Unfortunately we undermine this obvious asset by allowing familiarity to breed contempt; the remarkable becomes ordinary and we become blind to its brilliance. For many, that's why making good pictures of British wildlife is difficult. A tiger could draw out the artist, the genius in them, but a grey squirrel cannot even get them to lift their lens. And that's one of the reasons why these now prestigious awards are so important; it's not that our home-grown species are any less glamorous, only that we forget just how spectacular they are. Well, look again, because this catalogue of splendid, exciting, imaginative and artistic images proves beyond doubt that we have the richest palette of life to celebrate in our own backyard.

But there is another problem… that yard is crowded and contaminated, it's not a wilderness or a pristine paradise, it's a manscape, and many of the species that glow so magically in its mess are in trouble. We all know this, of course; again it's so familiar to us that we forget it. The threat of extinction is so everyday that we nod and move on. That's why we need to be 're-frightened' by its horror, and photography is a great tool to use to this end; a valuable device in effective conservation, one we should use more often and effectively.

We have an arsenal of abilities, technologies and plans to protect our natural heritage in all its diversity, we just need to get on with implementing them. Please find the energy to do so more urgently from the inspirational photographs in this book, enjoy them, be awed by them, applaud them but salute those who have made them by affording them the most important honour of all – action. Make all the dedication, time, toil and patience worthwhile by letting these pictures change your minds and inflame your hearts. Make these moments count for British wildlife.

WINNER OF THE YOUNG PEOPLE'S AWARDS, 12–18 YEARS CATEGORY

JOSHUA BURCH (AGE 16) >

On the Prowl
(Red fox, *Vulpes vulpes*)
Carshalton Beeches, Greater London, England
See page 204

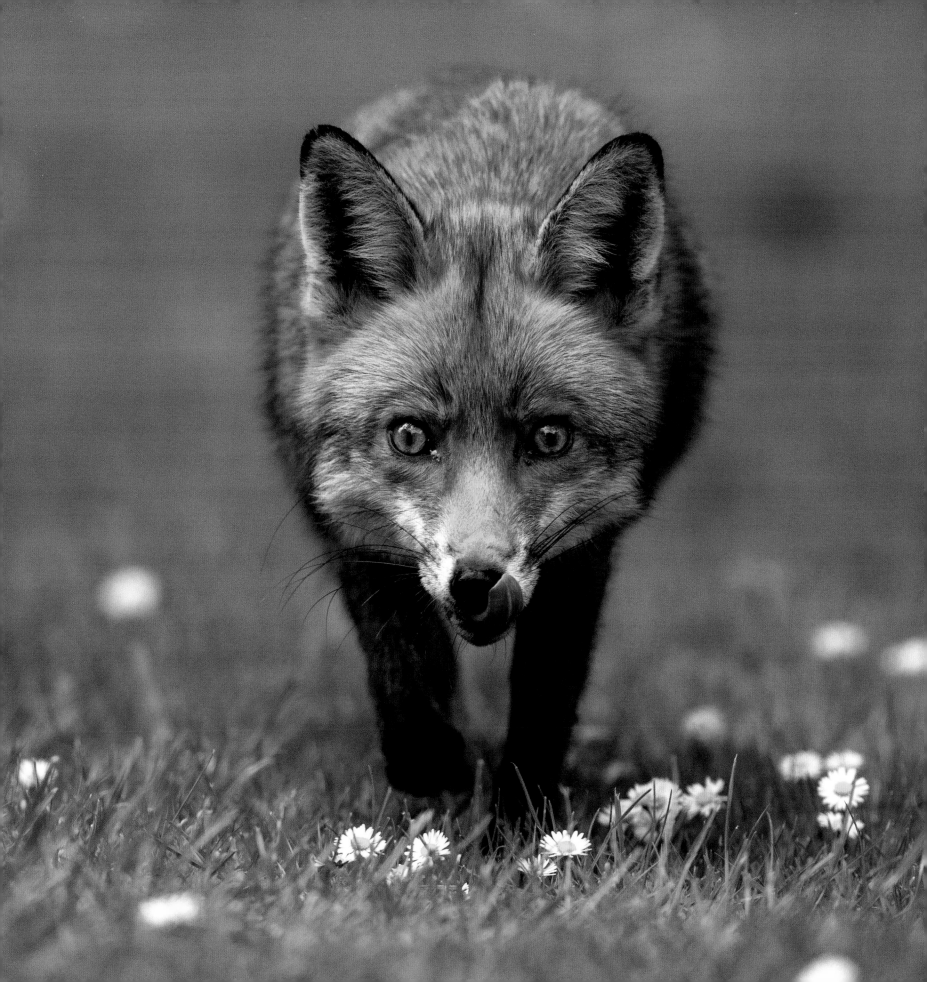

Canon

The British Wildlife Photography Awards 2014 are held in association with Canon. Canon is a world leader in imaging products and solutions for the digital home and office.

Canon is passionate about providing consumers with imaging solutions that empower creativity and innovation, ranging from digital compact and SLR cameras, through broadcast lenses and portable X-ray machines to multi-function and production printers, all supported by a range of value-added services.

To learn more about Canon products, please visit Canon's website:
www.canon.co.uk

Sky+HD

Sky+HD is proud to sponsor the Wildlife in HD Video category of the British Wildlife Photography Awards 2014.

Sky+HD is the UK's leading high definition TV service, with over five million customers now enjoying their favourite TV with up to five times more picture detail. With up to 73 HD channels to choose from, we offer a stunning range of entertainment across all genres, enabling our customers to get immersed in the action, emotion and detail of their favourite programmes whatever their passion.

It is our privilege to be sponsoring the Wildlife in HD Video category of the British Wildlife Photography Awards. This category puts into clear focus the beauty and richness of nature which is so superbly brought to life in HD.

To find out more about Sky's products and services, please visit
www.sky.com/products

RSPB Wildlife Explorers

RSPB Wildlife Explorers is the junior membership of the RSPB. With over 210,000 junior members, it is the world's biggest club for young people who love wildlife and want to make a difference.

The RSPB is the country's largest nature conservation charity, inspiring everyone to give nature a home. Together with our partners, we protect threatened birds and wildlife so our towns, coast and countryside will teem with life once again. We also play a leading role in a worldwide partnership of nature conservation organisations.
www.rspb.org.uk/youth

WWF

WWF is building a future where people and nature thrive together. That's why WWF is as passionate about tackling global climate change, and finding ways to share the planet's resources more sustainably, as it is about protecting endangered wildlife.
wwf.org.uk

The Wildlife Trusts

The Wildlife Trusts comprise 47 individual Wildlife Trusts covering the whole of the UK, with more than 800,000 members. Collectively they manage thousands of nature reserves and run marine conservation projects around the coast. The Wildlife Trusts also advise landowners on wildlife-friendly land management, and every year work with thousands of schools.
www.wildlifetrusts.org

Countryside Jobs Service

Countryside Jobs Service is a small ethically focused company providing information on countryside careers including jobs, volunteers, professional training and more. Established in July 1994, CJS is run by a small, dedicated team of ex-rangers, smallholders and ecologists working on a co-operative basis to ensure they publish the widest range of relevant information for readers.
www.countryside-jobs.com

Buglife

Buglife is a registered charity and the only organisation in Europe devoted to the conservation of all invertebrates – everything from bees to beetles, woodlice to worms and jumping spiders to jellyfish! Invertebrates are vital for the health of the planet. They pollinate our crops and wild flowers, recycle nutrients back into the ground, and are a vital source of food for other animals such as birds and mammals. The food we eat, the fish we catch, the birds we see, the flowers we smell and the hum of life we hear simply would not exist without wonderful, amazing, fascinating bugs.

www.buglife.org.uk

Kristal Digital Imaging Centre

Kristal Digital Imaging Centre is Surrey's premier professional photo-processing laboratory. A family-run independent business established in 2003, its continued investment in the most up-to-date equipment ensures the highest quality results. With an ever-growing product range from standard photographic prints through photobooks to acrylic panels, Kristal strives to develop products that will keep existing customers and attract new clientele.

www.kristal-photos.com

Young Pioneers

Young Pioneers is a charity that enables vulnerable young people to overcome adversity, be successful and lead change. It trains young people to become youth trainers who teach other young people skills such as photography, enterprise and how to use technology to drive change.

www.ypsanctuary.org

Páramo

Páramo Directional Clothing Systems provide exceptional performance and unrivalled comfort outdoors. Innovative, quiet fabrics that wick away water combined with professionally tested designs help photographers and naturalists to stay comfortable outside.

www.naturallyparamo.co.uk

City of London

The City of London Corporation protects, funds and manages over 11,000 acres of historic and natural green space, by charitable trust, for London's recreation and health. These include Hampstead Heath, Epping Forest, Burnham Beeches, Queen's Park, Highgate Wood, West Ham Park, seven 'commons' lying south of London and over 200 gardens, churchyards, parks and plazas across the Square Mile.

www.cityoflondon.gov.uk

Outdoor Photography magazine

Outdoor Photography is the UK's only magazine for photographers who are passionate about being out in wild places, seeing inspiring nature and wildlife and having great adventures. And, of course, these activities also go hand in hand with an interest in conservation and the environment. Each issue features a stunning array of photographs with regular contributions by leading photographers from the UK and beyond. The magazine is renowned for its in-depth technique features, cutting-edge opinion articles and its superb guides to photographic locations.

www.outdoorphotographymagazine.co.uk

RSPB

With over 1.1 million members the RSPB is the country's largest nature conservation charity, inspiring everyone to give nature a home.

www.rspb.org.uk

CVP.com

CVP.com is proud to sponsor the Documentary Series category of the British Wildlife Photography Awards 2014. CVP.com is unique in the UK in that it is owned and managed by broadcast and professional imaging practitioners with direct front-line user experience of the products they sell. Their passion and understanding of the market has resulted in a highly focused organisation structured to meet the needs of its customers. Respected by all the manufacturers whose products it sells, CVP.com is one of the leading broadcast and professional imaging solutions providers in the UK and Europe, with a comprehensive UK sales and support infrastructure. It has hubs in London, the Midlands, Wales, the North and Scotland.

cvp.com

THE JUDGES

Ross Hoddinott

Wildlife Photographer

Ross is one of the UK's leading outdoor photographers. He is best known for his landscape photography and intimate close-ups of insects and wild flowers. He is also a prolific author, having written seven books on the art of photography. Ross's work is represented by NaturePL and the National Trust Picture Library, and he is a multi-award winner in both the Wildlife Photographer of the Year and the BWPA competitions – including being overall winner in 2009. He co-runs Dawn 2 Dusk Photography and was a member of the 2020VISION photo-team – the most ambitious nature photography project ever staged in the UK. Ross is also proud to be an ambassador for Nikon UK.

Sophie Stafford

Consultant Editor

Sophie was editor of BBC *Wildlife Magazine* for over eight years. A trained biologist with a passion for photography, one of the most fulfilling parts of her role was working with the world's finest photographers, developing new talent and encouraging amateurs. She judged BBC *Wildlife's* prestigious Wildlife Photographer of the Year competition for over six years, joined the Nature jury on the World Press Photo Award in Amsterdam in 2011 and 2012, and flew to Moscow to judge the Golden Turtle Competition.

She recently assisted co-judge Mark Ward in launching the RSPB's new magazine *Nature's Home* and is an affiliate of the International League of Conservation Photographers. Sophie is delighted to join the BWPA jury this year.

Mark Ward

Editor-in-Chief
RSPB *Nature's Home* magazine

Mark Ward is the RSPB's Editor-in-Chief, a role that includes editing its quarterly magazine, read by 1.3 million people. He recently oversaw the relaunch of the long-running title *Birds as Nature's Home*.

Mark has been writing about birds, travel, wildlife and conservation from a young age – his first feature appeared in *Birdwatch* magazine when he was 15 and he wrote a birdwatching column in *The Sunday People* for seven years from the age of 18. He has written hundreds of magazine features for a range of titles that include *Birdwatching, Country Walking* and *FHM*. Mark has also worked on the Wildlife Trust's *Natural World* magazine and has written several books, including *Bird Identification and Fieldcraft: a Birdwatcher's Guide* and *RSPB Pocket Garden Birdwatch*.

Rob Cook

Segment Manager
Canon

Rob is a Segment Manager at Canon UK, responsible for the UK's wildlife and nature photographers. He works closely with many of the country's leading professionals, enabling Canon to be instrumental in the development of British nature photography, for the benefit of all professionals and amateurs alike.

He is passionate about landscape photography and Britain's wilderness areas, and whenever possible will be out with his camera. While fortunate to have travelled extensively, he maintains a preference for the UK and its more open spaces, with a specific love for Dartmoor, northwest Scotland and the Outer Hebrides.

Alison Bevan

Director
Royal West of England Academy

Alison Bevan (née Lloyd) is Director of the RWA in Bristol – England's only regional Royal Academy of Art. From 1999 to 2013 she was Director of Penlee House Gallery & Museum, Penzance, which specialises in the work of the Newlyn, Lamorna and St Ives colonies (1880–1940).

After graduating in Art History from Nottingham University in 1986, she worked in public galleries in Wales, latterly at the Glynn Vivian Art Gallery, where she was Exhibitions Officer. She moved to Cornwall in 1999 and became an expert on Newlyn School paintings, on which she has written and lectured in the UK, USA and France. She was awarded the British Empire Medal in 2013 for services to Cultural Heritage in Cornwall.

Paul Wilkinson

Head of Living Landscape
The Wildlife Trusts

Paul leads The Wildlife Trusts' vision to create A Living Landscape, which has the restoration of the natural environment at its heart. Paul's interest in wildlife photography was rekindled through this recovery plan for nature, championed since 2006, to create a resilient and healthy environment, rich in wildlife. Paul previously worked as the Director of Regional Policy for The Wildlife Trusts in the East of England, during which time he was a member of the East of England Regional Assembly and chaired the region's Biodiversity Forum for six years.

Paul is a member of the Institute of Ecology and Environmental Management.

Hilary Clothier

Picture Editor
Countryfile magazine

Hilary has worked as a picture editor in the publishing industry for 16 years, on a variety of quality publications and digital media. These include titles at News International, *National Trust* magazine and *Countryfile* magazine, all of which demand the highest standards of imagery.

Hilary works closely with experts on wildlife and the environment for features and articles published in *Countryfile* magazine, sourcing the stunning imagery that is key to its appeal. She also commissions specialist photographers to work to tight briefs and deadlines. Hilary is always keen to champion great photographic work and is thrilled to be a BWPA judge this year.

James Brickell

Wildlife film-maker

James Brickell is a two-time BAFTA award-winning wildlife film-maker at BBC Natural History Unit. As a zoologist James has been fascinated by nature from a young age. He joined the BBC in 1997 where he has been responsible for many groundbreaking sequences and 'world firsts'. His work includes *The Really Wild Show*, *Wildlife on One*, *Life in Cold Blood*, *Great Barrier Reef* and *Deadly 60*. Most recently he broke new ground in harnessing the public's own love of nature to help make the BBC1 series *The Great British Year*. He has a particular love of the oceans and reptiles, and he heads the NHU's dive team.

THE JUDGES

Kate Foreshew

Picture Editor
WWF UK

Kate worked at *Illustrated London News*, Associated New Media and National Geographic Digital Motion before joining the team at WWF-UK, where she heads up the photography desk.

Always searching for the perfect shot to illustrate WWF's print portfolio and online campaigns, she commissions photographers to capture inspiring field stories and works closely with photographic agencies and WWF network offices around the world. Her selections are informed by a genuine passion for wildlife photography and a sound understanding of global conservation issues.

Kate is thrilled to be part of the BWPA judging panel. It's her chance to select shots that showcase the incredible diversity of British wildlife and surprise people with the beauty on our doorstep.

Steve Watkins

Editor
Outdoor Photography magazine

Steve Watkins has been a professional photographer and author for over 18 years. His work has taken him to over 70 countries and every continent. He is the photographer and co-author of three international bestselling BBC books in their *Unforgettable Things to Do* series. Among his other editorial clients are the *Daily Telegraph*, the *Times*, *Mail on Sunday*, *Sunday Express*, *USA Today*, *Wanderlust*, *Traveller*, *Country Walking* and *Geographical*.

Steve is a sought-after speaker and has appeared on arts programme interviews on ITV, the BBC's *Tomorrow's World* and C4 as well as many radio programmes, giving interviews and taking part in travel-related discussions. He is the Director of Photography for the Travellers' Tales Festival and he regularly shares his knowledge and experience via his photography and writing workshops.

Jules Cox

Wildlife Photographer

Jules is a London-based wildlife photographer drawing inspiration from the wildlife of Britain and the arctic wildernesses of the far north. He is a regular contributor to BBC *Wildlife* magazine, with several cover shots to his name. His wildlife images have been published internationally, appearing widely in books, magazines and the press. Jules' work has been recognised by BWPA on a number of occasions. In 2012 he won the British Seasons category with his portfolio of mountain hare images.

Jules is represented by several leading natural history photographic libraries, including FLPA, Minden Pictures, the Natural History Museum Image Library and NHPA, now part of Photoshot. In 2012, he took part in London Wild Bird Watch Live as one of their Masterclass leaders, and he also leads trips for two wildlife photography tour and hide operators.

James Tims

Digital Assets Manager
AA Publishing

James has been a travel photographer for 20 years. Published in books, magazines and websites across five continents, he has an unfaltering passion for inspirational and emotive photography.

His relationship with AA Publishing as an image maker, buyer, editor and seller spans almost his entire career and at the end of 2012 he was promoted to the position of Digital Assets Manager. His remit now encompasses design, imaging, proofing, picture library, digital products and, ultimately, providing a strong creative steer for all visual aspects of AA Media's publishing programme.

Embracing the new technologies, challenges and demands that face the industry in this exciting new era of digital publishing, James is proud to be a part of the BWPA competition.

WITH THANKS TO

All the photographers who participated in the awards

The sponsors, supporters and judges

The Mall Galleries

Nature in Art

Moors Valley Country Park

Whitstable Museum and Art Gallery

The RSPB's Wildlife Explorers Team

Pinkeye Graphics

Made by Hippo Ltd

Natural England

Nunnington Hall, Yorkshire

Picture This Gallery

Stockwood Discovery Centre, Luton

Royal West of England Academy, Bristol

Exhibitions on Tour

Royal Albert Memorial Museum and Art Gallery, Exeter

Wild Photos

Wildlife Film.com

Wildeye

Jason Peters

Phil Gowan

Ralph Tribe

Greg Armfield

Jennie Hart

Babs Gowan

Claire Harris

Rebecca Moran

Stephen Moss

David Johnson

Anna Guthrie

Minesh Amin

Carol and Geoff Sewell

Charlotte Salaman

Michelle Hawkins

Angus Robinson

Iain Green

Siroun Tarayan

Dympna Marsh

BRITISH WILDLIFE
PHOTOGRAPHER OF THE YEAR

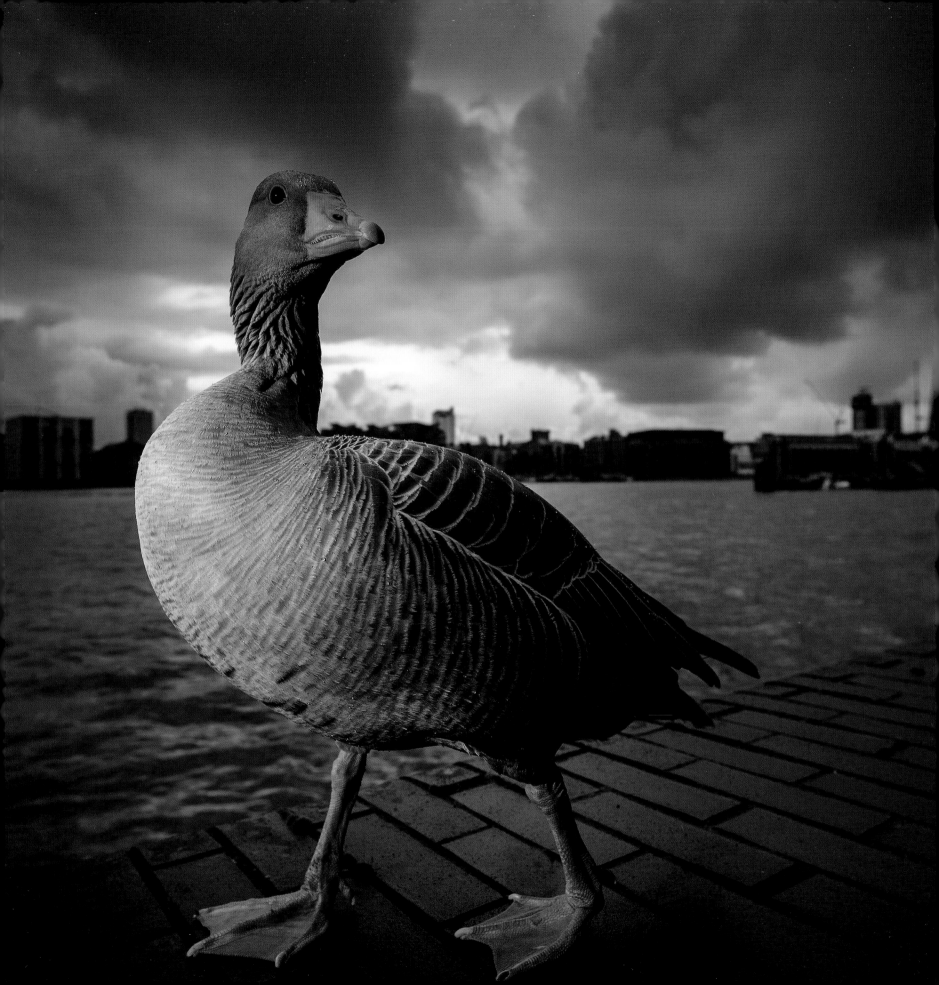

BRITISH WILDLIFE PHOTOGRAPHER OF THE YEAR 2014

OVERALL WINNER

LEE ACASTER

The Tourist
(Greylag goose, *Anser anser*)
London, England

I was set up for shooting a stormy cityscape with a manual-focus wide-angle lens when this goose landed on the river wall. I decided to see if I could get really close to him to fill the frame and keep the London skyline in the background for context. I underexposed and used a handheld flash in my left hand to enhance the drama.

ANIMAL
PORTRAITS

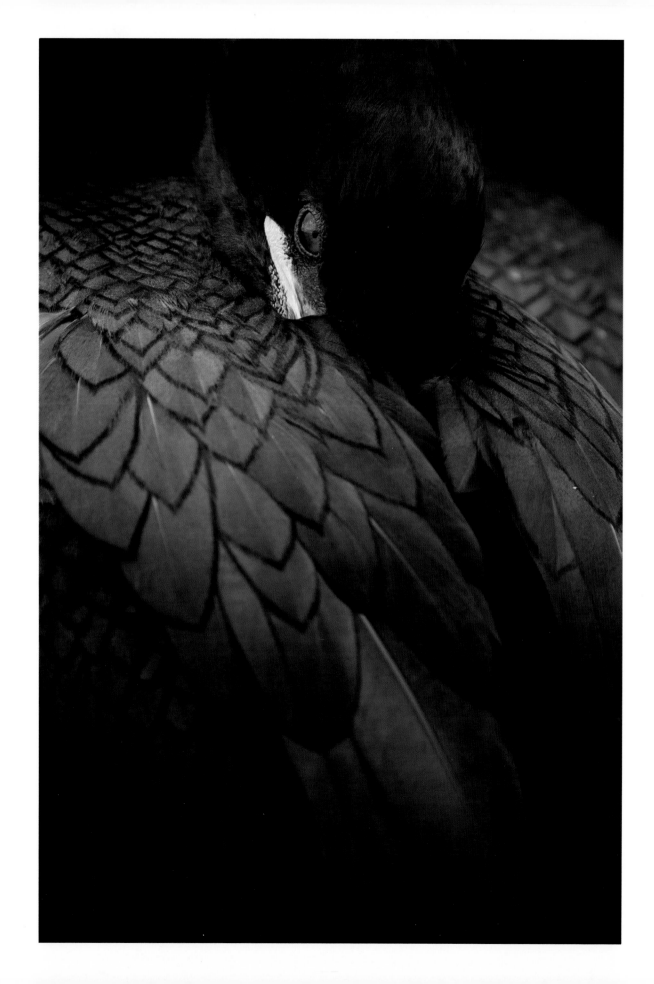

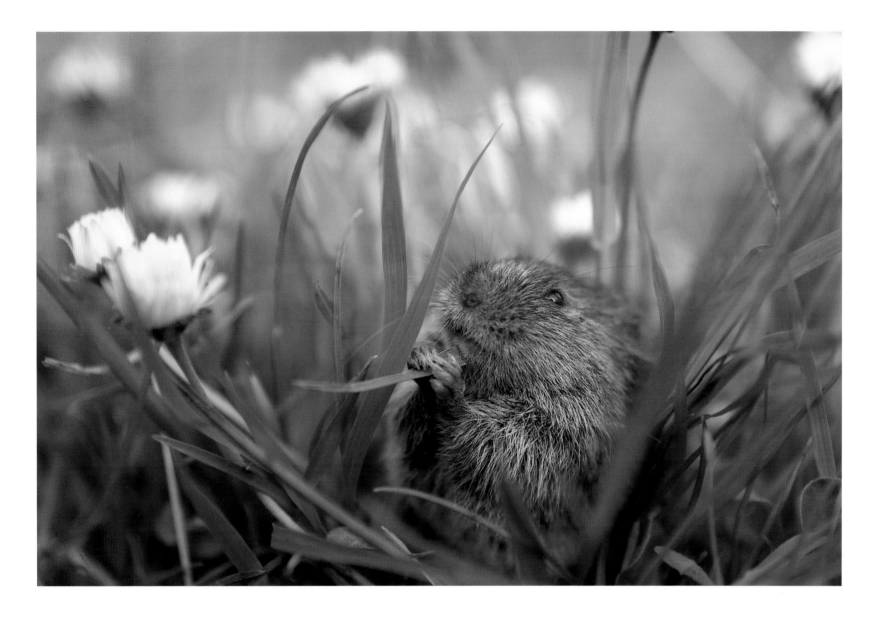

ANIMAL PORTRAITS WINNER

STEVEN FAIRBROTHER <

Shag Resting
(Shag, *Phalacrocorax aristotelis*)
Farne Islands, Northumberland, England

It's always a thrill to get so close to a wild bird and it's hard to believe that any bird on the Farnes is able to rest with all the frantic activity and noise that the breeding season brings.

JAMIE UNWIN ∧ HIGHLY COMMENDED

Hungry Vole
(Bank vole, *Myodes glareolus*)
Islip, Oxfordshire, England

I was producing some images of rodents for my zoology coursework for uni and wanted to capture something slightly different. The bank vole was located in a patch of daisies, which added a nice dimension to the picture. I just had to wait until it did something interesting. When it started to eat a blade of grass, I captured the image I was after.

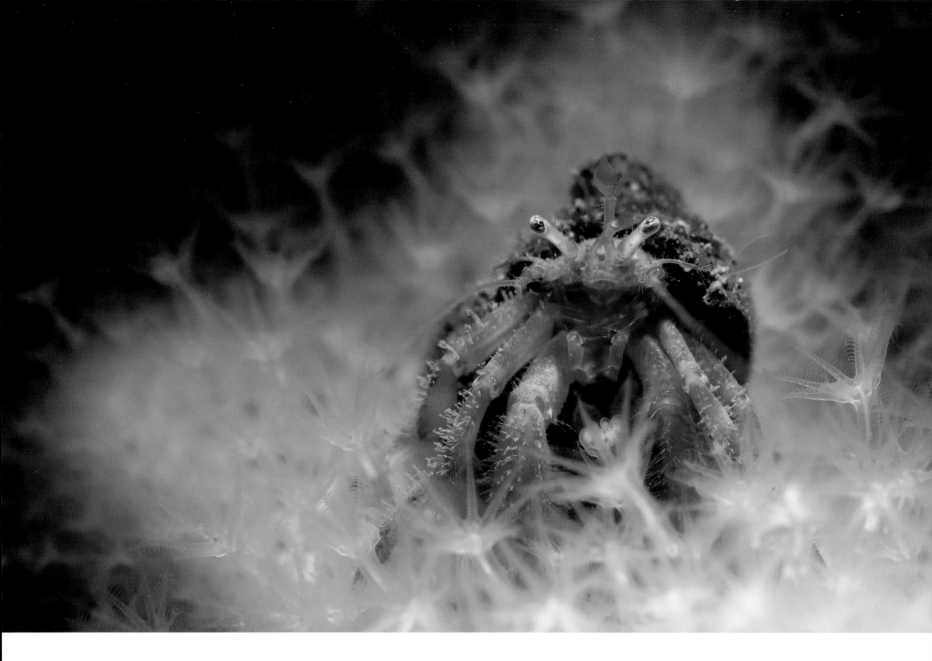

MATT DOGGETT HIGHLY COMMENDED

Hermit Crab

(Hermit crab, *Pagurus bernhardus;*
Dead man's finger, *Alcyonium digitatum*)
Loch Carron, Scotland

Loch Carron is a diver's paradise, sporting a huge diversity of species and
habitats. Towards the end of a dive on the maerl beds I came across this
crab perched atop a throne-like Dead man's finger. As the current picked up
I worked against the clock to get the lighting right. The crab didn't mind me
getting close to fire off a few shots before heading back to shore.

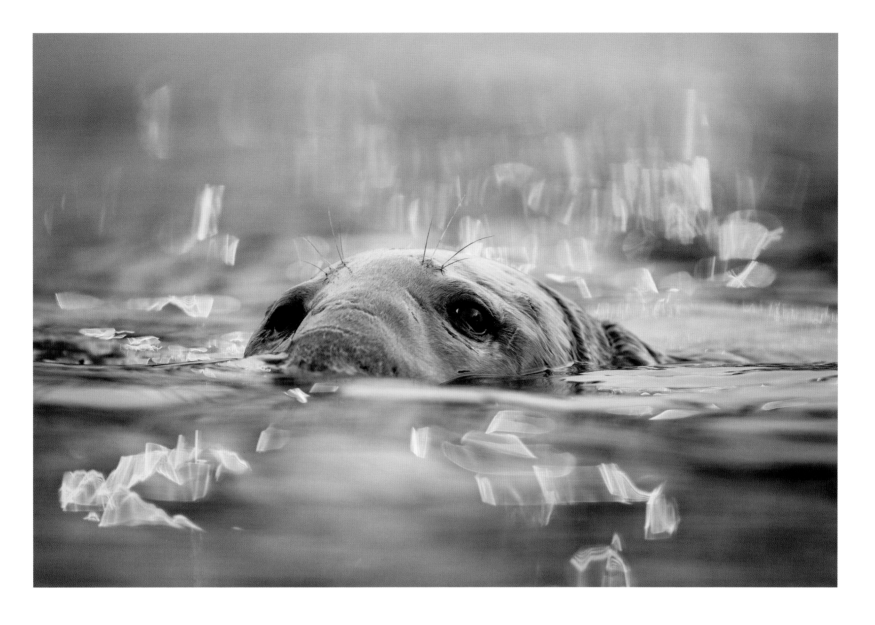

PETER CAIRNS HIGHLY COMMENDED

Seal on Fire
(Grey seal, *Halichoerus grypus*)
Shetland Isles, Scotland

As the natural light faded in Lerwick Harbour and the lights from the
trawlers were reflected in the water like fire, I could immediately see the
potential if and when a seal popped up in the right place. As I lay prone
on kelp-covered rocks, this inquisitive bull came to check me out.

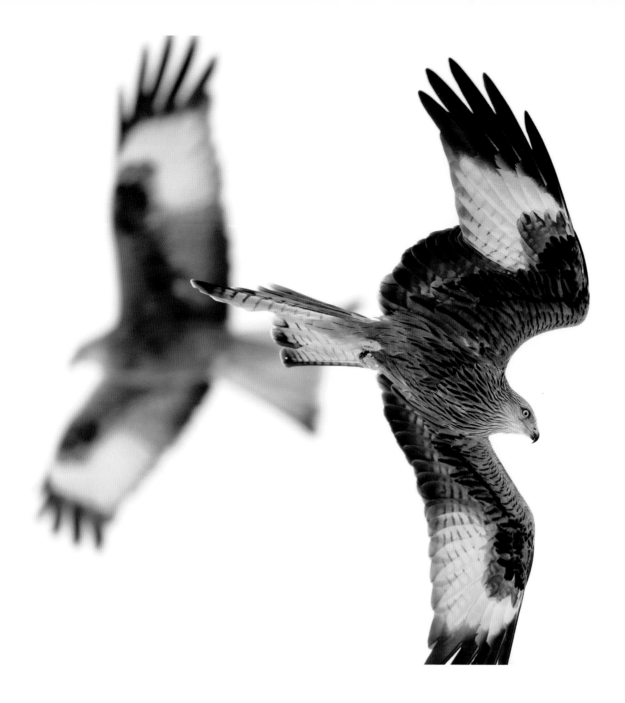

ANDREW MASON HIGHLY COMMENDED

Red Kites
(Red kite, *Milvus milvus*)
Gigrin Farm, Powys, Wales

I visited the Red Kite Feeding Station and Rehabilitation Centre at Gigrin
Farm on a cold and overcast winter's day. With the sky being white and the
snow on the ground acting as a natural reflector, I was able to photograph
the birds against a white background as they flew around the Centre. This
image shows two of them passing in flight.

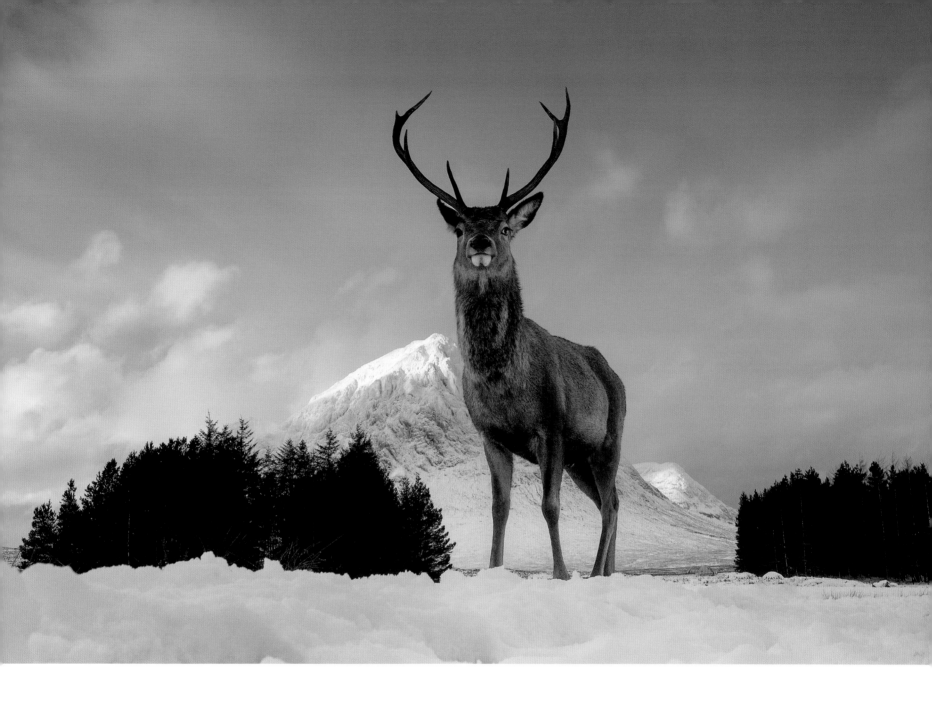

KEITH THORBURN HIGHLY COMMENDED

King of Rannoch Moor and Glencoe
(Red deer, *Cervus elaphus*)
Glencoe, Scotland

This wild stag which frequents Rannoch Moor is known in the area and can be seen with the herd getting scraps from a local hotel. Patience and slow, deliberate crouching low to the ground allowed the stag to feel unthreatened. To help with the shadows I used flash from the right, from my helper wife.

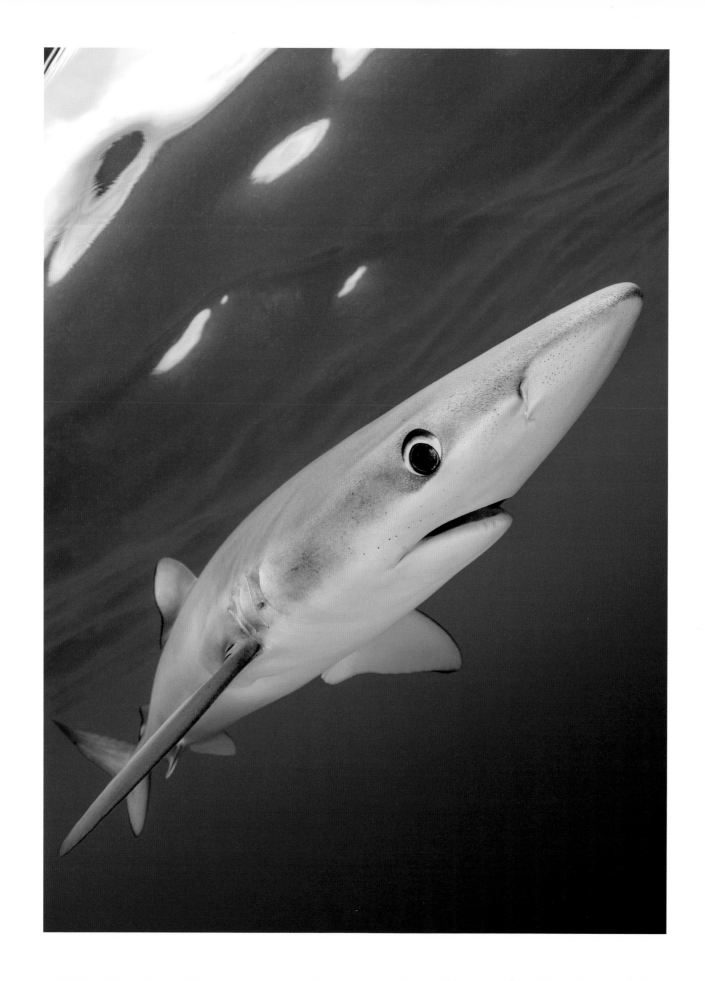

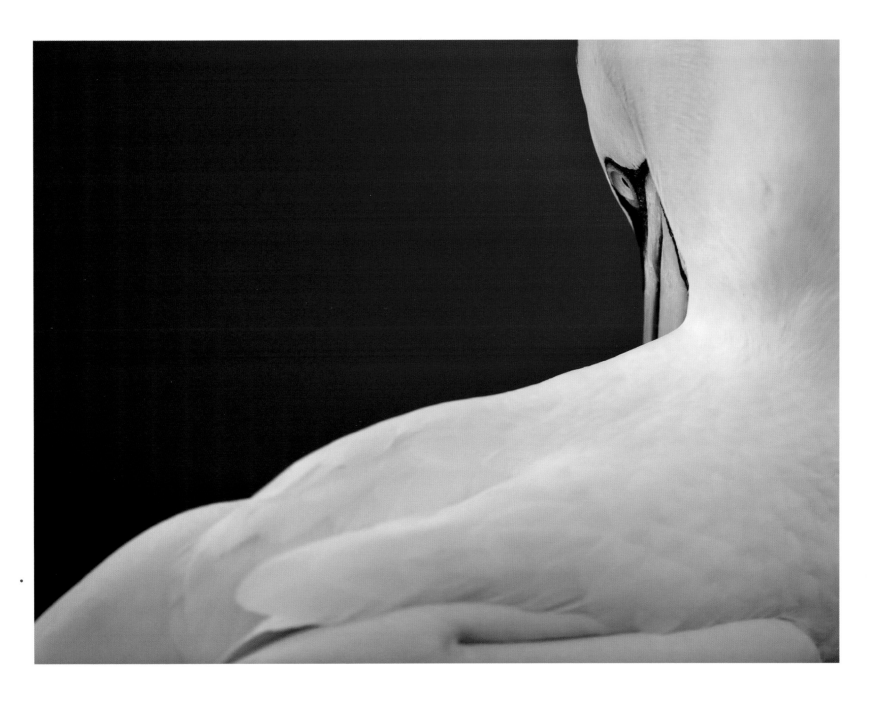

ALEXANDER MUSTARD < HIGHLY COMMENDED

Oceanic Hunter
(Blue shark, *Prionace glauca*)
Penzance, Cornwall, England

My friend Charles Hood discovered a spot off Penzance to encounter blue sharks, something I thought I'd never see in British seas. I composed this shot diagonally to emphasise their athleticism. I added a teleconverter to my lens to reduce the angle of coverage and fill the frame with the shark.

RADOMIR JAKUBOWSKI ∧ HIGHLY COMMENDED

Northern Gannet Portrait
(Northern gannet, *Morus bassanus*)
Bass Rock, Scotland

There are so many great pictureas of the Northern gannet, I tried to take a different one. I wanted to show a portrait with intimacy. To take a portrait without manipulation I chose a long lens (800mm) and took this image.

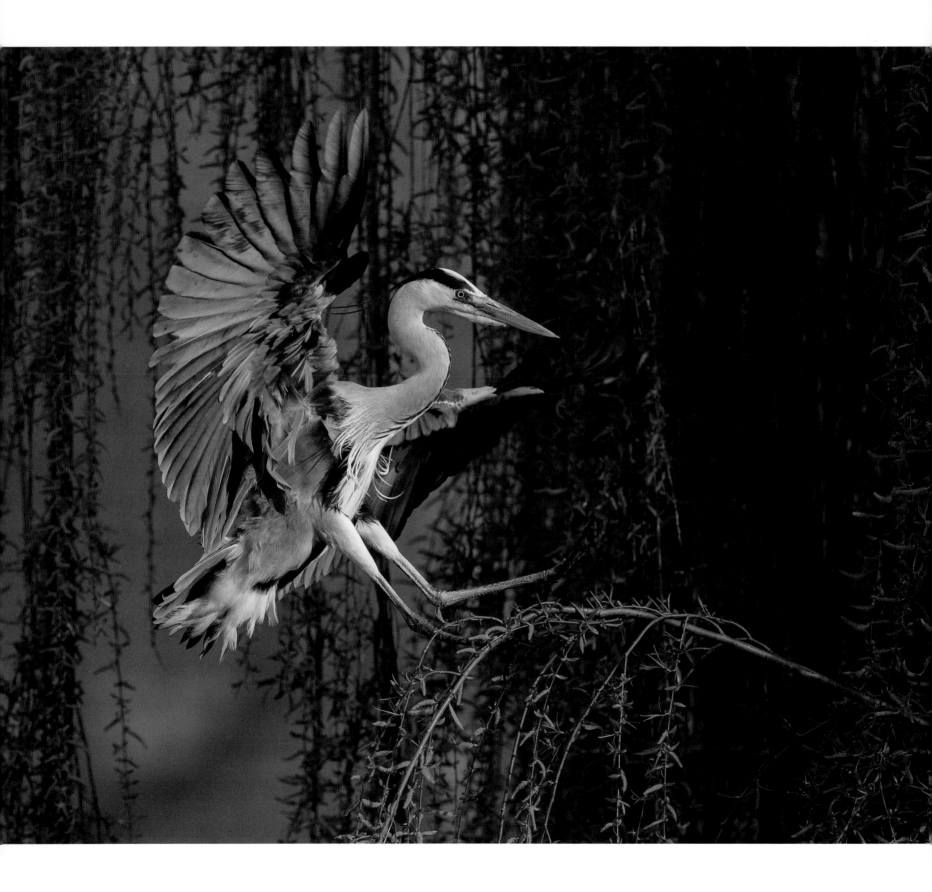

GERARD SEXTON < HIGHLY COMMENDED

Grey Heron Applying the Brakes
(Grey heron, *Ardea cinerea*)
Regent's Park, London, England

This male heron was part of a pair nesting on the edge of the boating lake in Regent's Park, London, in a low-lying willow. Here the heron is coming in to land in the willow. He is collecting nesting material to take back to the nest and present to the female, who is brooding the eggs.

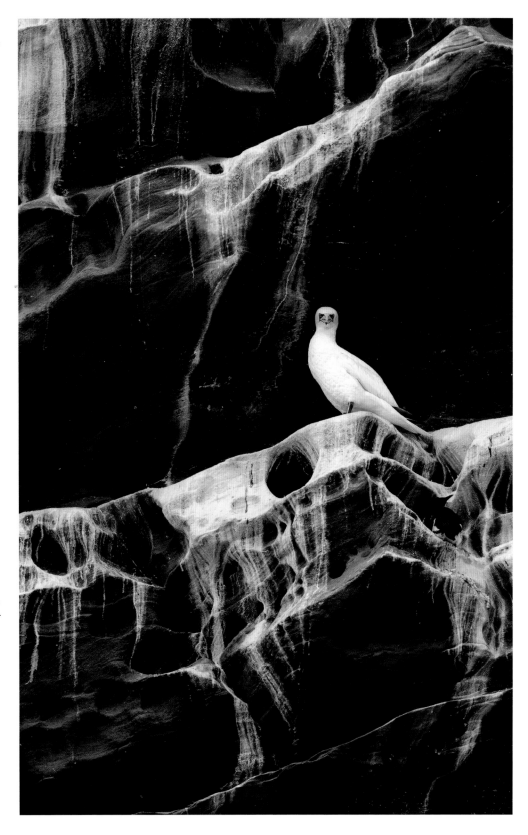

ANDREW MASON > HIGHLY COMMENDED

Northern Gannet on Sandstone Cliff
(Northern gannet, *Morus bassanus*)
Noss, Shetland Isles, Scotland

While in Shetland I took a boat trip from Lerwick to Noss to see the spectacular seabird colonies on the sandstone cliffs of this small island. I struggled to photograph this solitary gannet among the guano-covered sandstone as I handheld my camera and lens while standing on the back of the small boat as it moved constantly in the heavy sea.

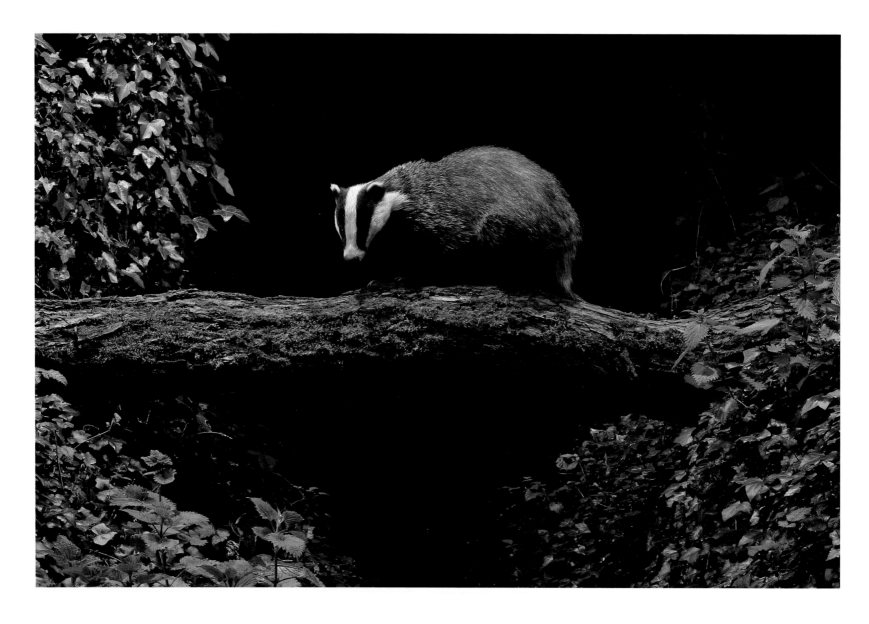

RUSSELL SAVORY ∧ HIGHLY COMMENDED

Brock over Brook
(Badger, *Meles meles*)
Orsett, Essex, England

I watched the badgers over a period of time and established their routes.
Next, I set up a small screen hide with a remote camera operating on
infra-red and three flashlights.

MARK HAMBLIN > HIGHLY COMMENDED

Mountain Hare in Snow
(Mountain hare, *Lepus timidus*)
Cairngorms National Park, Inverness-shire, Scotland

I've been working on Mountain hares at a site local to where I live for the
past few years but stepped this up last winter with a view to spending
more time with them. Encounters with these animals vary considerably
depending on conditions, time of year and specific individuals. This hare
'approached' me while I was photographing another animal further away
and in the end came too close for me to focus (less than 6m).

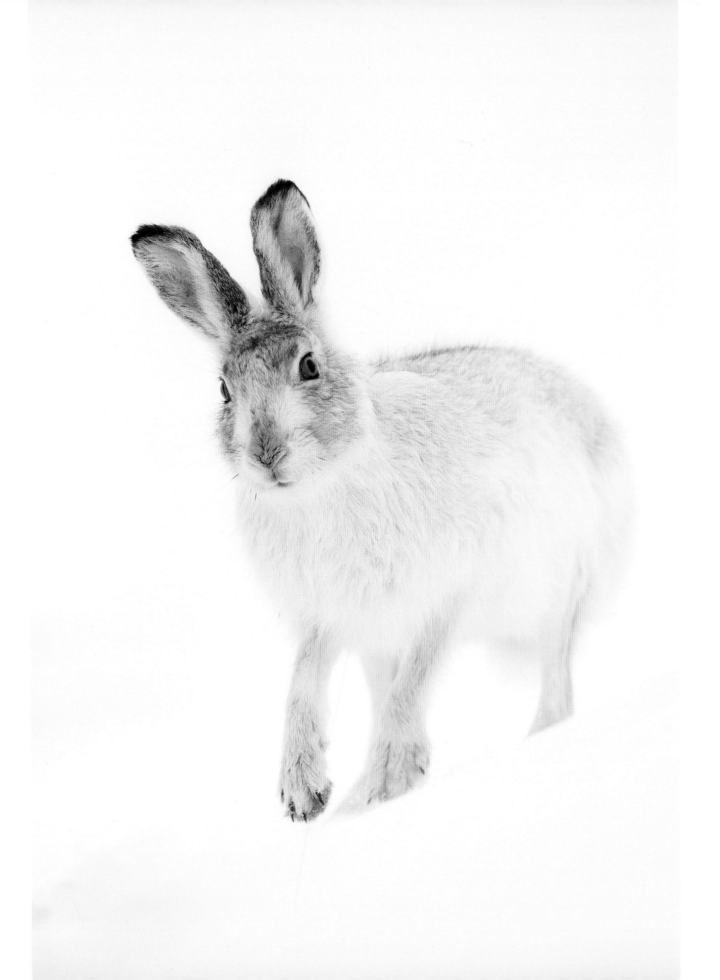

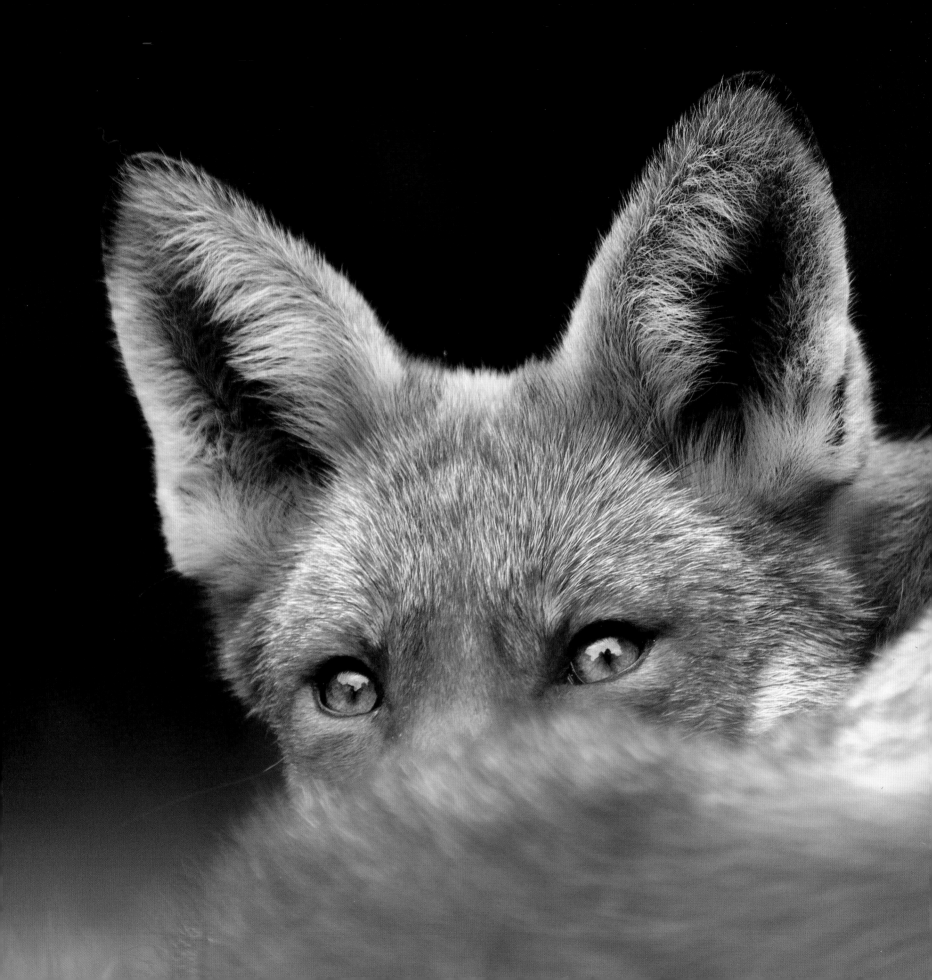

ALANNAH HAWKER HIGHLY COMMENDED

A Quick Glance
(Red fox, *Vulpes vulpes*)
Merstham, Surrey, England

When I noticed this wild vixen curled up asleep I knew I had to get a shot of her, so I lay down and slowly crept closer and closer. I tried a few shots from a distance but knew I wanted something more intimate, so crept closer still, making sure not to disturb her. After a while of waiting with the shot framed she glanced up and I got the shot I wanted.

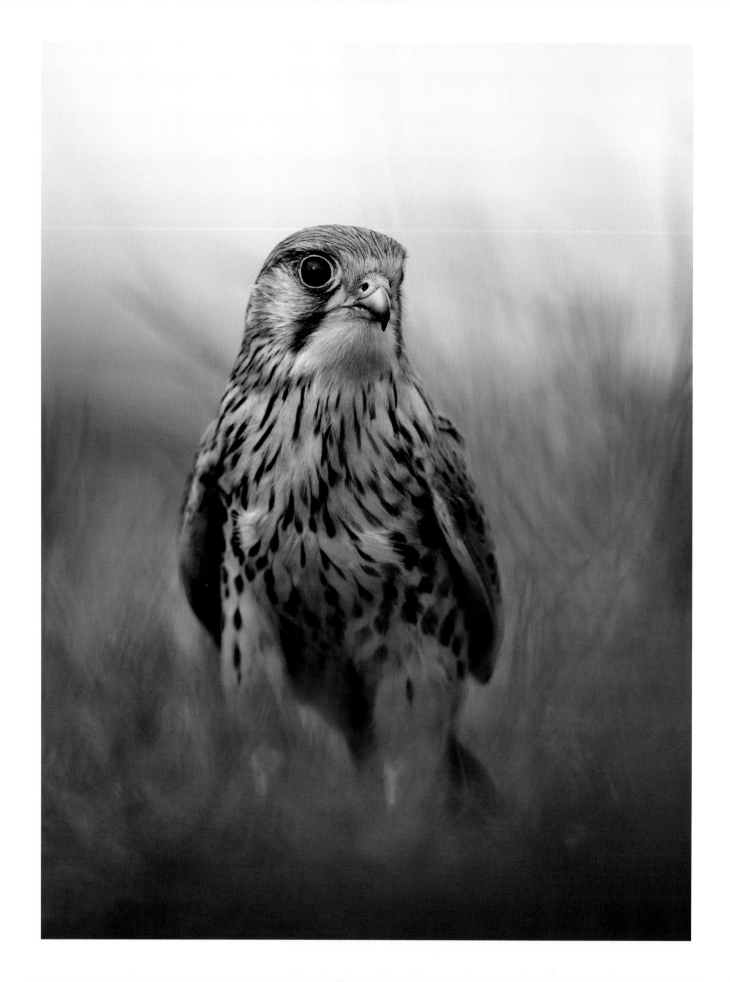

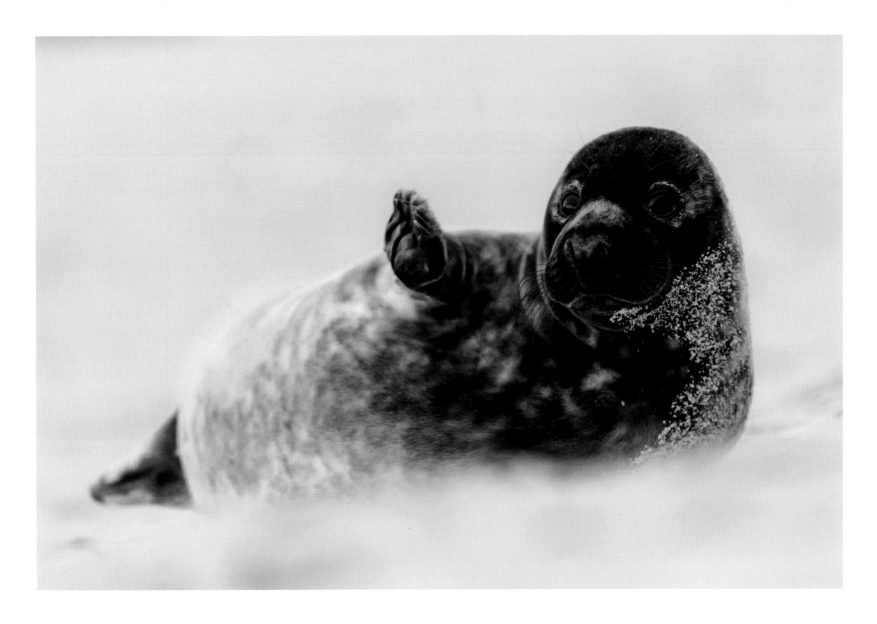

AUSTIN THOMAS < HIGHLY COMMENDED

Wild Kestrel in the Grasses
(Kestrel, *Falco tinnunculus*)
Formby, Lancashire, England

This kestrel image was the product of a fortunate encounter while photographing Little owls. The kestrel was attracted to the noise and activity of a young Little owl that had recently fledged. The kestrel flew down nearby to investigate and I was able to rotate my lens slowly and initially got a record image. When the kestrel heard my camera shutter it turned towards me, then this image was taken.

LUKE WILKINSON ∧ HIGHLY COMMENDED

Waving Seal
(Grey seal, *Halichoerus grypus*)
Winterton-on-Sea, Norfolk, England

During the pupping season I spend several days a week with the grey seals as they have their pups on my local beach. On one particular morning I headed down there while it was still dark. After crawling slowly along the sand, I took a few shots. Then for about two or three seconds the seal lifted up his head and gave me a little wave.

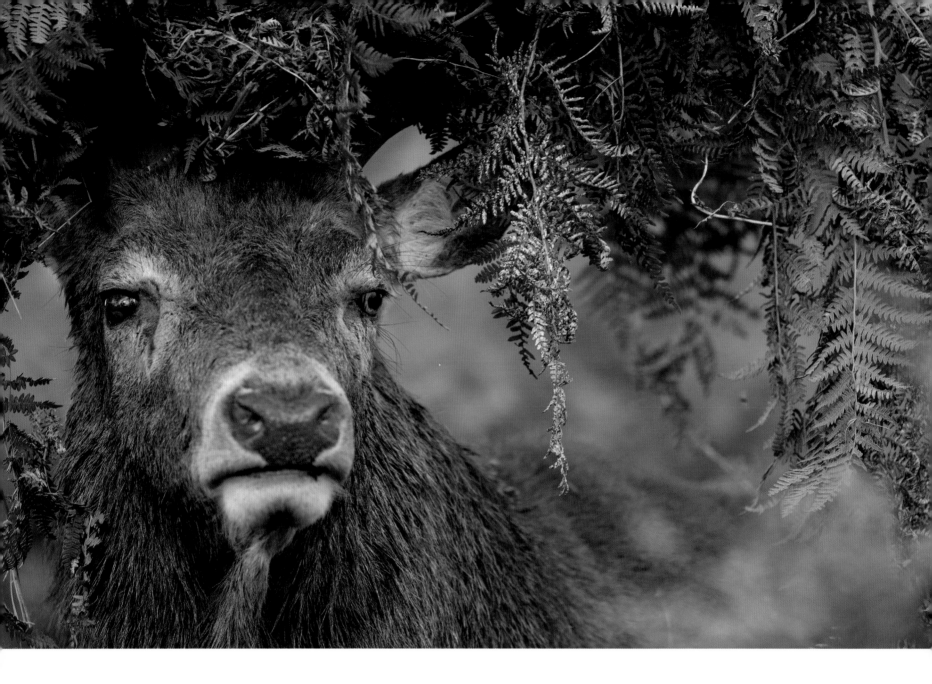

JAMIE HALL ∧ HIGHLY COMMENDED **SIMON LITTEN** >

Commando Stag
(Red deer, *Cervus elaphus*)
Surrey, England

This stag had been making his way through the bracken, roaring at a rival. I was already in position, watching, when the stag suddenly started thrashing his antlers through the bracken. He lifted his head up again and his antlers were full of foliage. Because he had wandered so close I managed to get a tight head shot. He resembled a commando all camouflaged in fern.

Norfolk Gold
(Barn owl, *Tyto alba*)
Norfolk, England

Over a period of about three weeks I moved a canvas hide ever closer to an old tree stump that several barn owls used regularly. I then waited for the evening light to be at its best and returned to take a snap or two. This is a male that would often roost in a nearby windmill.

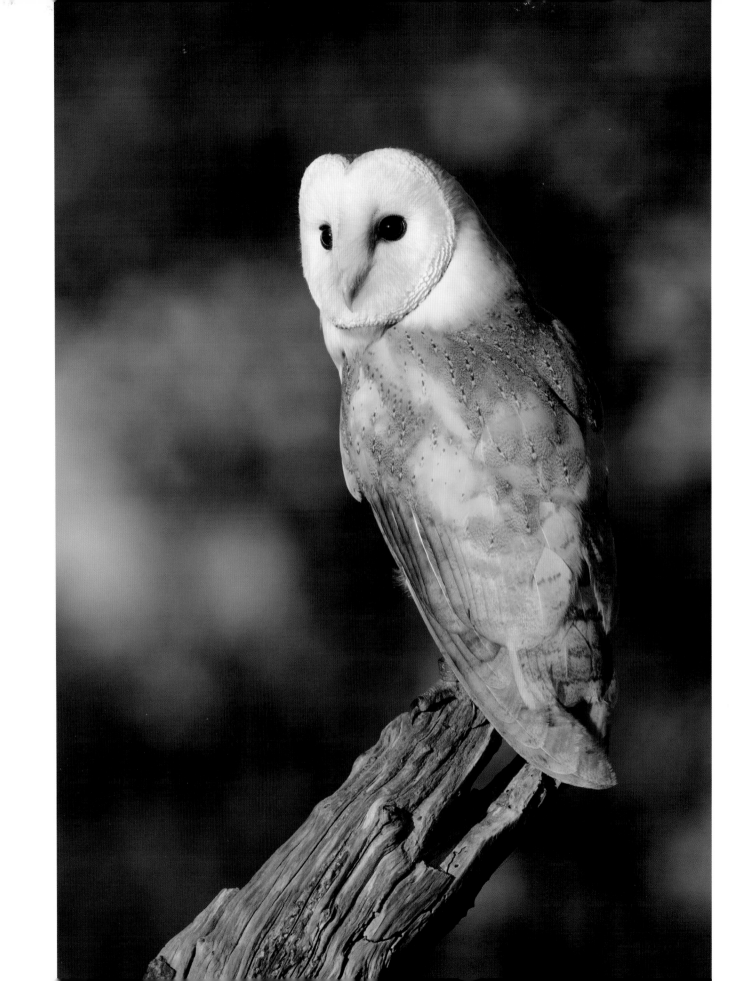

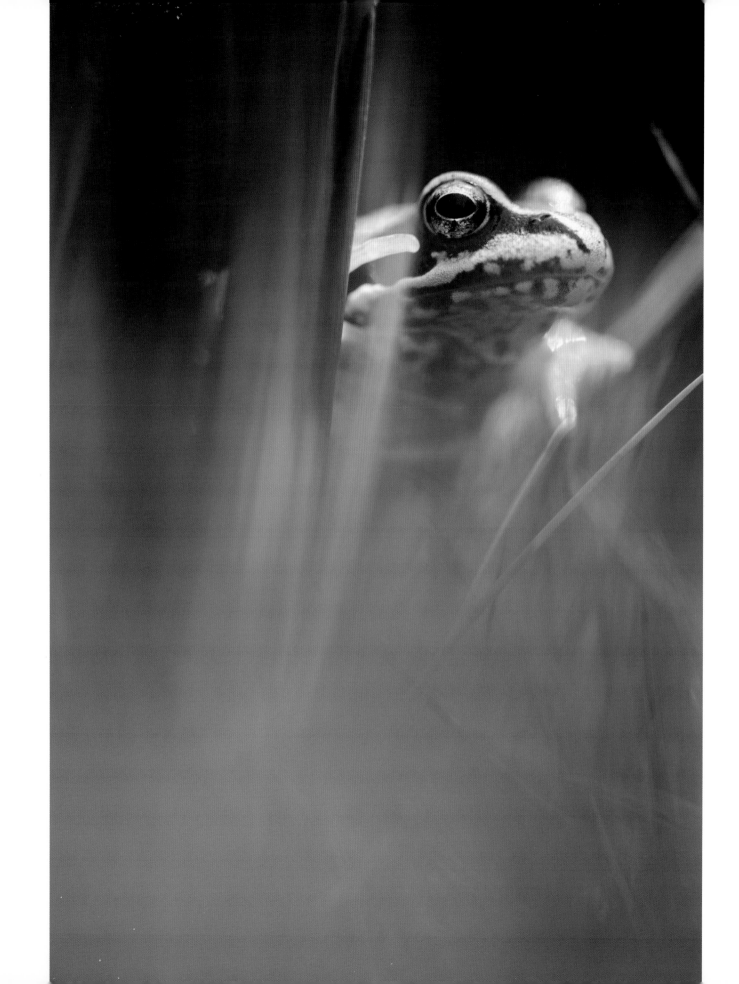

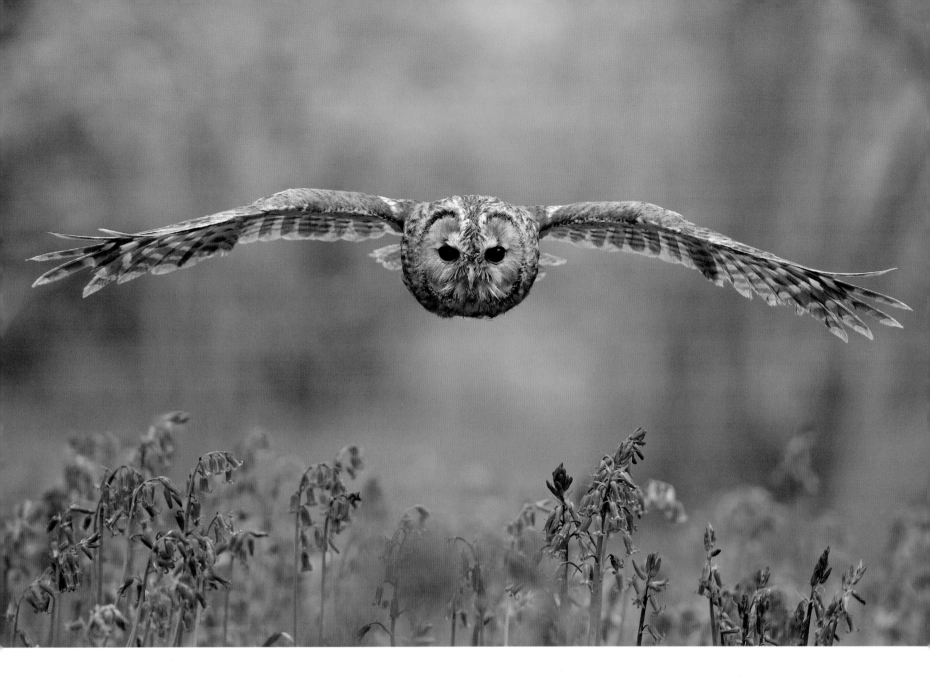

JACK BREADMORE <

Common Frog
(Common frog, *Rana temporaria*)
Windmill Farm Nature Reserve, Cornwall, England

I encountered this common frog in the scrubland of Windmill Farm where
I found it resting in the grass tussocks. I wanted to show the landscape
in which amphibious species such as the common frog can be seen, and
by getting down to eye level with the subject demonstrate the small-scale
environments in which fantastic wildlife encounters can occur.

MATT BINSTEAD ∧

Tawny over Blue
(Tawny owl, *Strix aluco*)
British Wildlife Centre Nature Reserve, Surrey, England

I often fly the owls outside of work to give them some enrichment. I look
forward to photographing the bluebells each year, but have to have an
animal there to make it special for me. I took this owl down to the woods
one evening with my camera and got lucky enough to get this photograph
of her while she was flying over the beautiful carpet of bluebells.

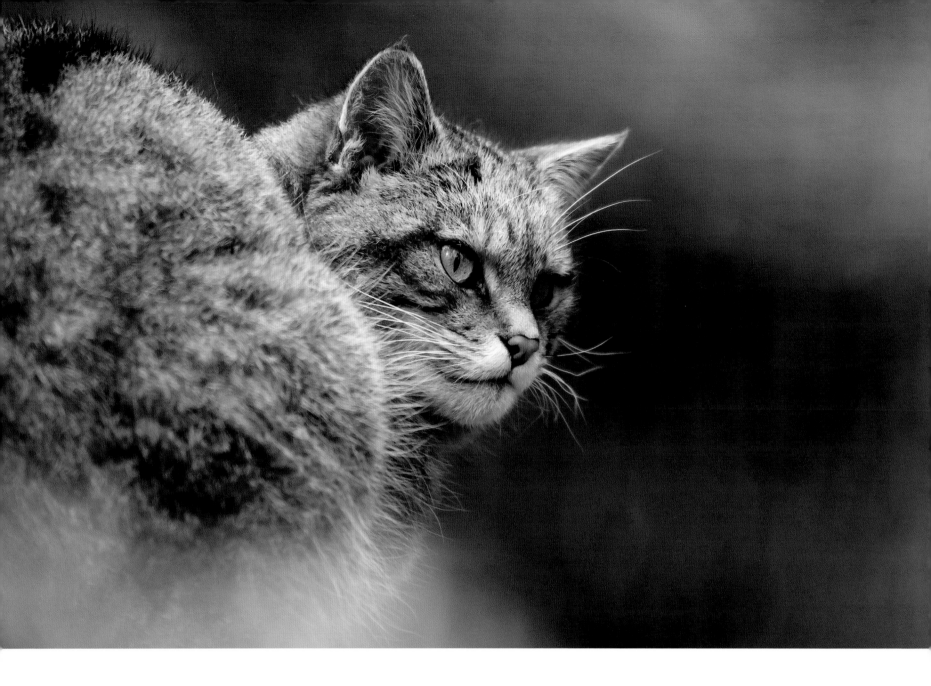

SIMON HAWKINS

Highland Tiger
(Scottish wildcat, *Felix sylvestris grampia*)
Aigas Field Centre, Inverness-shire, Scotland

While staying at the Aigas Field Centre I had an opportunity to visit the site
of their Scottish wildcat breeding programme. Access is restricted, limited
to a hide and by special arrangement to avoid disturbance. The cats are
elusive and maintained in a set of large enclosures. I was fortunate that one
chose to show itself at a distance that allowed me to photograph through
the fencing with a wide aperture.

CARL DAY

Wee Crestie
(Crested tit, *Lophophanes cristatus*)
Abernethy Forest, Aviemore, Scotland

Capturing these little beauties is always tricky as they don't often stay still for long. Using small bursts of the shutter enabled me to capture the bird as it was just about to leave its perch, giving a different take on what's normally seen.

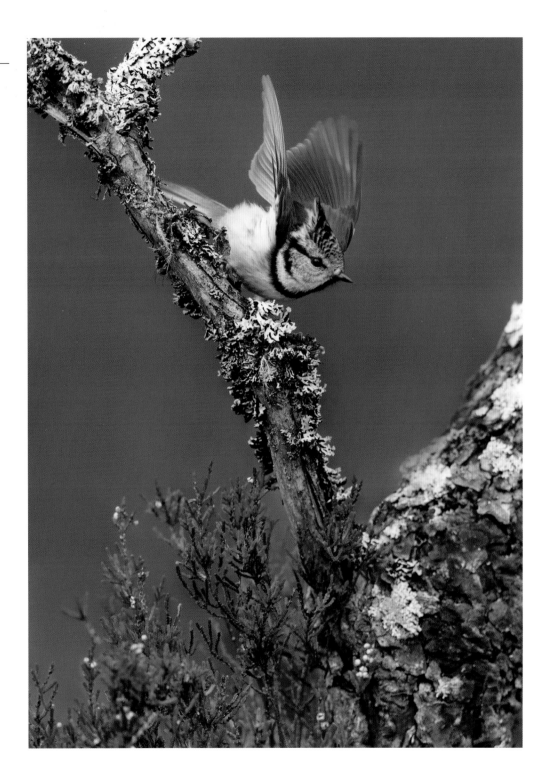

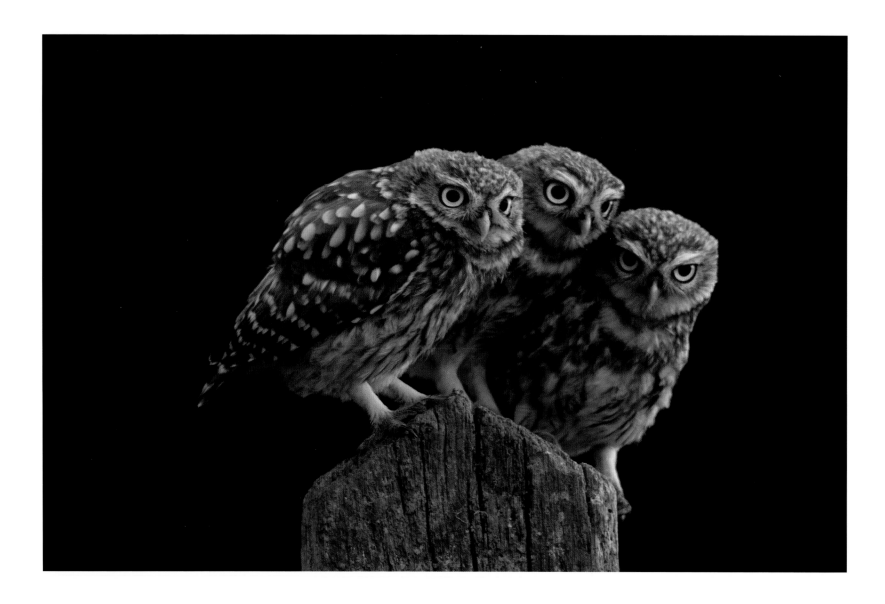

RUSSELL SAVORY

Parliament in Session
(Little owl, *Athene noctua*)
Stow Maries Aerodrome, Essex, England

Taken at the aerodrome from my mobile hide (specially adapted car),
this image came about by watching the pairing of the owls and following
through to eggs hatching. The owls seemed very keen to keep together
as a group so I put up a post to see if anything happened. As soon as one
landed on it, the others had to follow.

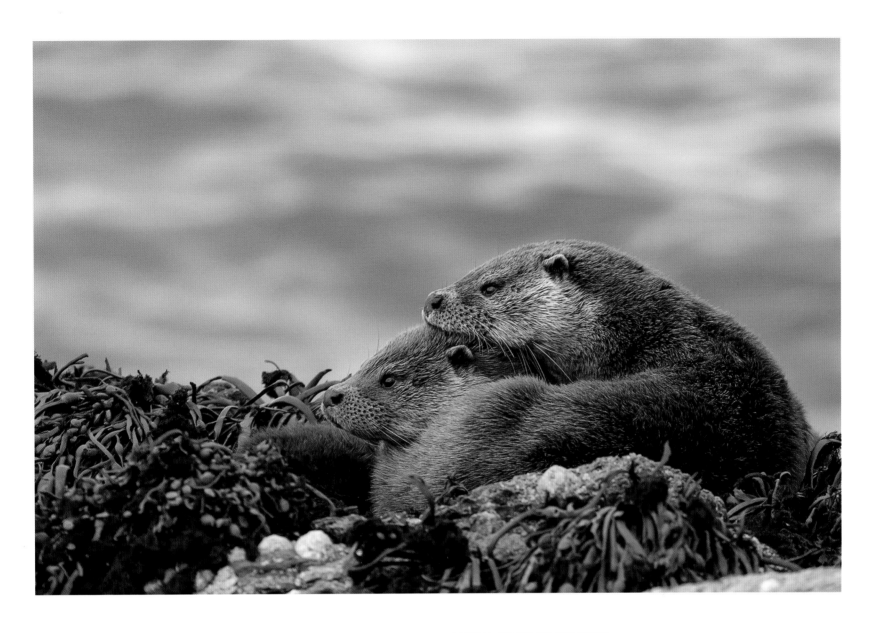

OLIVER CHARLES WRIGHT

Otter Cubs Resting
(Otter, *Lutra lutra*)
Isle of Mull, Scotland

I spent two weeks on the Isle of Mull in March 2014 and spotted this family unit of otters on day one of the trip. I watched them from a distance a number of times. On this opportunity, two of the otter cubs came quite close and settled down to rest. Care was taken never to approach but to wait and see if the otters came within range for photography.

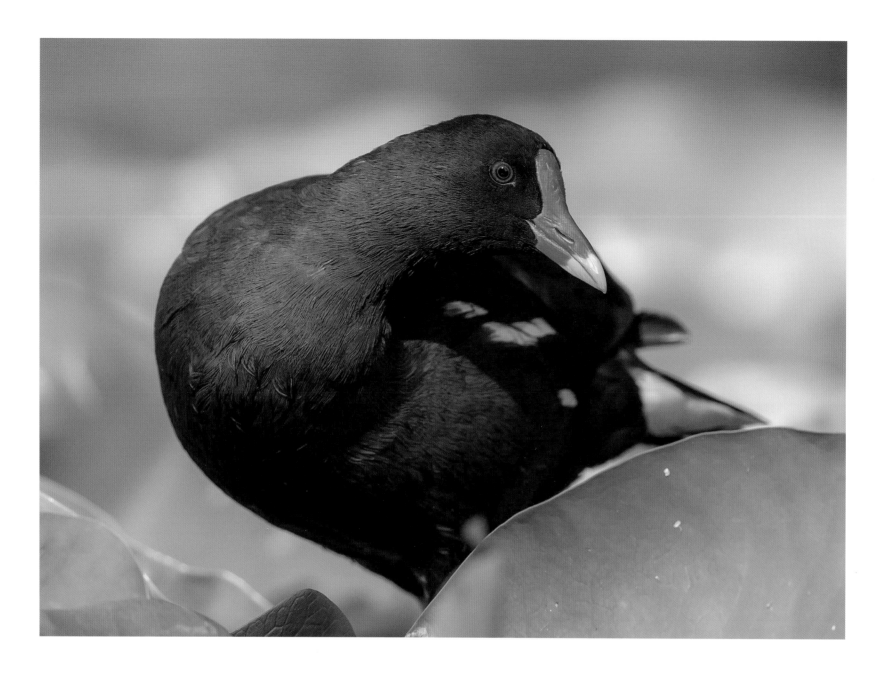

JULIAN PETRIE

Moorhen Traversing Lily Pads
(Common moorhen, *Gallinula chloropus*)
River Chelmer, Essex, England

I was observing this moorhen making use of its generously large feet to traverse a wide patch of lily pads from a purpose-built floating hide. With my presence being totally unnoticed, I realised that the subject would soon be too close to photograph so, waiting for the right moment, I let the shutter off to gain its attention, then took the shot I was hoping for.

STEVEN WARD

Short-eared Owl Hunting
(Short-eared owl, *Asio flammeus*)
Altcar Moss, Merseyside, England

Having spent over 250 hours from early October
watching these birds when they first arrived in
Lancashire until March when they left, I was very
familiar with their daily routine and feeding patterns.
I was hidden away in my bag hide in the trees facing
their favourite hunting ground in the long grass.
The light was great and I waited patiently to capture
the owl diving into the long grass for its prey.

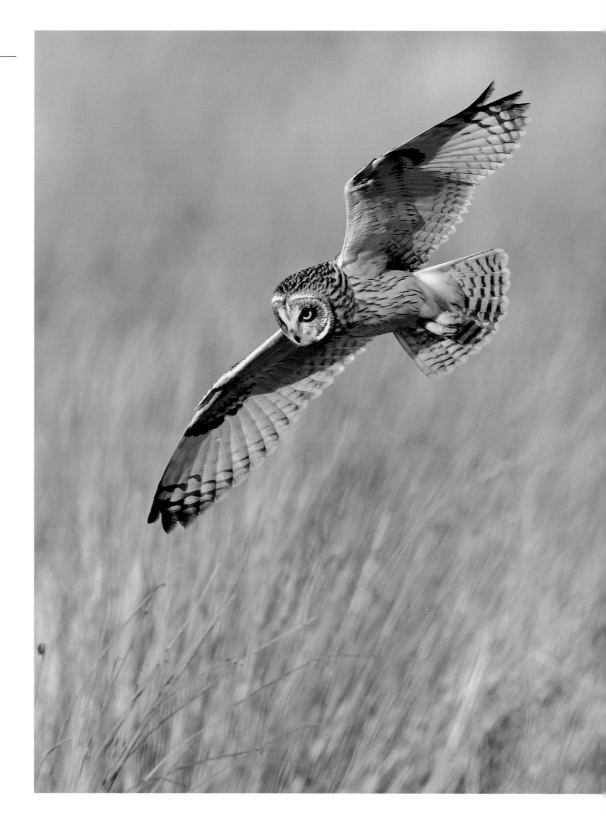

ANIMAL
BEHAVIOUR

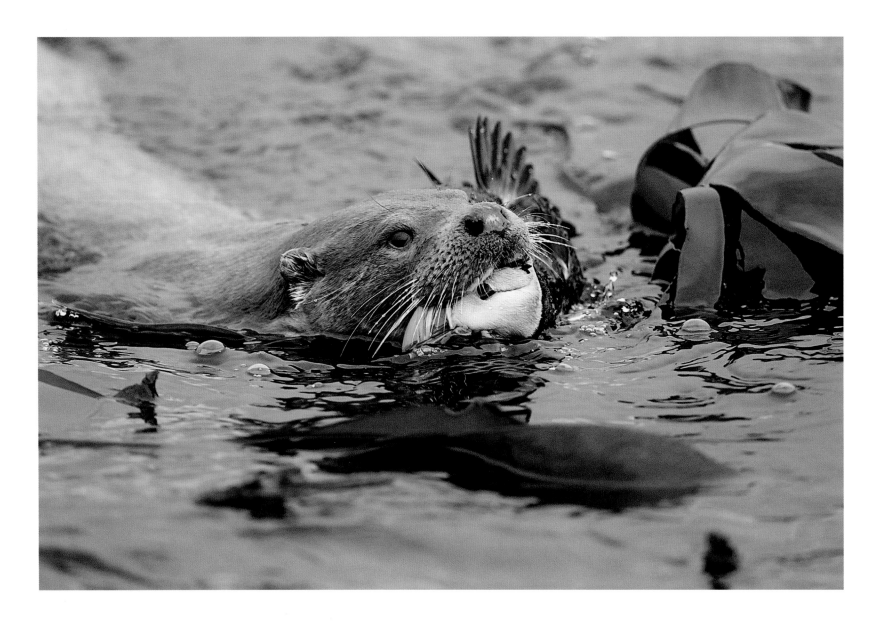

ANIMAL BEHAVIOUR WINNER

RICHARD SHUCKSMITH

The Otter and the Puffin
(Eurasian otter, *Lutra lutra*; Puffin, *Fratercula arctica*)
Shetland Isles, Scotland

It is said you make your own luck. Spending a lot of time out in the field, eventually you will
see the rare and the unusual, and this is exactly what happened. Working a particular stretch of
coast that I know intimately, an otter was foraging along the shore. It moved to a reef that was
30m out from the coast and as it dived, so did a puffin several metres away. I was astonished
when a few seconds later the otter appeared on the surface with the puffin in its mouth.

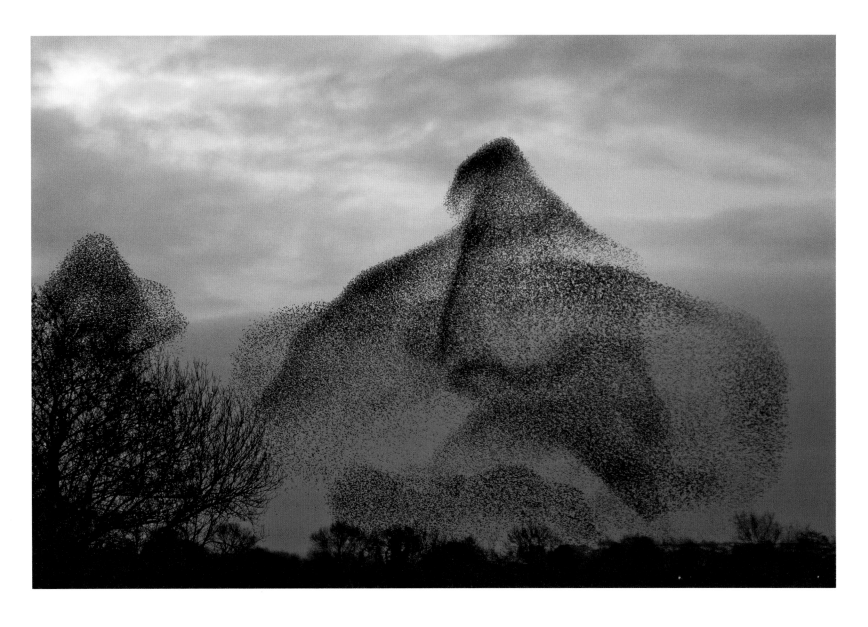

PETER WHITEHEAD HIGHLY COMMENDED

Is it a Bird?
(Common starling, *Sturnus vulgaris*)
Shapwick Heath, Somerset, England

We were watching thousands of starlings coming into roost over Shapwick
Heath at dusk. The large numbers attracted predators like peregrine falcons
that kept attacking the flock. I would like to think that the starlings mounted
their own form of defence by forming themselves into this outline of a
massive bird. Needless to say, the shape which lasted for a split second
soon morphed!

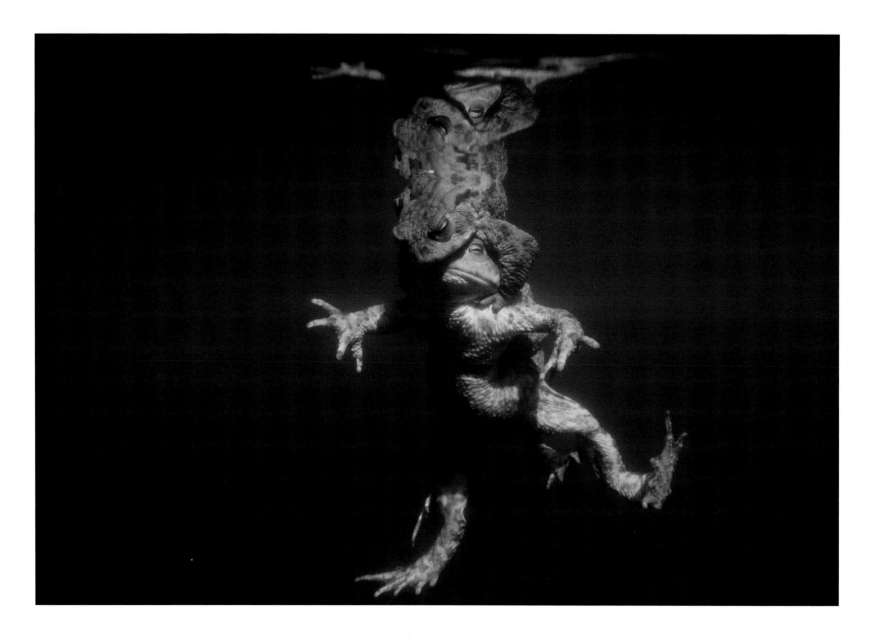

PAUL HOBSON ∧ HIGHLY COMMENDED

Underwater Toad Ballet
(Common toad, *Bufo bufo*)
Derbyshire, England

I spent some time working with toads at their breeding pond this year using an underwater camera bag. I achieved a split-level effect but in some images, by slightly submerging the camera and bag below the surface, I got a reflection of the toads on the under surface of the water as well. There are two toads here in amplexus, a male grappling with a larger female.

MARGARET WALKER > HIGHLY COMMENDED

Dancing Razorbill
(Razorbill, *Alca torda*)
Farne Islands, Northumberland, England

When visiting the Farne Islands the main species I want to photograph is my favourite seabird, the puffin. This time I decided to tear myself away from puffins and concentrate on some of the other birds that breed on the island. I was photographing guillemots when I noticed this razorbill lining up its approach to land. There was little wind so it was a bit of a crash landing.

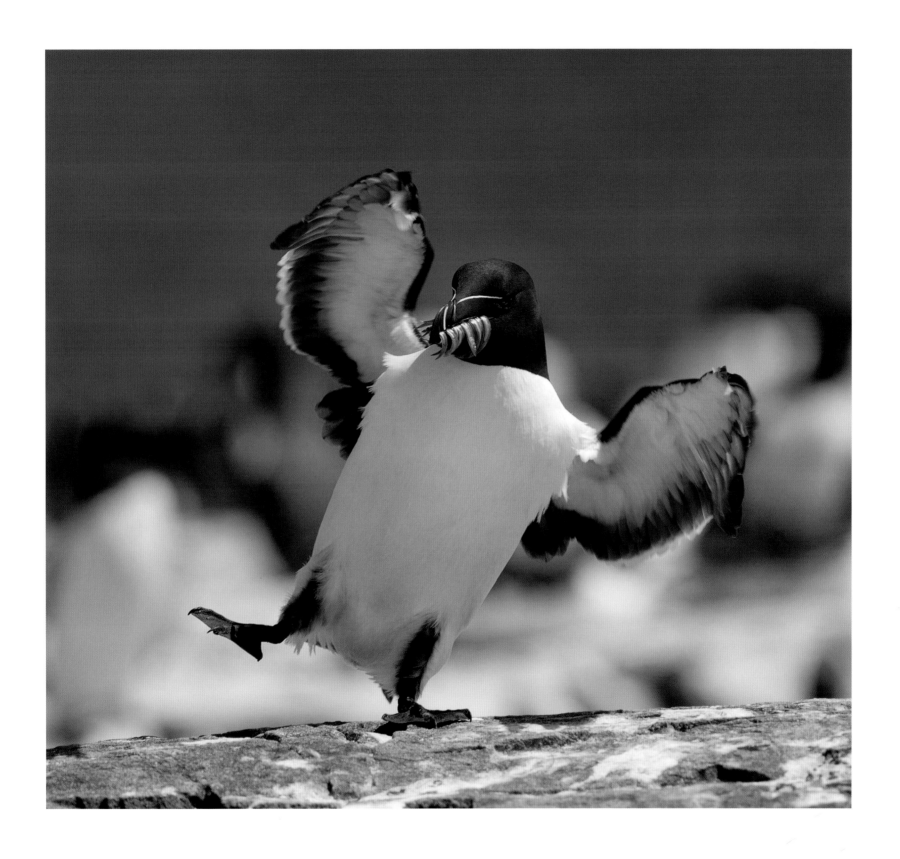

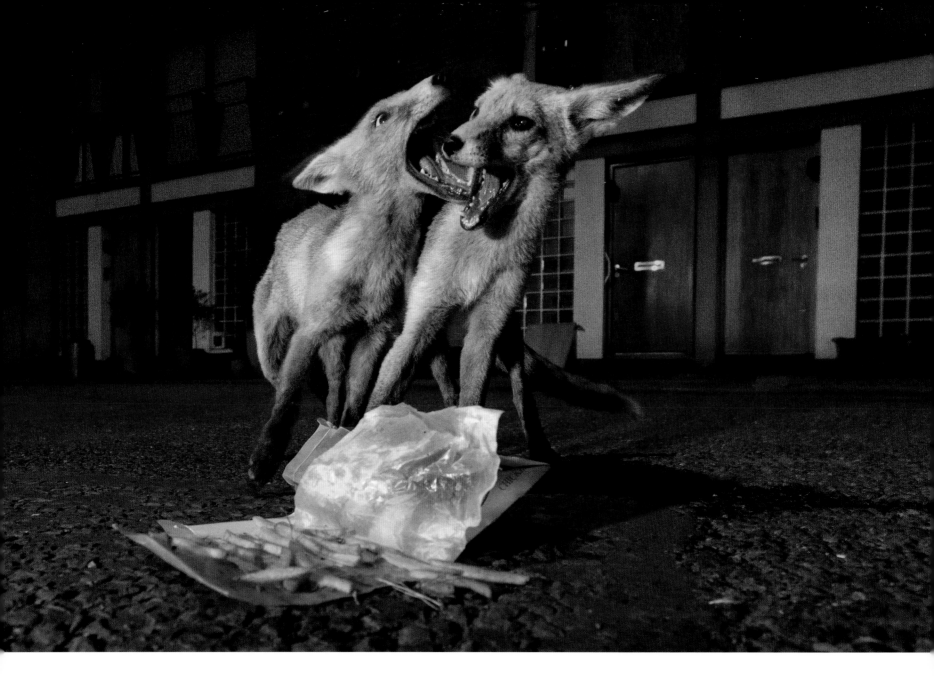

MARK SMITH HIGHLY COMMENDED

Sibling Rivalry
(Red fox, *Vulpes vulpes*)
London, England

This street is a cut-through for pedestrians and receives more than its fair
share of discarded food from nearby takeaways. On this particular evening
a half-eaten box of chips had been discarded in the street so I decided to
set up there. Once it had quietened down two cubs emerged from the den.
This was the first time I witnessed the female start to see her brother as
direct competition and drive him away. A week later he had gone.

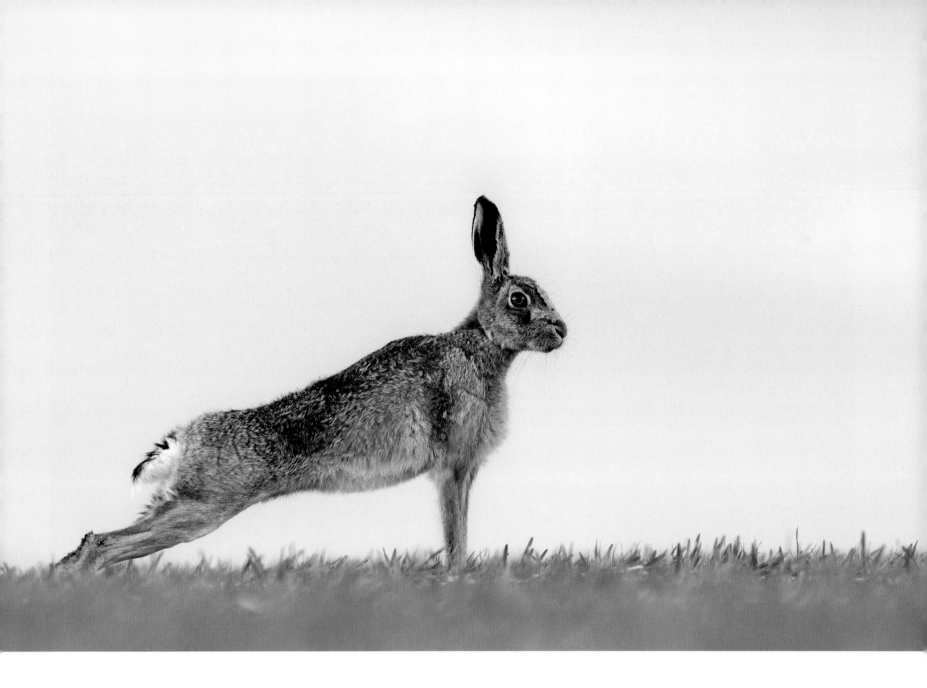

FELICITY MILLWARD HIGHLY COMMENDED

The Stretching Hare
(Brown hare, *Lepus europaeus*)
Mere, Wiltshire, England

I managed to slowly creep up behind the hare. Lying flat on the ground
I shuffled myself closer and closer to it. Just after this shot was taken
a hailstorm began and I got drenched, but it was all worth it.

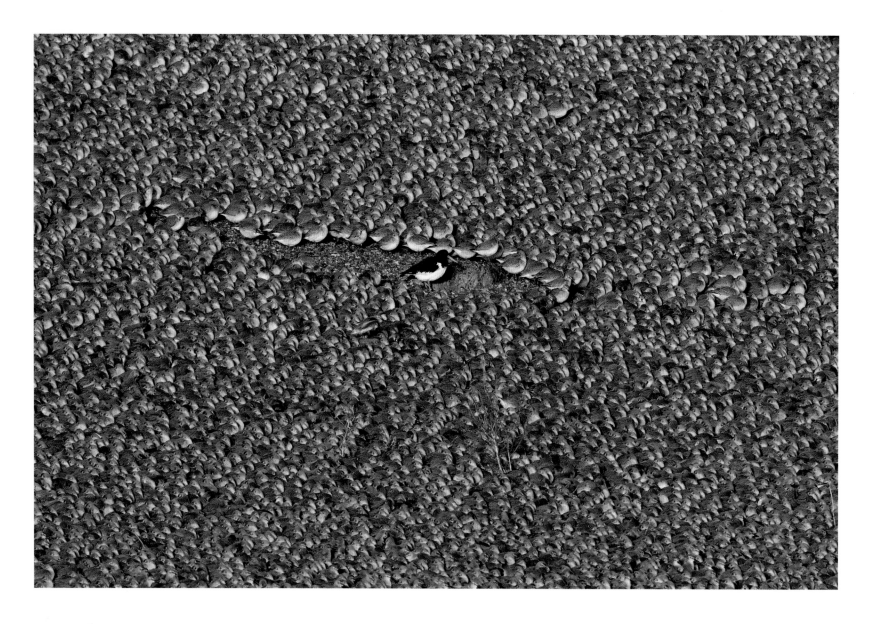

DAVE BARTLETT ∧ HIGHLY COMMENDED

Mr Unpopular – Oystercatcher in Knot Flock
(Oystercatcher, *Haematopus ostralegus*)
Snettisham, Norfolk, England

I was watching the high-tide knot roost in the gravel pits at Snettisham hoping for a mass take-off, which never happened. A number of oystercatchers were around the periphery of the knot flock but I spotted this particular bird in among the flock being given a wide berth – it didn't look very popular.

IZZY STANDBRIDGE > HIGHLY COMMENDED

I Wanna Hold Your Hand
(Common starling, *Sturnus vulgaris*)
Llangwyryfon, Ceredigion, Wales

The starlings were bickering over food all the time during the winter. I spent many happy hours trying to capture just two of them mid battle. It wasn't easy, as they would rise high in the air very quickly each time a fight broke out, but I managed to get a few in the frame. I was in a hide I built at the bottom of my garden.

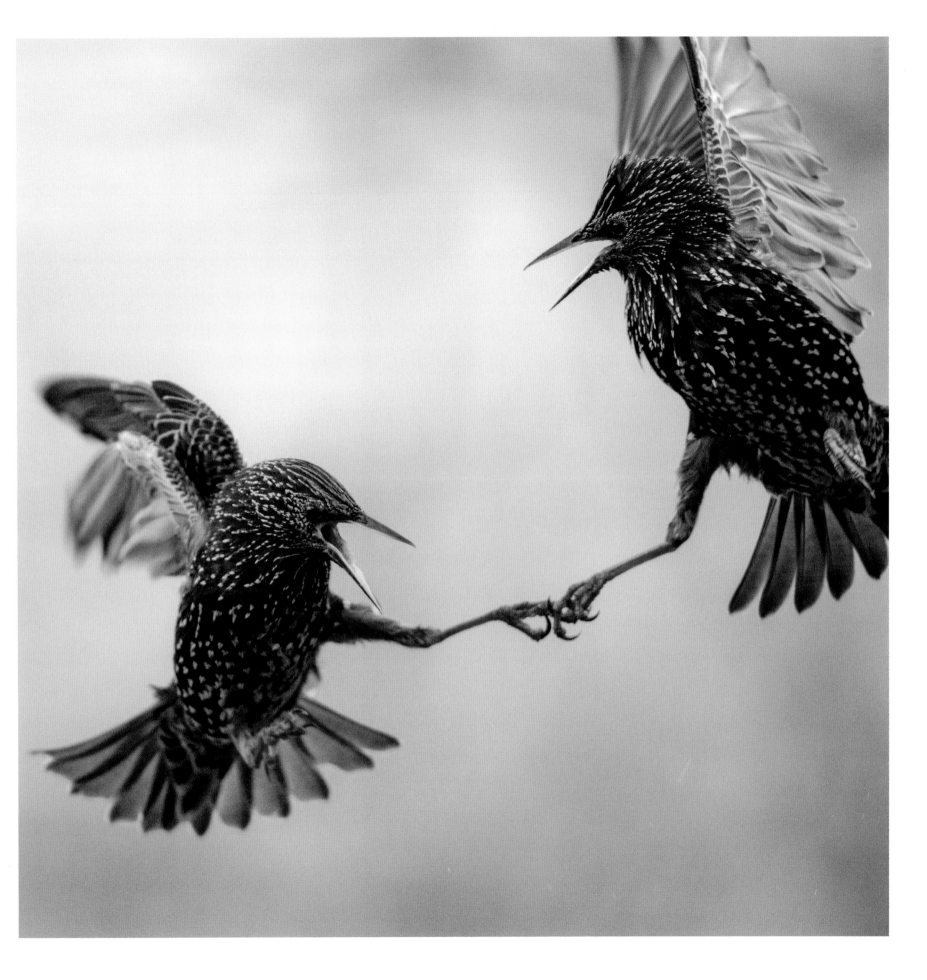

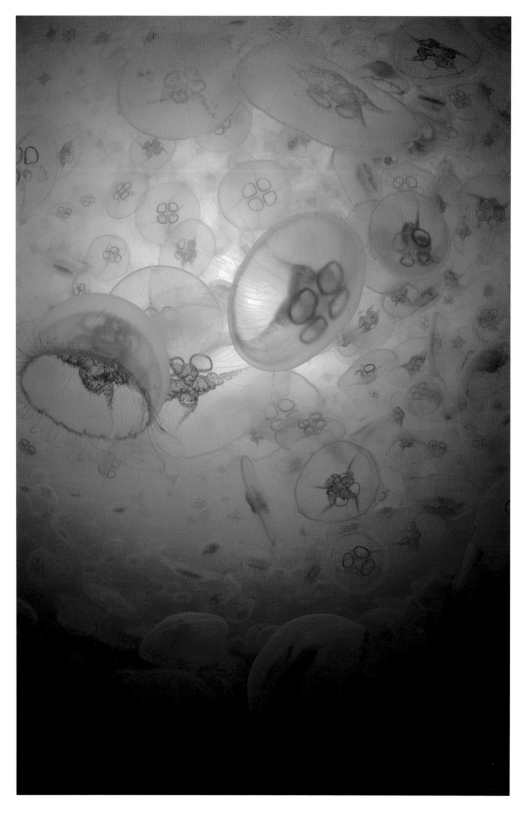

Primordial Soup
(Moon jelly, *Aurelia aurita*)
Loch Duich, Scotland

I had gone to Loch Duich to photograph a shy little fish called Frie's goby which inhabits deep, muddy sea lochs. Entering the water armed with a 100mm macro lens I was stunned to find myself surrounded by tens of thousands of moon jellies in the emerald-green water; a surreal but calming, almost meditative experience. I pressed on with the dive to find the goby but returned the next day at the same state of tide armed with my wide-angle lens. I was not disappointed!

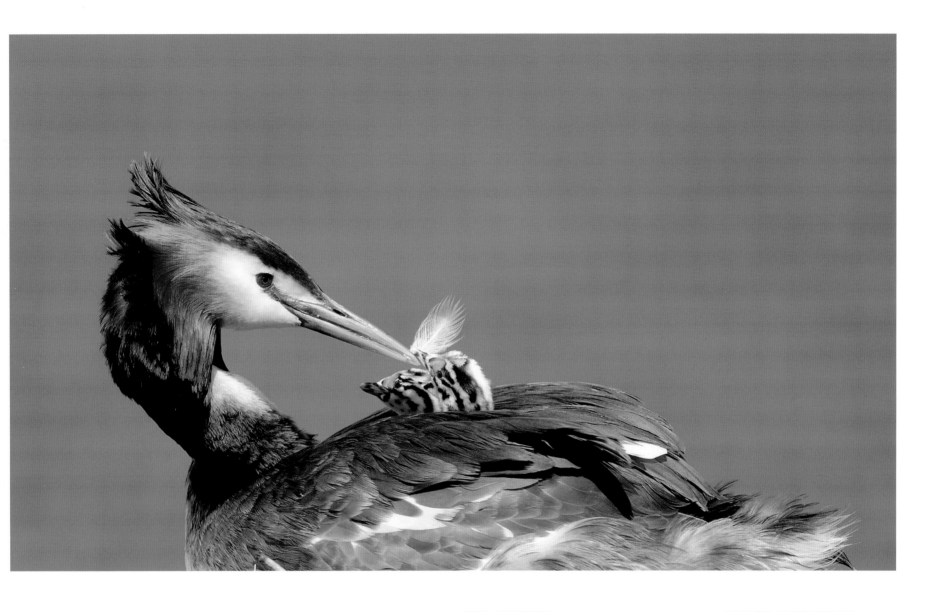

BEN ANDREW HIGHLY COMMENDED

A Tender Moment
(Great-crested grebe, *Podiceps cristatus*)
York University Campus, York, England

Great-crested grebe adults feed their young feathers plucked from their
own bodies. It is thought this aids digestion and protects the young grebes
from harming themselves when swallowing sharp fish bones. It was a
pleasure to capture this behaviour and observe the first few days of these
chicks' lives.

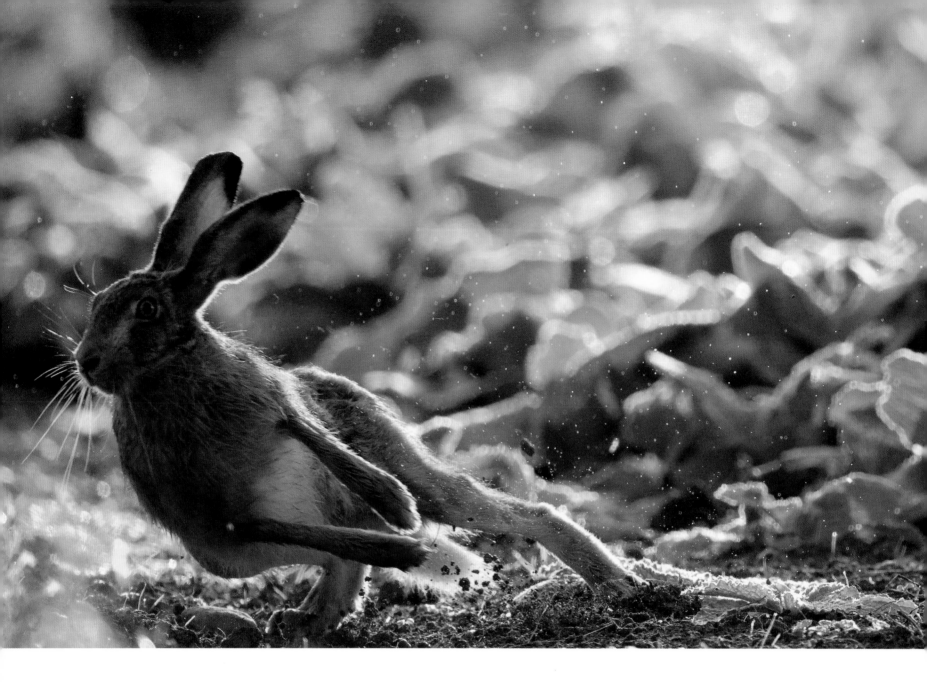

MICHAEL RAE HIGHLY COMMENDED

Brown Hare Side Leap
(Brown hare, *Lepus europaeus*)
Norton, Suffolk, England

Brown hares use a field sown with a wildlife mix at Halls Farm, Norton for food and shelter. My hide had been set up for a few weeks so the hares took no notice of it. The hares are active on early autumn mornings, this one especially so. The hare ran directly towards me in the hide, stopped, and leapt straight up. This photograph shows its next leap, which was to the side.

DAVID WHITE HIGHLY COMMENDED

Waterdance

(Great-crested grebe, *Podiceps cristatus*)
Stover Country Park, Devon, England

On a crisp, clear early morning the grebes were swimming, beautifully reflected in the water. Suddenly one of them dipped down into the water and rose up with some waterweed. They then both rose out of the water to perform their wonderful courtship display, passing the weed to each other and finally throwing their heads back in exuberance. I captured a whole sequence but particularly like this one of them rising out of the water.

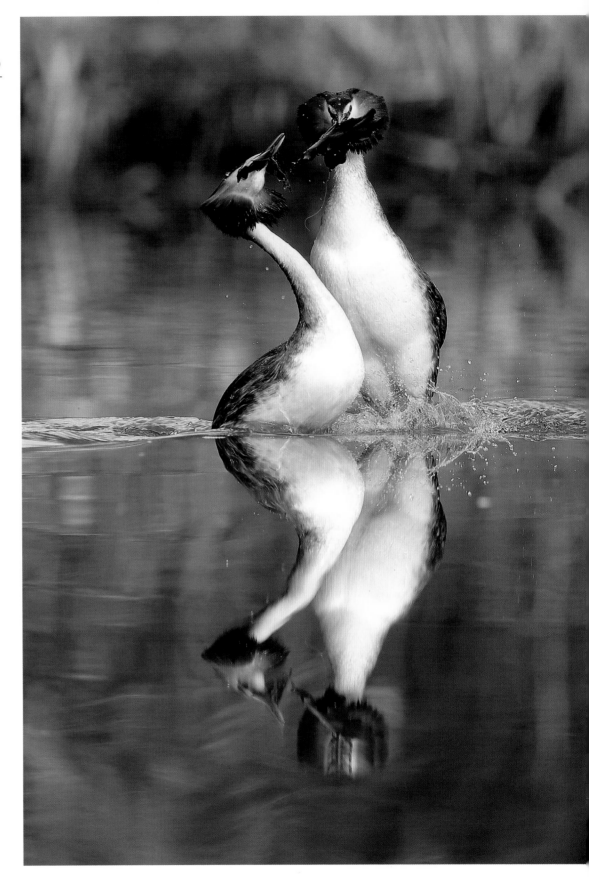

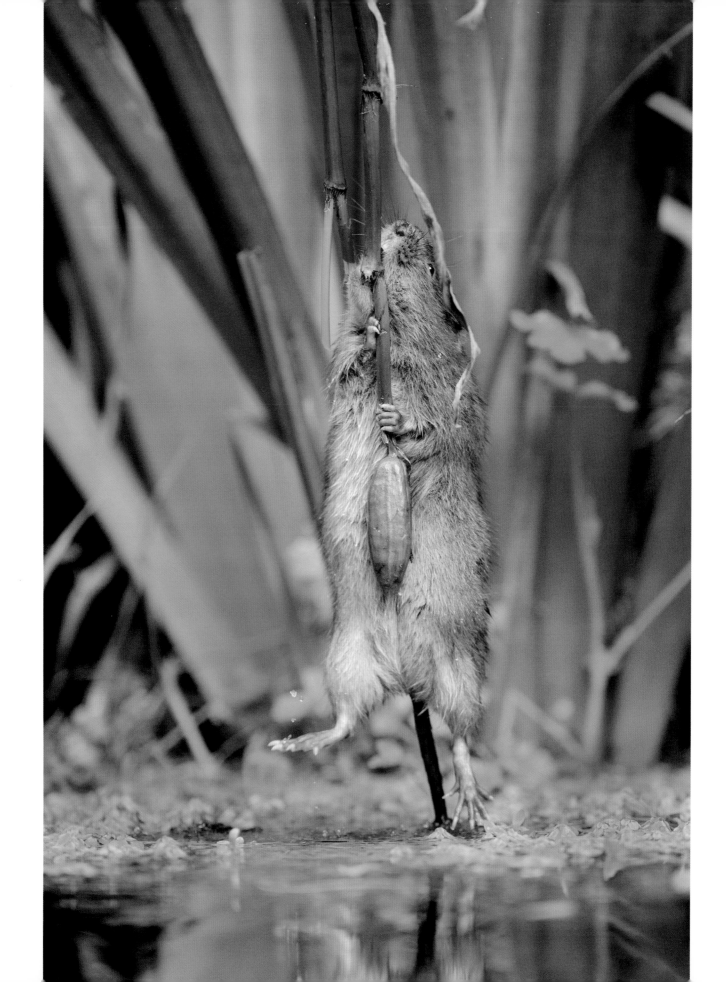

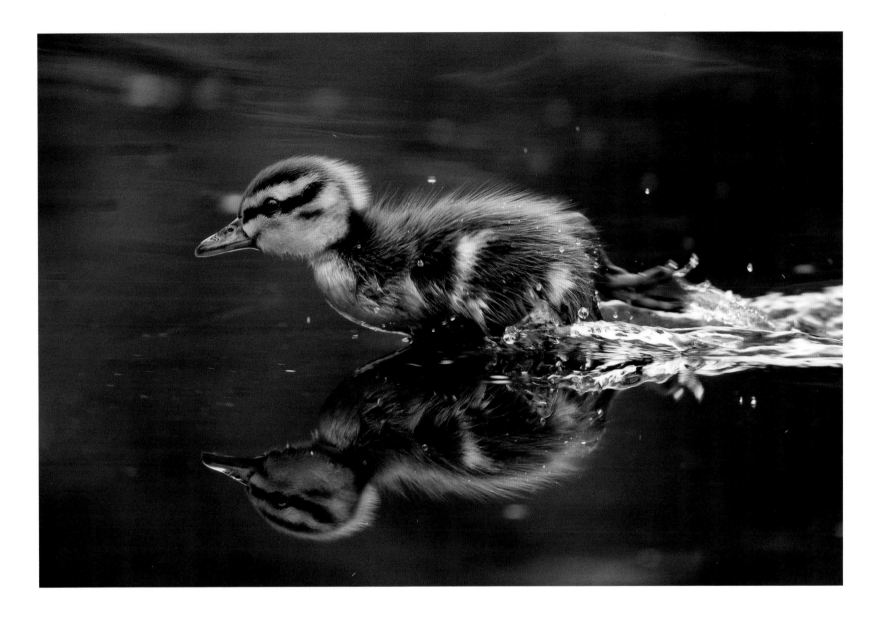

TERRY WHITTAKER < HIGHLY COMMENDED

OLIVER CHARLES WRIGHT ∧ HIGHLY COMMENDED

Water Vole Feeding on Flag Iris Seedpods
(Water vole, *Arvicola amphibius;* Flag iris, *Iris pseudacorus*)
East Malling, Kent, England

I knew water voles feed on the seedpods of this plant but normally they either have to wait for the pods to droop low enough to reach or wait for them to fall into the water. In this case I lowered the seedpods a little so the vole could reach them. It could reach all except the last pod easily and took each one away to store in its burrow. I was surprised to see the vole climb right off the ground to get the last one.

Scooting Baby Mallard
(Mallard, *Anas platyrhynchos*)
Cromford Canal, Derbyshire, England

I was walking down the canal looking for water voles and I got distracted by the antics of these chicks. I decided to focus on them to try to catch that motion of them scooting across the water at high speed.

LIZZIE SHEPHERD

When the Squirrel Met the Pheasant
(Red squirrel, *Sciurus vulgaris*)
Snaizeholme, Yorkshire Dales, England

Taken at the viewing area in this woodland reserve. The squirrels, although wild, are accustomed to the many visitors and walkers in the area. The forest is coniferous and therefore quite dark, and I worked almost lying on the ground, watching these enchanting animals interact with the various birds competing for food.

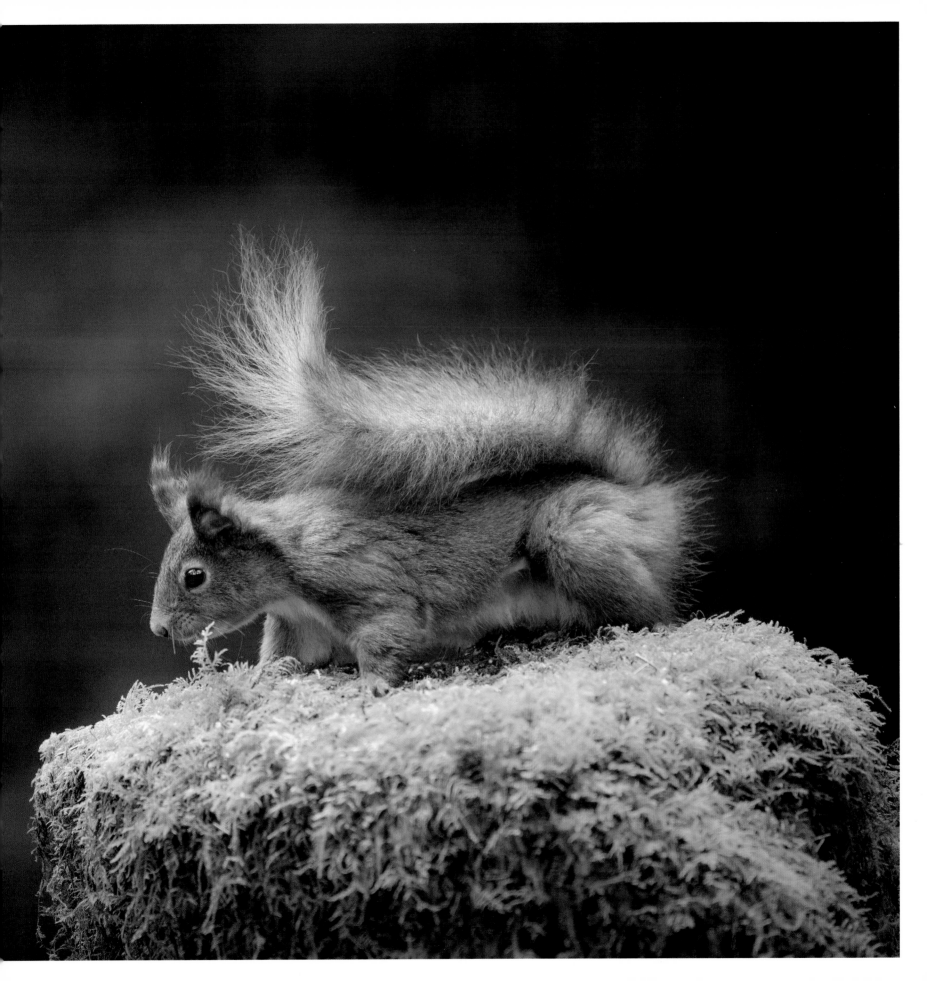

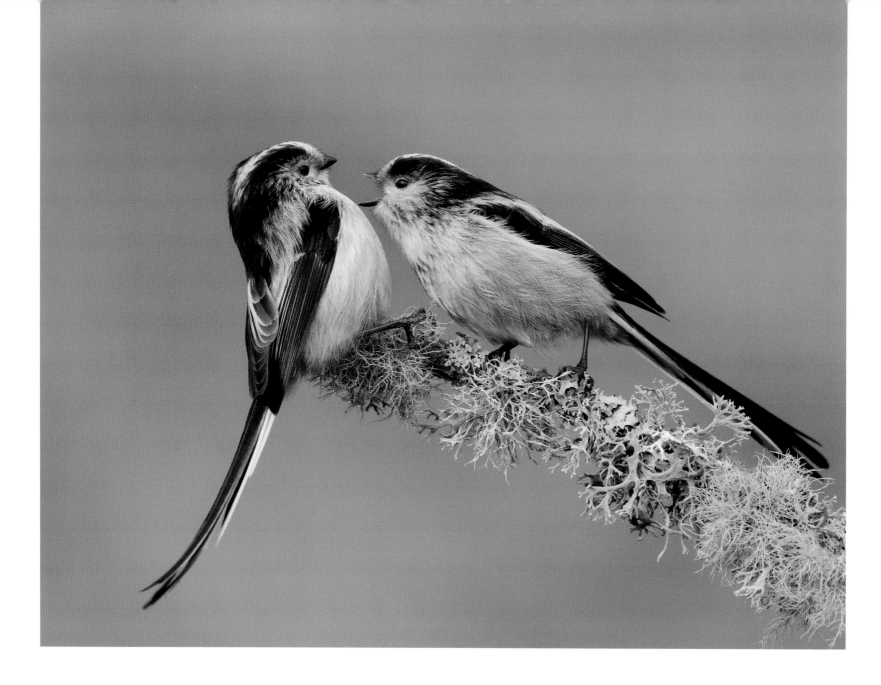

JOHN R BARLOW

Long-tailed Tits Aggression
(Long-tailed tit, *Aegithalos caudatus*)
Edgworth, Bolton, Lancashire, England

The regular winter gang of long-tailed tits that visits the feeders in my woodland-edged garden had started to get quite aggressive with each other as the milder weather arrived in early March. When the light was good, it provided a perfect opportunity to capture these argumentative little birds in action.

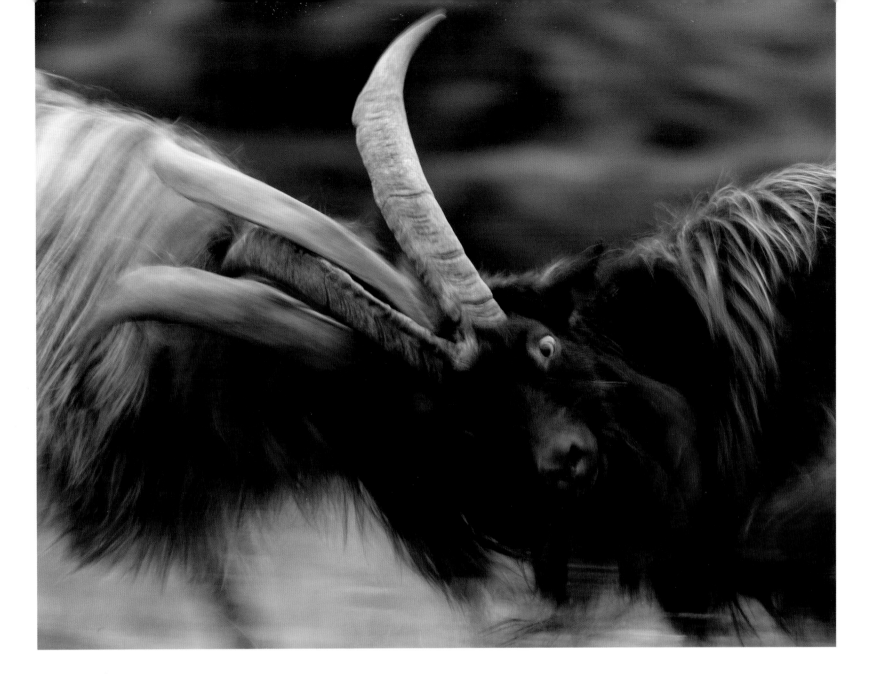

KRIS WORSLEY

Feral Goat Rut
(Feral goat, *Capra aegagrus hircus*)
Scoor, Isle of Mull, Scotland

I followed these goats over a period of several weeks, during which I was privileged to witness a great variety of interesting behaviour. The rut is a remarkable display of both power and respect; the goats signal to each other by licking and hoof-scraping before slamming their horns together with eye-watering force. As the daylight faded, I tried to capture the shapes and sense of movement of these goats locked in a tussle.

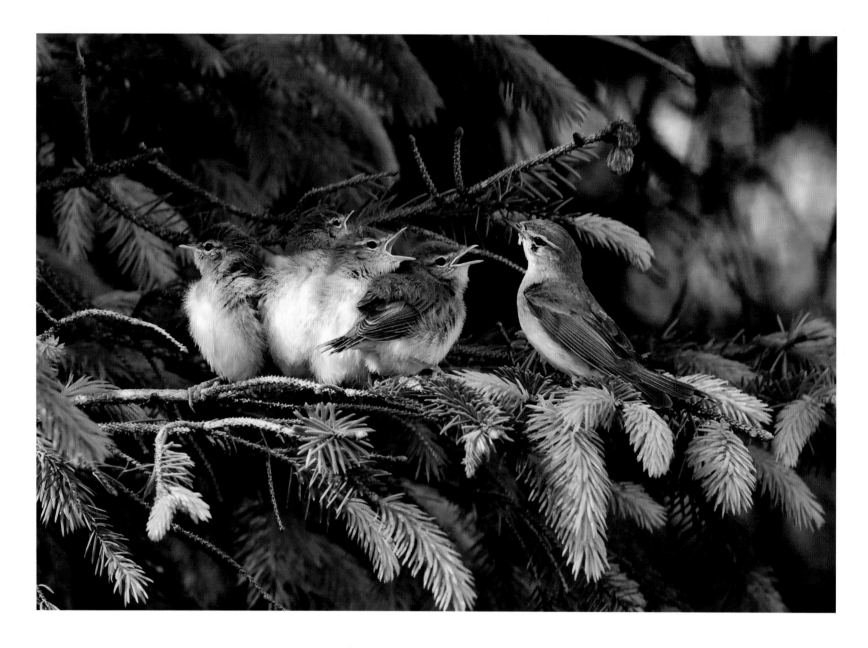

LISA NAYLOR ∧

Willow Warbler Family
(Willow warbler, *Phylloscopus trochilus*)
Isle of Mull, Argyll & Bute, Scotland

As I photographed waders in a small bay my attention was caught by the chirping of chicks. As I turned around the four youngsters were waiting for their food on the branch. I settled in and enjoyed the comings and goings of the parents feeding the chicks.

BEN HALL >

Greenfinches in Snowfall
(Greenfinch, *Carduelis chloris*)
Holmes Chapel, Cheshire, England

During spells of harsh weather the action at my local feeding station can turn frantic, with flocks of birds descending, many of them forced to wait on nearby branches. I pre-focused on this branch with its twigs and berries encrusted in frost. After a few hours a pair of greenfinches appeared. One bird would land on the branch and feed the other as it hovered close by. I felt privileged to witness this behaviour in such a beautiful setting.

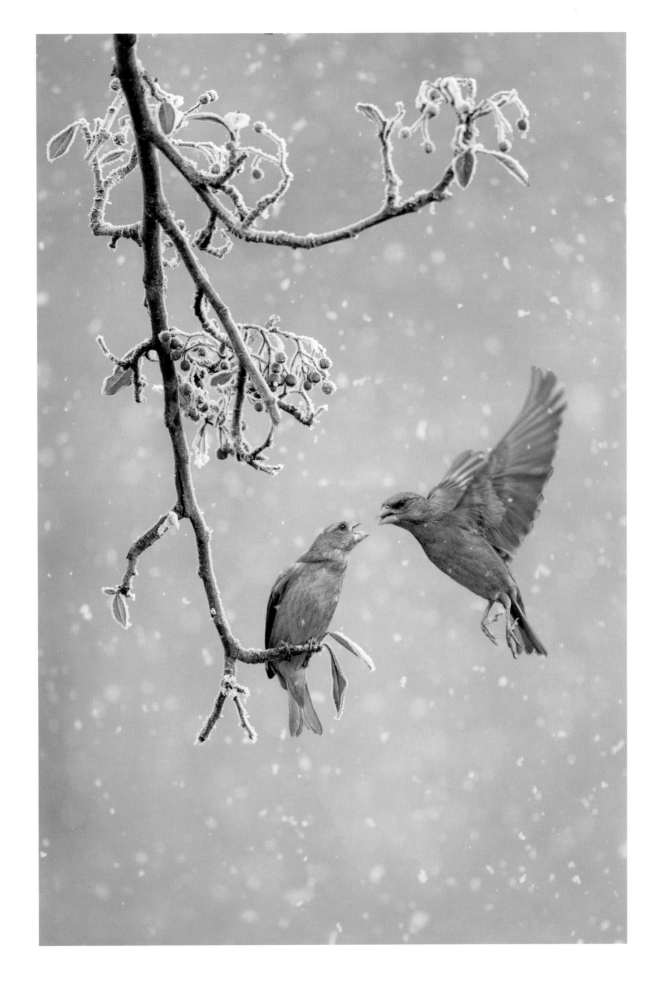

URBAN
WILDLIFE

SPONSORED BY
CITY OF LONDON

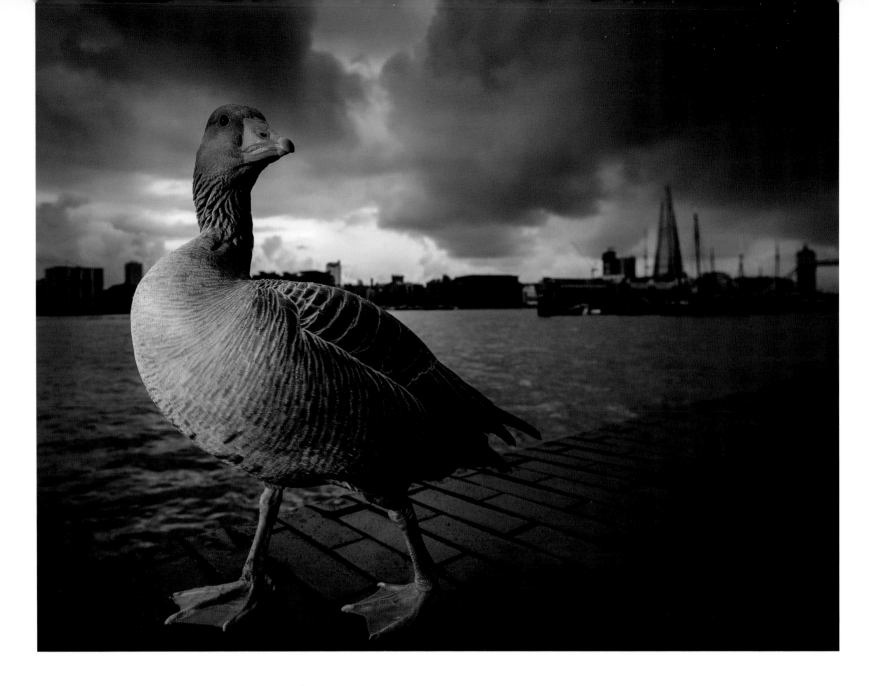

URBAN WILDLIFE WINNER AND BWPA 2014 OVERALL WINNER

LEE ACASTER

The Tourist
(Greylag goose, *Anser anser*)
London, England

I was set up for shooting a stormy cityscape with a manual-focus wide-angle lens when this goose landed on the river wall. I decided to see if I could get really close to him to fill the frame and keep the London skyline in the background for context. I underexposed and used a handheld flash in my left hand to enhance the drama.

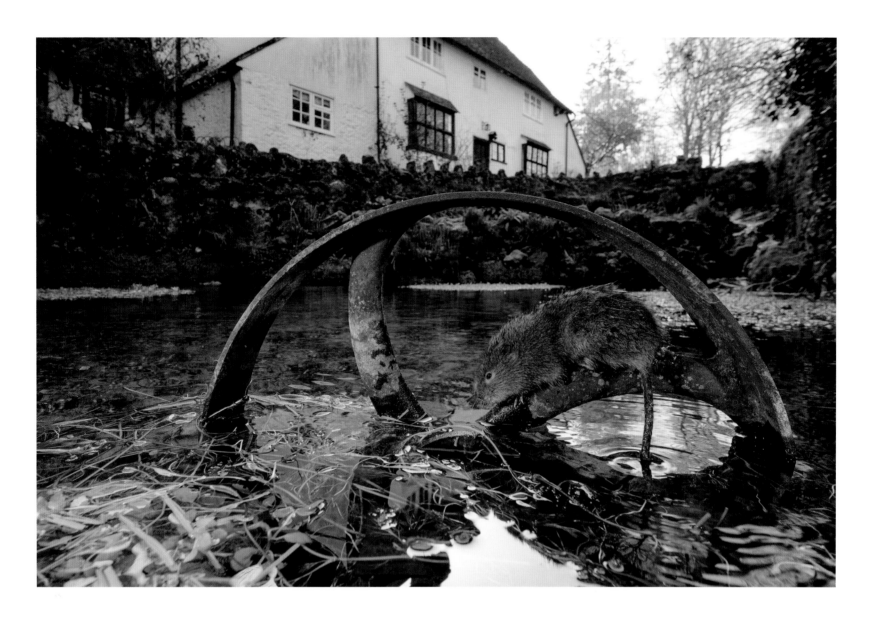

TERRY WHITTAKER HIGHLY COMMENDED

Water Vole on Old Pump Wheel
(Water vole, *Arvicola amphibius*)
East Malling, Kent, England

I found the old pump wheel in the stream and moved it to where I could get a better view of the house in the background. Voles immediately started to use it as a feeding platform and I encouraged this with small pieces of apple. I then placed the camera and flashes and triggered them remotely by radio.

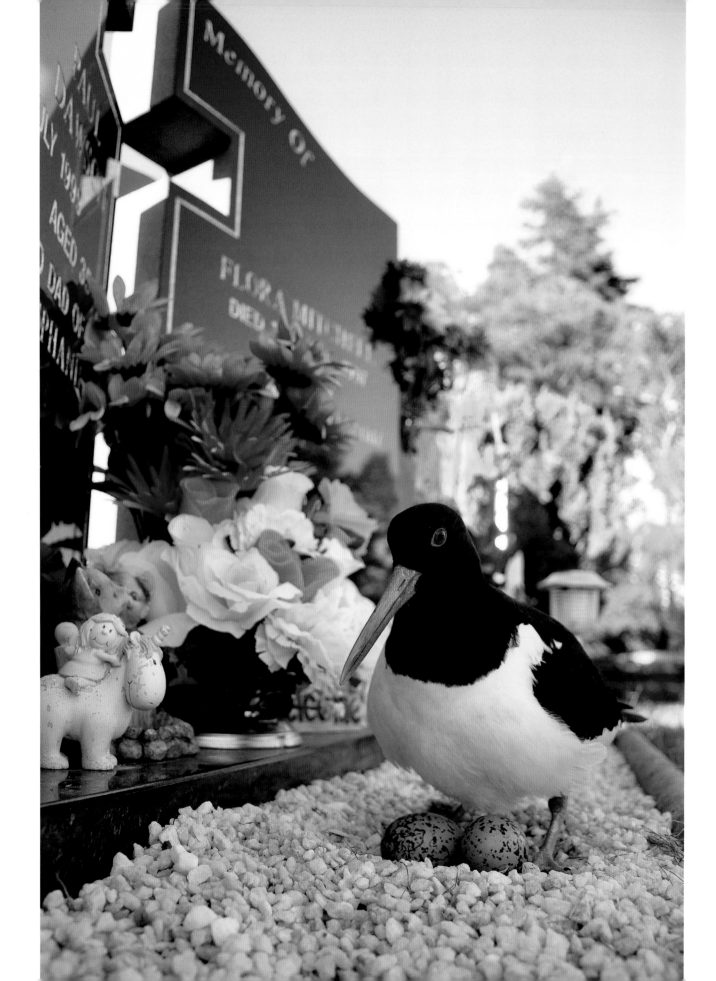

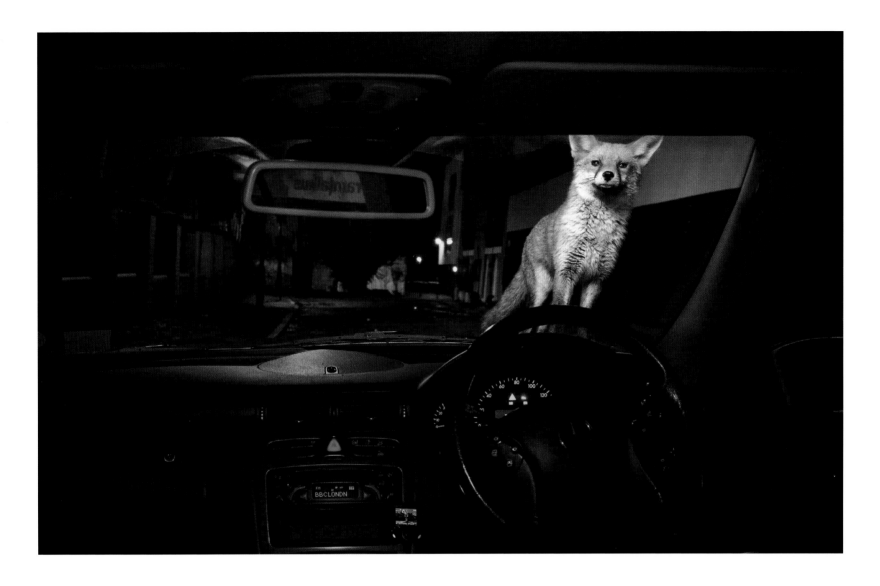

TOMASZ GARBACZ < HIGHLY COMMENDED

Life after Death
(Oystercatcher, *Haematopus ostralegus*)
Dundee, Tayside, Scotland

Even a busy cemetery seemed a good place for oystercatchers to lay their eggs. In general, the birds tolerated people visiting the graves. They would leave a nest only when somebody got really close. I waited for one of these moments and quickly placed a wireless remote-controlled camera on the edge of a gravestone. The bird returned immediately after and went back to business as usual.

MARK SMITH ∧ HIGHLY COMMENDED

Inquisitive Urban Fox
(Red fox, *Vulpes vulpes*)
London, England

One evening I was out photographing urban foxes and left the car in a street where their den is. When I returned to the car I found dusty paw prints all over the windscreen. I realised that I'd parked next to a building site structure that allowed access straight on to the car. I left some food that I found in the street on top of the car 'out of reach' while I scouted around. Never missing an opportunity, I suspected the fox would return so I placed a remote flash on the roof and sat in the back seat listening to the radio while I waited. Sure enough, the flash itself was more than enough to gain the fox's interest as she completed another circuit of her territory and came to investigate after traversing the builders' debris.

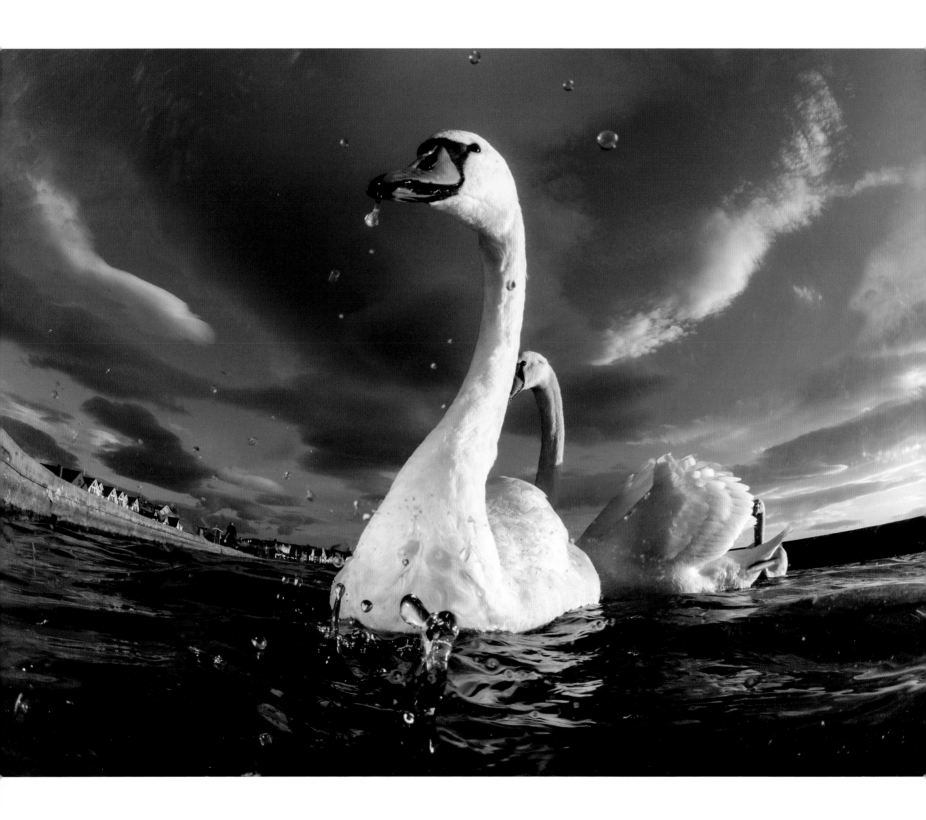

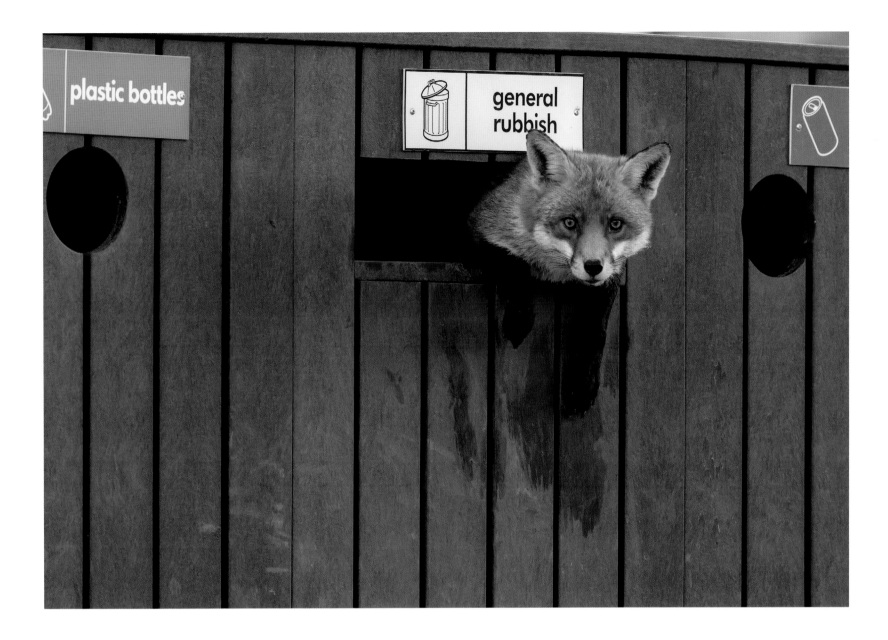

TREVOR REES < HIGHLY COMMENDED

Swan on Town Pond
(Mute swan, *Cygnus olor*)
Llandudno, North Wales

On a late sunny afternoon while walking around Llandudno seafront I came across the town duckpond. A number of tame swans were present and looking for a free meal of bread being thrown in by the locals. My underwater camera was set up and ready to use so I aimed for a low-angle shot close to the water. Use of a little artificial strobe light balanced the strong back light from the dramatic sky. I was relieved that the swan did not attempt to peck at my camera's acrylic dome port and cause any nasty scratches.

NEIL PHILLIPS ∧ HIGHLY COMMENDED

Red Fox in a Bin
(Red fox, *Vulpes vulpes*)
Wat Tyler Country Park (SSSI), Essex, England

This vixen had worked out not just that there was food in the bin, but how to jump in and out of the narrow entrance. It was fascinating to watch as the sun went down one March evening in Essex.

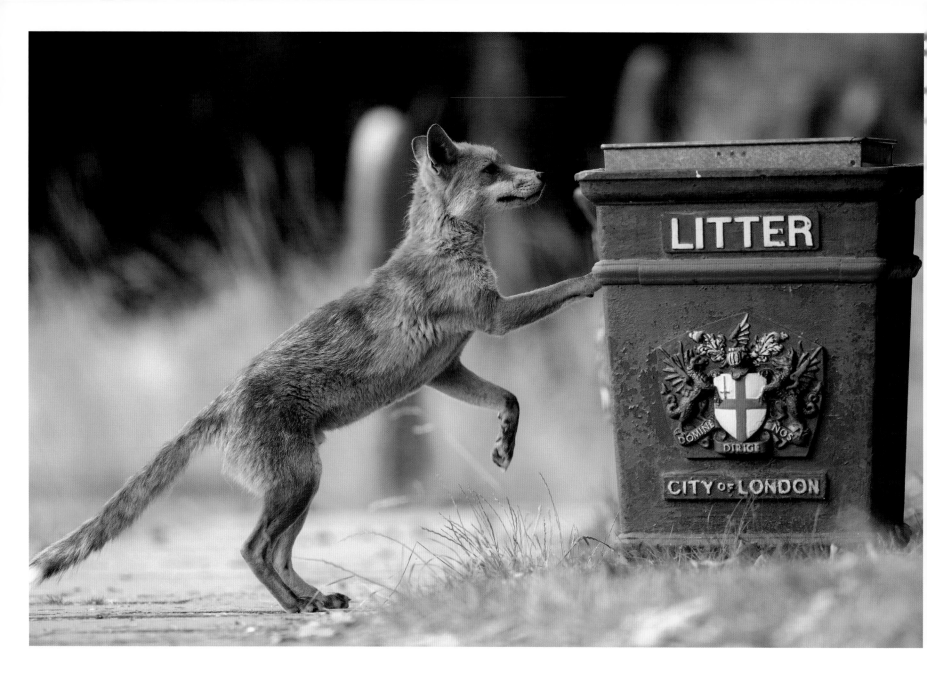

JAMIE HALL HIGHLY COMMENDED

Urban Red Fox Searching for Food
(Red fox, *Vulpes vulpes*)
London, England

I was lucky enough to spend most of the summer of 2013 photographing
a family of urban foxes in one of London's many parks. Each evening this
male would emerge from his daytime resting place and head straight to the
bins to look for titbits of food. Now and again he would find little scraps.

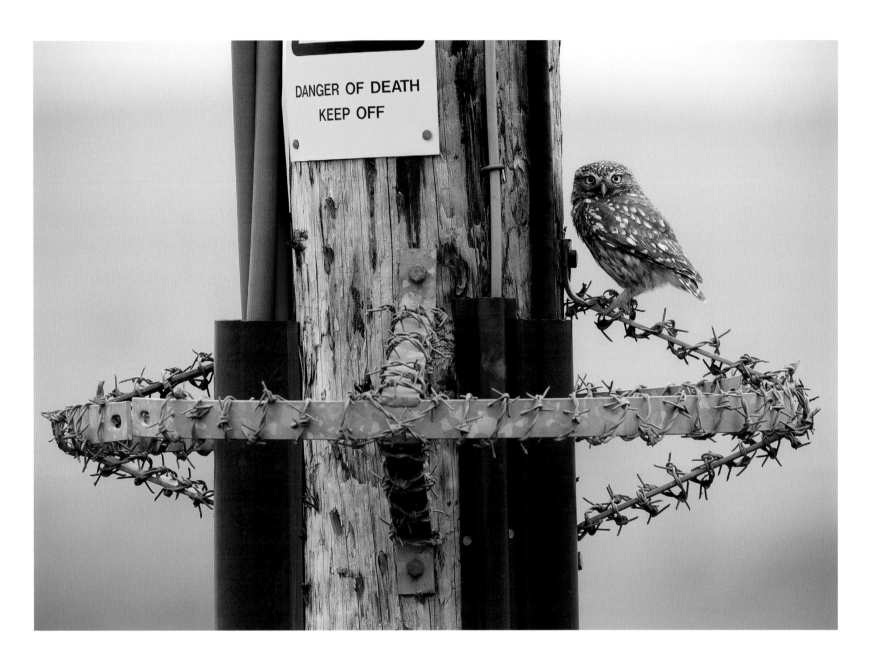

JOHN R BARLOW

Little Owl in Danger of Death
(Little owl, *Athene noctua*)
Edgworth, Bolton, Lancashire, England

As I drove into the village near where I live, returning from photographing warblers on the moors, this Little owl flew off a wall straight on to the spiked perch that surrounds the pylon supplying electricity to the properties nearby. The light was not very good, but I saw the shot, stopped the car, wound the window down and took the handheld shot.

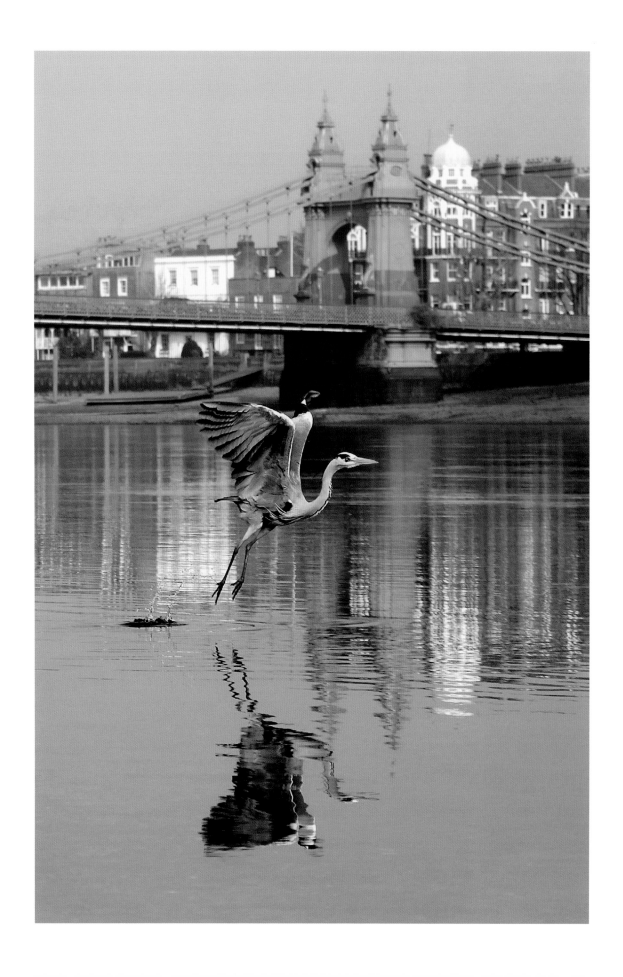

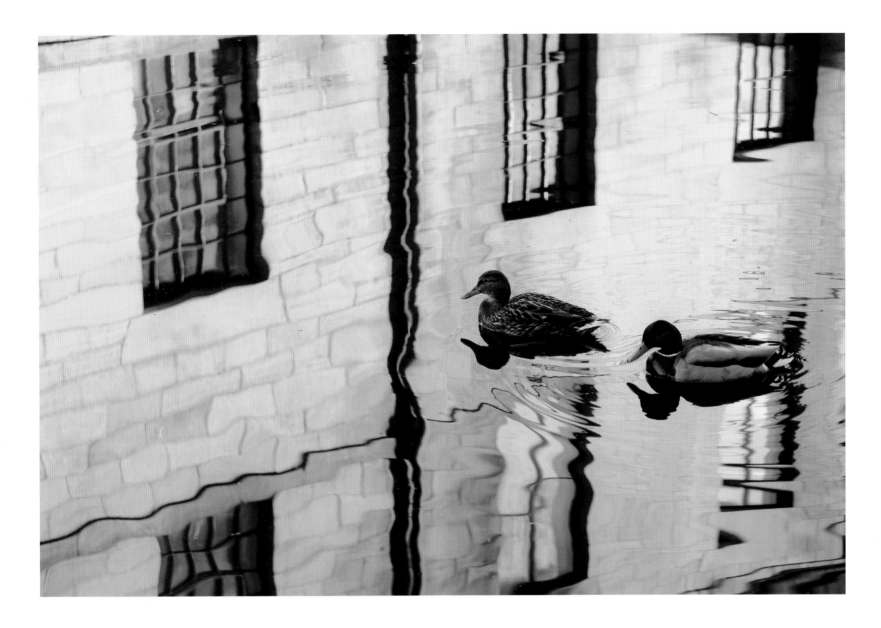

ALEX STEWART <

The Hammersmith Bridge Heron
(Heron, *Ardeidae*)
London, England

This heron is a regular visitor around Hammersmith Bridge. He normally takes the air in the early morning at low tide. I stalked him slowly, walking up the riverbed from Putney to Hammersmith on the Barnes side. Eventually, as I neared his spot near the bridge, he tired of my presence and took off to the opposite bank, but by then I had him pre-focused in my viewfinder and snapped away.

ROBERT BIRKBY ∧

Going Up the Wall
(Mallard, *Anas platyrhynchos*)
Hebden Bridge, West Yorkshire, England

This image was taken on a very pleasant January morning while walking along the canal towpath. I noticed this pair of ducks passing through the reflections and wondered if I could capture them in a way which confuses the eye. I took a few frames and this one seemed to be the best combination of composition and reflections.

HIDDEN
BRITAIN

SPONSORED BY

BUGLIFE

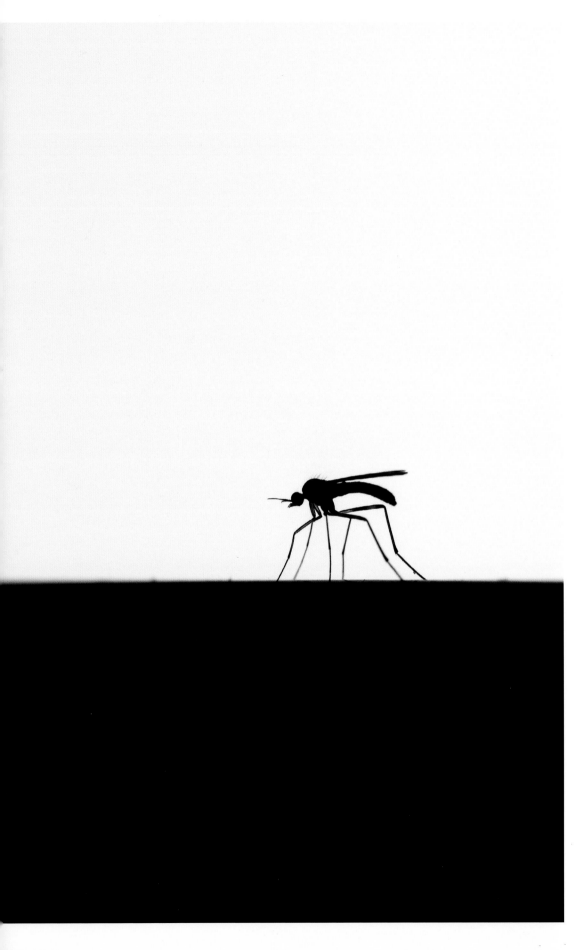

SUSIE HEWITT

Window Gnat
(Window gnat, *Sylvicola*)
County Antrim, Northern Ireland

I was on the phone to my boyfriend at the time and hung up on him to photograph this gnat that I had noticed was wonderfully silhouetted against the sky, as it stood on the door bar of my conservatory. I didn't even have to leave my house for this one but I did have to stand on a chair to try to get the angle level. It flew away moments later.

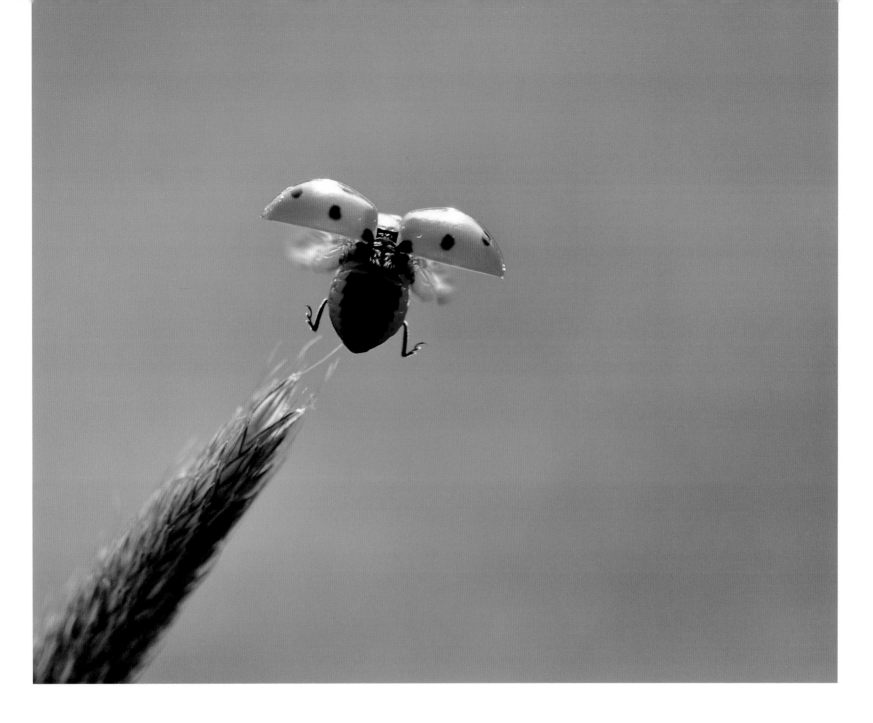

CAROLYNE BARBER HIGHLY COMMENDED

The Lady Departs
(Seven spot ladybird, *Coccinella septempunctata*)
Walthamstow Marshes, London, England

I have spent a long time observing ladybirds as they move in the grass and among flowers and have learnt a lot about their behaviour, especially on hot days. I was able to get some focus on the tip of the grass just in time, in the hope that the ladybird would fly away – she sure did and I was able to capture that magical moment.

DAVID MAITLAND HIGHLY COMMENDED

Baby Snail 1
(Pond snail, *Lymnaea stagnalis*)
Feltwell, Norfolk, England

Pond snail eggs are microscopic and laid in a mass of jelly on the underside
of a leaf or stone in the water. As the embryo develops, it rasps away at
the egg 'shell' until eventually the shell ruptures and the miniature snail
escapes. To take these pictures, I placed some glass microscope slides
in my garden pond onto which the eggs were laid, thereby allowing the
pictures to be taken.

DAVID MAITLAND HIGHLY COMMENDED

Baby Snail 2
(Ram's horn snail, *Planorbarius corneus*)
Feltwell, Norfolk, England

DAWN STEPHENS-BORG
HIGHLY COMMENDED

A Rainy Day
(Harvestman, *Opiliones*)
Milltown, Devon, England

Before heading out to work, I noticed the morning dew had settled on the garden. Seeing the harvestman outside on the water butt, I knew that this would be a beautiful opportunity to experience this creature's hidden world. The harvestman stayed very still and what struck me was the water droplet covered its body. I felt so privileged to witness this magical moment in nature, for this insect was immersed in its surroundings.

ED PHILLIPS HIGHLY COMMENDED

Alien Landscape
(Globular springtail, *Sminthurinus aureus*)
Moreton Morrell churchyard, Warwickshire, England

In winter when invertebrate activity is low, searching in leaf-litter can be very rewarding. This tiny springtail (about 0.5mm long), was on the underside of a wet, fallen laurel leaf. The flash used to illuminate the subject imparted a lovely glow to the scene and the detailed structures of the leaf added an 'otherworldly' appearance to the whole image. Truly, a hidden world.

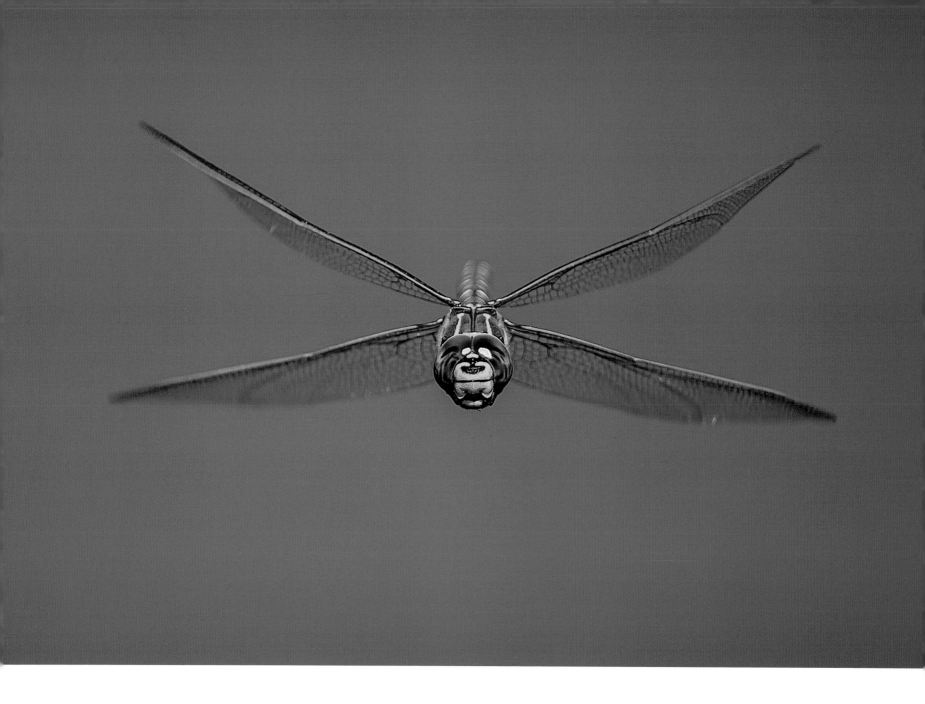

STEPHEN WILLIAMS HIGHLY COMMENDED

Brown Hawker Dragonfly Hovering
(Brown hawker, *Aeshna grandis* Linnaeus)
Chesterfield, Derbyshire, England

I was watching these brown hawkers darting low above the water on my local ponds. I was trying to capture them in flight and getting frustrated with their rapid change of direction. After working with them for two hours, an inquisitive individual came and hovered right in front of me. I managed to lock on to the dragonfly and get the shot I was after.

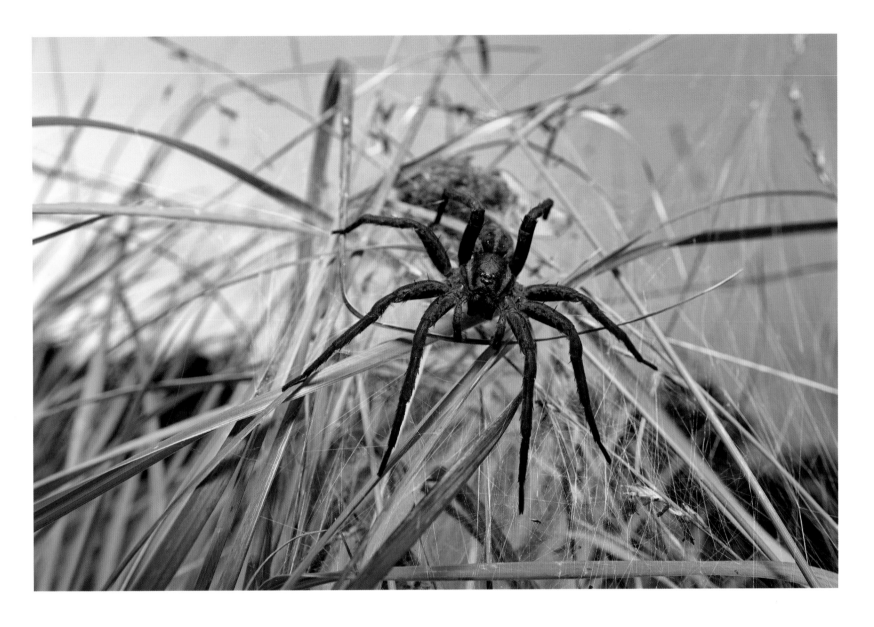

TIM HUNT HIGHLY COMMENDED

The Guardian in the Grass
(Raft spider, *Dolomedes fimbriatus*)
Arne, Dorset, England

I found this raft spider in the long grass that surrounded a small pond
on the Arne Peninsula in Dorset. The spider was resting beside a web
containing hundreds of spiderlings. The adult raft spider, which was the
largest of the species that I had seen, posed as a guardian. Crouching in
the grass, I shot up at the spider to show its authority.

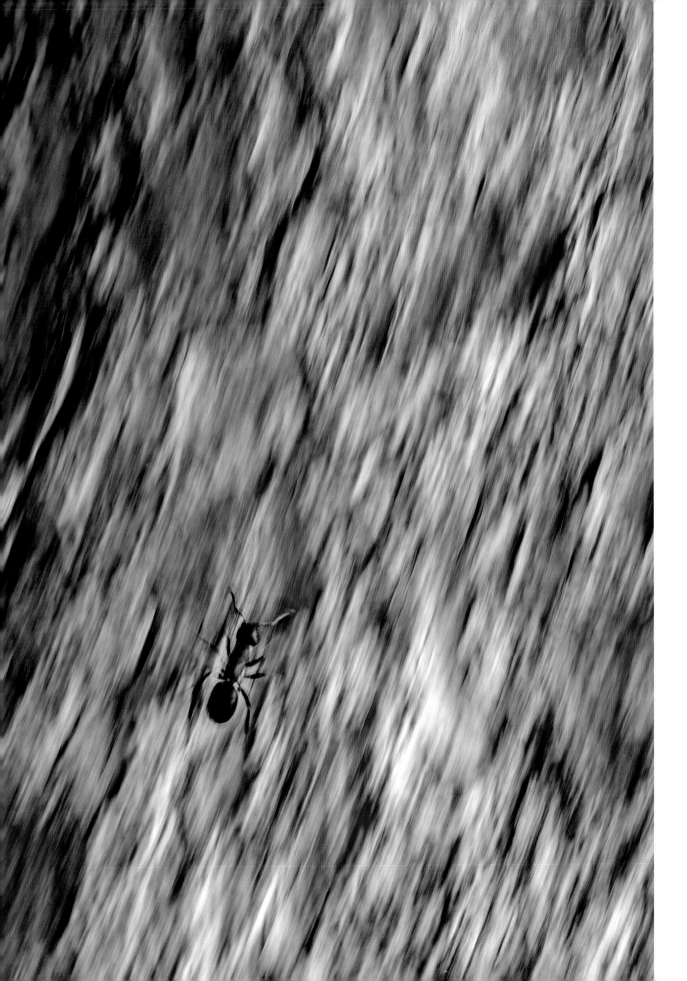

RADOMIR JAKUBOWSKI

Run
(Wood ant, *Formica lugubris*)
Glen Etive, Scotland

Ants are incredible animals.
They are strong and fast. I wanted
to show the speed of that species
in an image, so I used a lot of
panning technique.

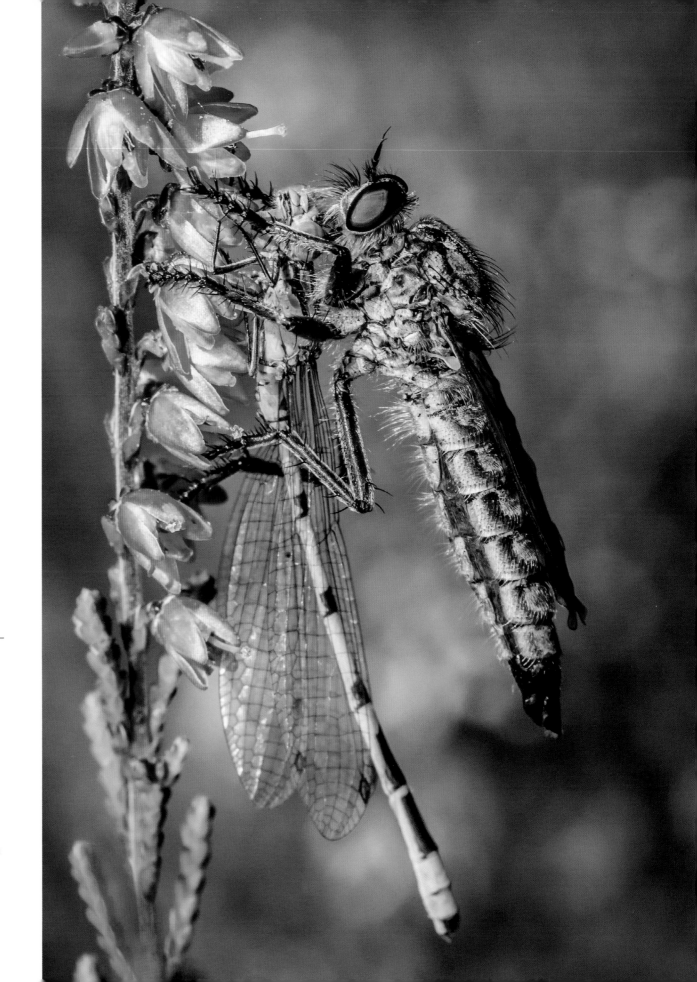

STEPHEN DARLINGTON

Damsel for Lunch
(Robber-fly, *Dysmachus trigonus*)
Thursley National Nature Reserve,
Surrey, England

The robber-fly was struggling to fly
with such large prey and settled on
the vegetation in front of me. I lay
on my stomach to get the camera
as close to the ground as possible,
and slowly inched myself closer,
taking photos as I went. I took both
portrait and landscape shots, but
this one works best for me.

COAST AND MARINE

SPONSORED BY WWF

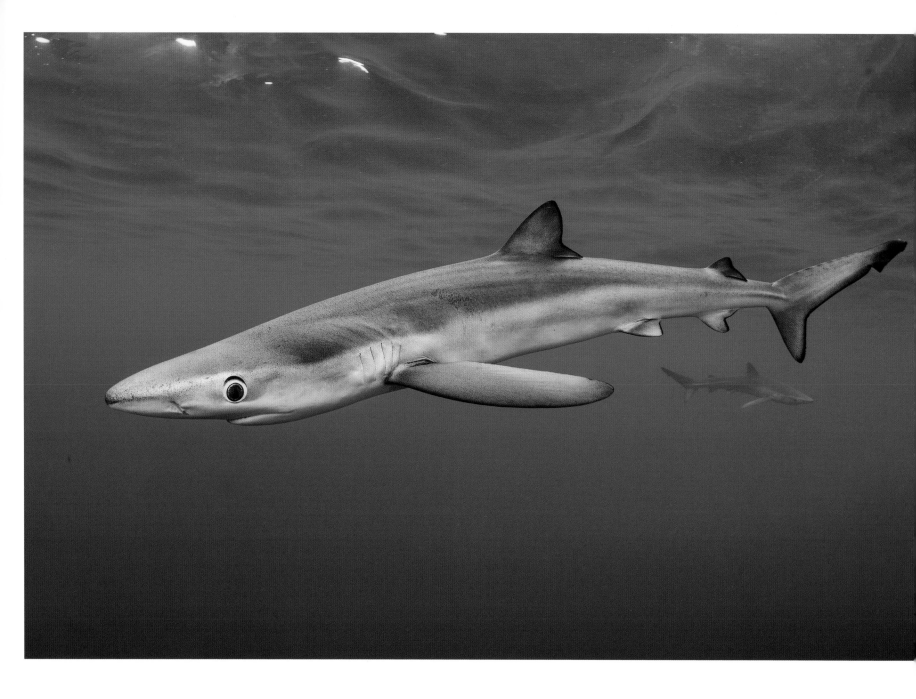

COAST AND MARINE WINNER

ALEXANDER MUSTARD

Big Blues
(Blue shark, *Prionace glauca*)
Penzance, Cornwall, England

Blue sharks are something I thought I'd never encounter in Britain, as they are rare visitors to our shores. I was amazed to see one shark, so when a second arrived I was keen to capture a frame with a pair of sharks cruising beneath the surface.

RICHARD SHUCKSMITH HIGHLY COMMENDED

The Cave
(Mauve stinger, *Pelagia noctiluca*)
Sula Sgeir, Scotland

Exploring the cave of Sula Sgeir, a remote rock in
the northwest Atlantic, I came across this jellyfish that
had been pushed in by the tide. The beautiful jellyfish,
clear Atlantic water and the dramatic sea cave made
for an exciting dive. Sula Sgeir is home to 20,000
nesting gannets and plays host to the Guga hunters,
men from Lewis who harvest the young gannets to
eat every summer.

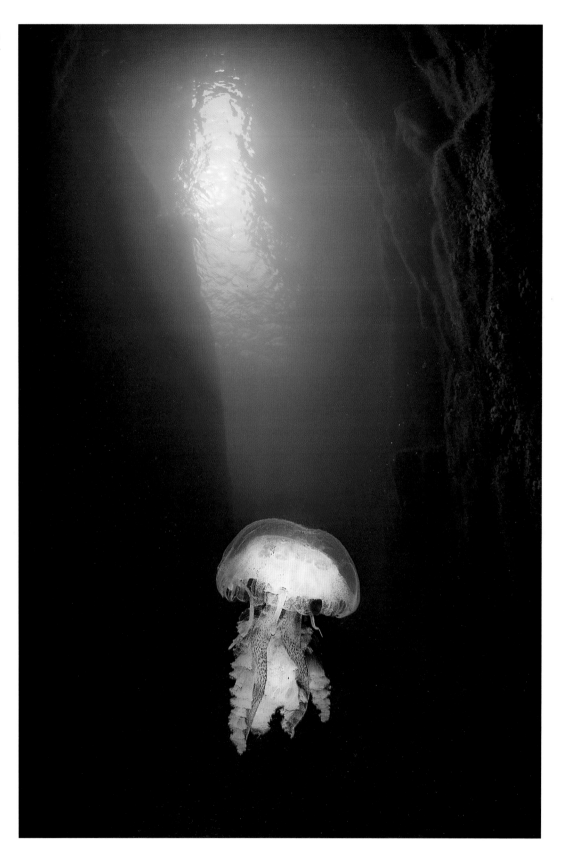

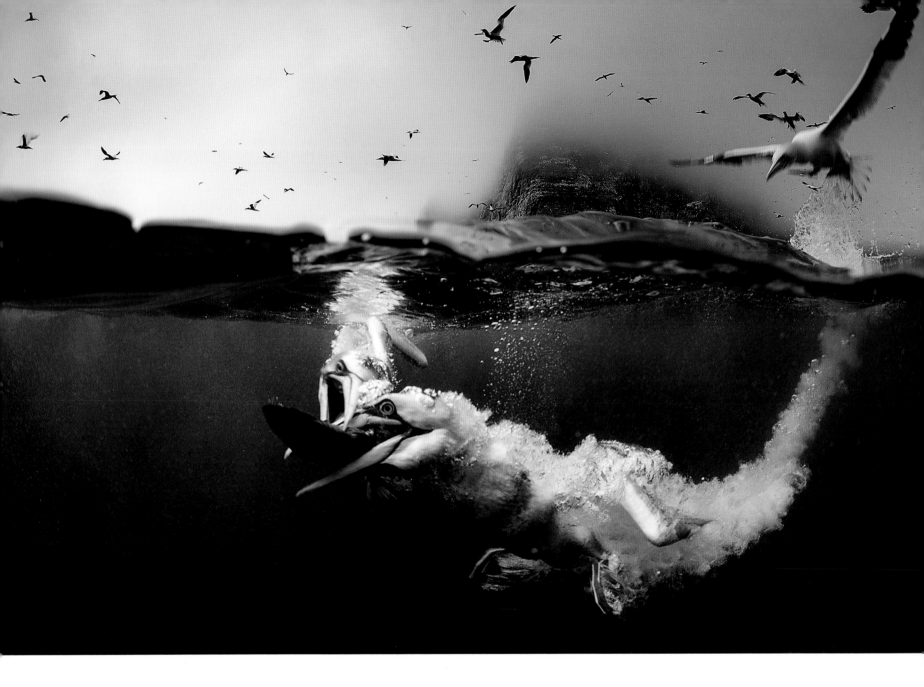

RICHARD SHUCKSMITH HIGHLY COMMENDED

Gannet Bubbles
(Northern gannet, *Morus bassanus*)
Shetland Isles, Scotland

Fast and furious, the gannets dive, and as one dives it's a cue for other birds to dive; sometimes 10, 20 or 30 birds can be diving at once. It's crazy, as the area where the birds dive turns to bubbles. They show amazing awareness and never hit one another. Trying to capture a split-level shot of a diving gannet with gannets flying above proved challenging. There was a little bit of guesswork as I found it easier not to look through the viewfinder and watch the scene before me but aim to fire the shutter as the gannet hit the water.

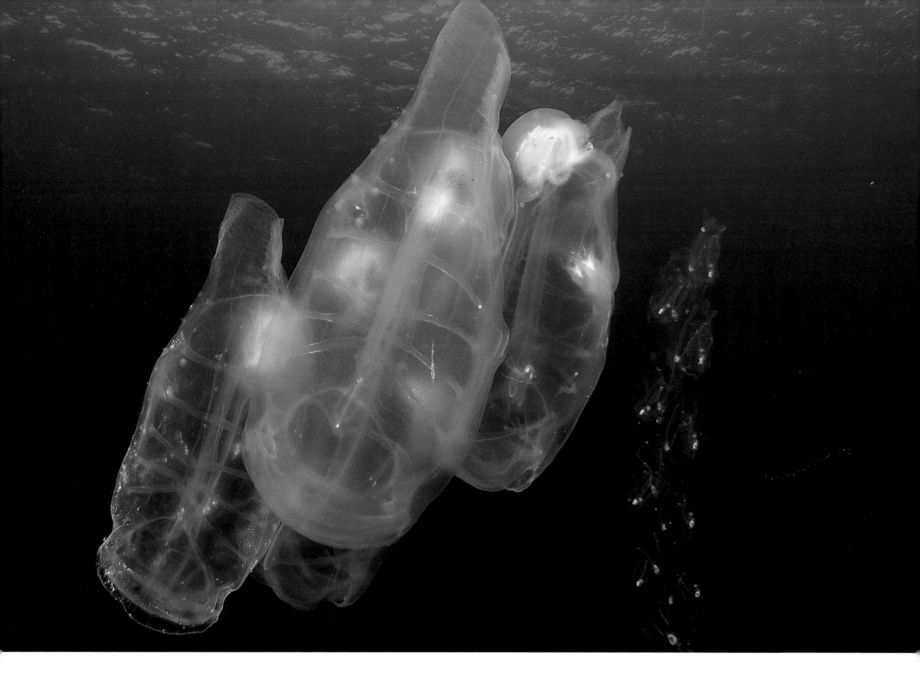

RICHARD SHUCKSMITH HIGHLY COMMENDED

Floating Jellies
(Maiden's salp, *Thetys vagina*)
North Rona, Scotland

Diving expeditions to this remote island off the northwest coast of Scotland
are always full of surprises. This year the visibility was outstanding, reaching
30m of clear blue water. Dropping into the water revealed a phenomenon
I have rarely seen – millions of jelly structures consisting of varied species.
Some were 'salps', soft-bodied organisms, others were jellyfish and some,
like this creature, were pelagic tunicates.

CYRIL CHEVILLOT HIGHLY COMMENDED

Edge of the World Jellyfish
(Compass jellyfish, *Chrysaora hysoscella*)
South Harris, Scotland

When I first arrived on this South Harris beach I got the
feeling I could reach the edge of the world: impressive
light, a dark blue sky and fantastic green water. When I
came into the sea I was lucky enough to come across
this jellyfish in two minutes. I swam along with it for
quite a long time before I realised it was the unique
jellyfish of the area.

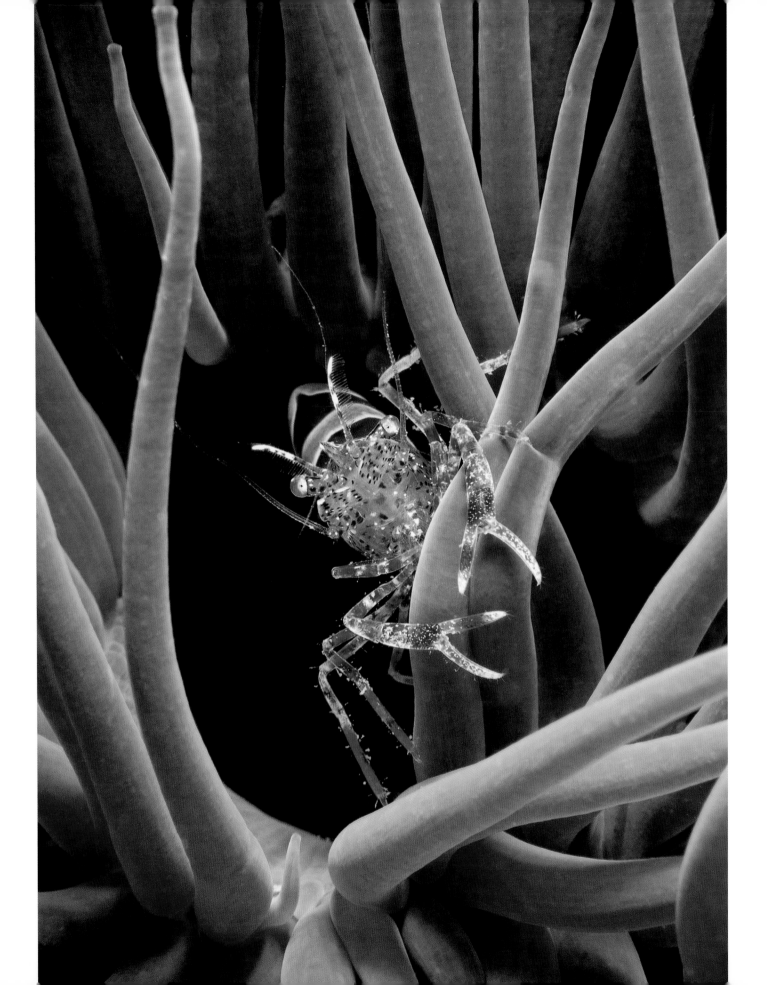

TREVOR REES < HIGHLY COMMENDED

Safety in a Snakelocks Anemone
(Blue shrimp, *Periclimenes sagittifer*)
Babbacombe, Devon, England

Blue shrimp have made a relatively recent appearance in Britain, possibly as a result of warming seas. At present they are only seen at a number of sites on the south coast of Britain. This one was photographed in the shallows off Babbacombe beach. The biggest challenge, apart from finding one, was to get a pleasing composition of the shrimp with its host anemone.

IAN WADE > HIGHLY COMMENDED

Common Shore Crab
(Shore crab, *Carcinus maenas*)
Clevedon, North Somerset, England

I love shore crabs. It's the alien way they look, and for such a small animal they are incredibly feisty. I spent over a couple of hours looking for crabs and by chance stumbled upon this one trying to get into the seaweed. The light was fading fast so I used my flash to light up the foreground. After a couple of shots the crab was hidden beneath the seaweed.

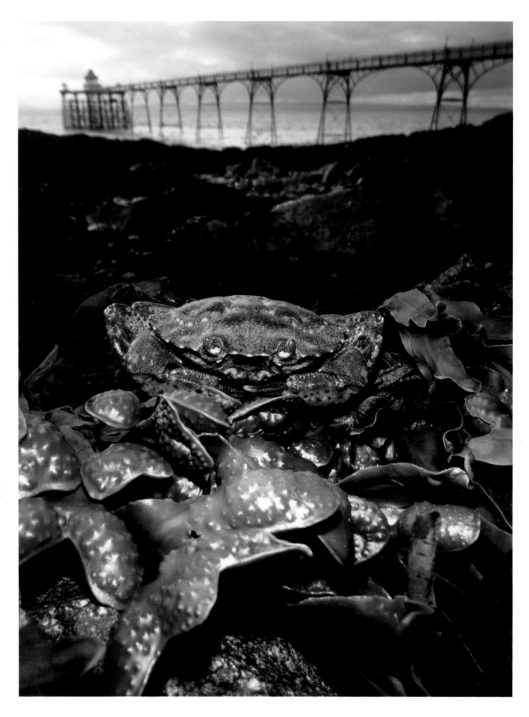

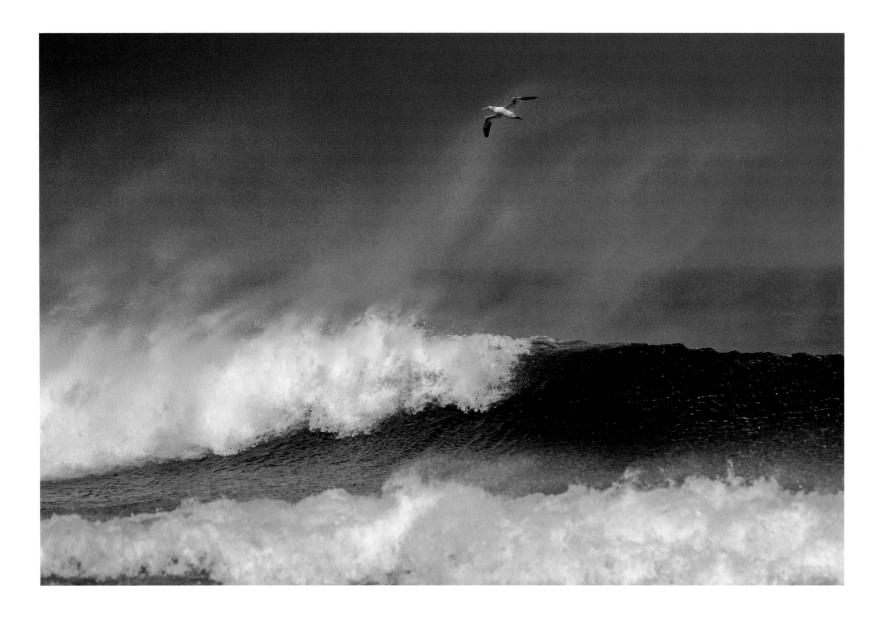

CAROL DILGER HIGHLY COMMENDED

Seaspray
(Northern gannet, *Morus bassanus*)
Lewis, Outer Hebrides, Scotland

Braving the fiercest winds on the British coast, a lone gannet searches for fish among swirling seaspray. The wind was so strong on the beach I couldn't stand up straight, hence a wobbly horizon that needed to be cropped straight.

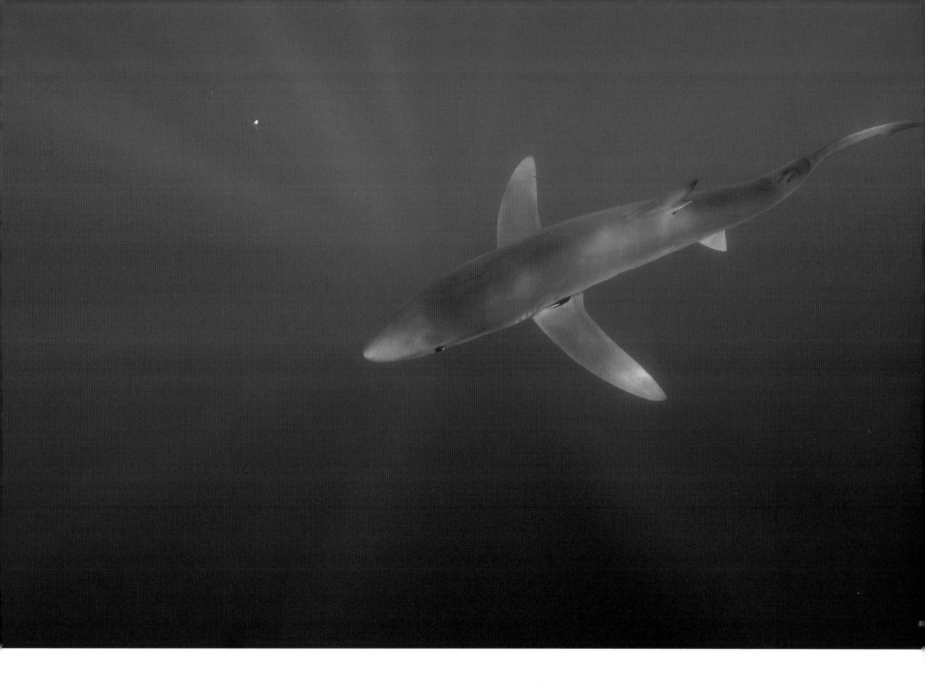

COLIN MUNRO HIGHLY COMMENDED

Blue Shark, Blue Water
(Blue shark, *Prionace glauca*)
Penzance, Cornwall, England

I took this image approximately eight miles offshore from Penzance. A small
group, we left shore at 9am specifically to photograph sharks. However,
we seemed to be out of luck. At 4.50pm we decided to give up. At 4.55pm
our shark arrived. I slipped carefully into the water in mask and snorkel and
drifted a little; the shark was curious and approached me time and again.
This was almost my final image of the day.

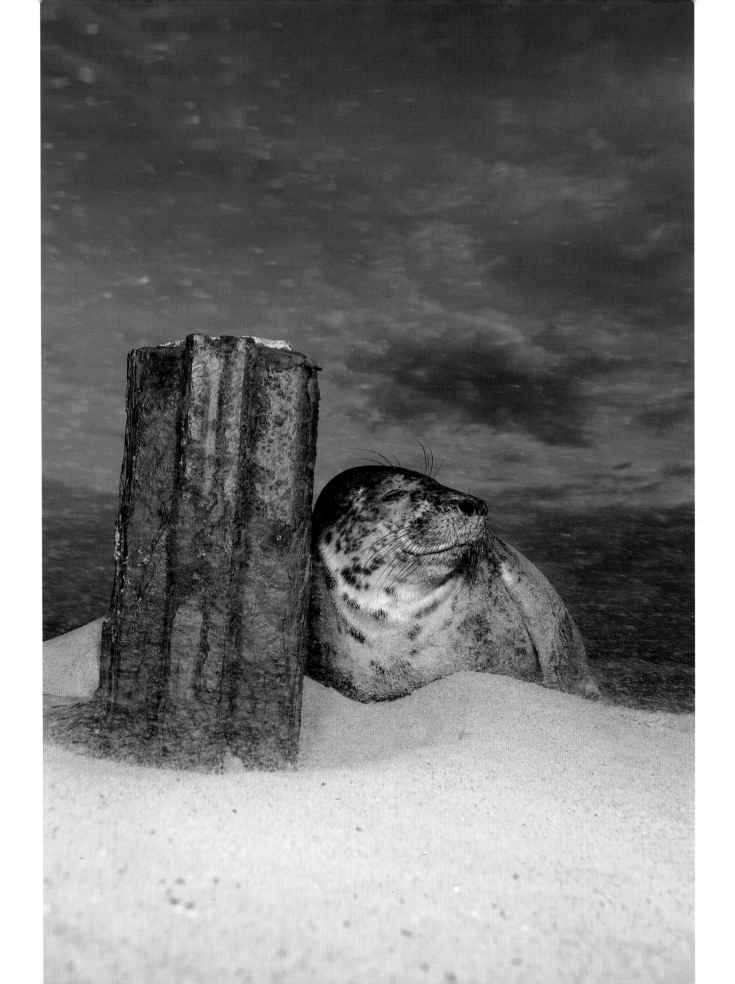

Grey Seal in a Sandstorm
(Grey seal, *Halichoerus grypus*)
North Norfolk, England

This seal pup was trying to take shelter behind a rusty groyne during a cold and very windy January afternoon. The wind kept changing direction and at times it was exposed to the sand that was being blown all over the beach. There is no escaping the elements for young seals as they can't retreat into the water until their fur is 100 per cent waterproof.

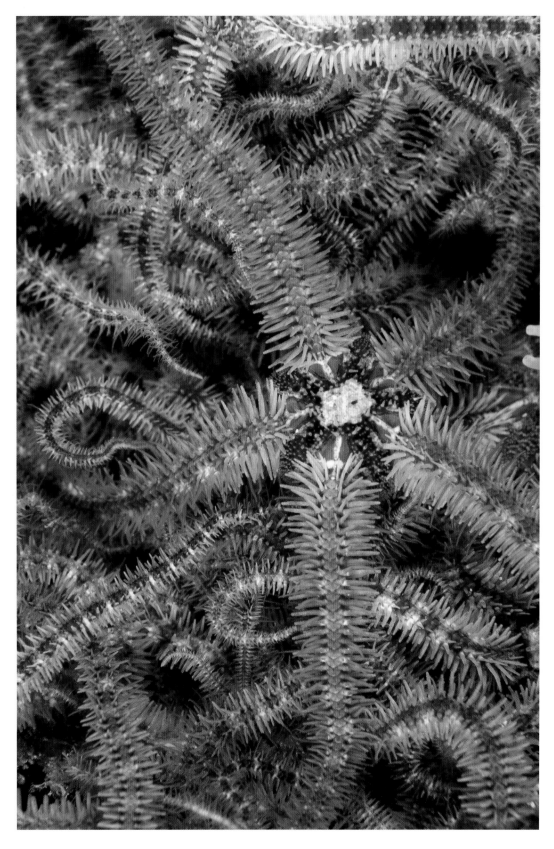

JANE MORGAN ＞ HIGHLY COMMENDED

A Brittle Bed
(Common brittlestar, *Ophiothrix fragilis*)
Tolsta Head, Lewis, Outer Hebrides, Scotland

Tolsta Head is the first promontory south of the Butt of Lewis. The bay to the north was the site of top-secret biological warfare experiments in the early 1950s. This involved the release of toxic agents such as bubonic plague. Despite its history, this is without doubt one of the prettiest reefs I have ever dived. The rocks and boulders were hidden beneath a carpet of brittlestars. The common brittlestar forms dense aggregations offshore, with as many as 2,000 individuals recorded per square metre.

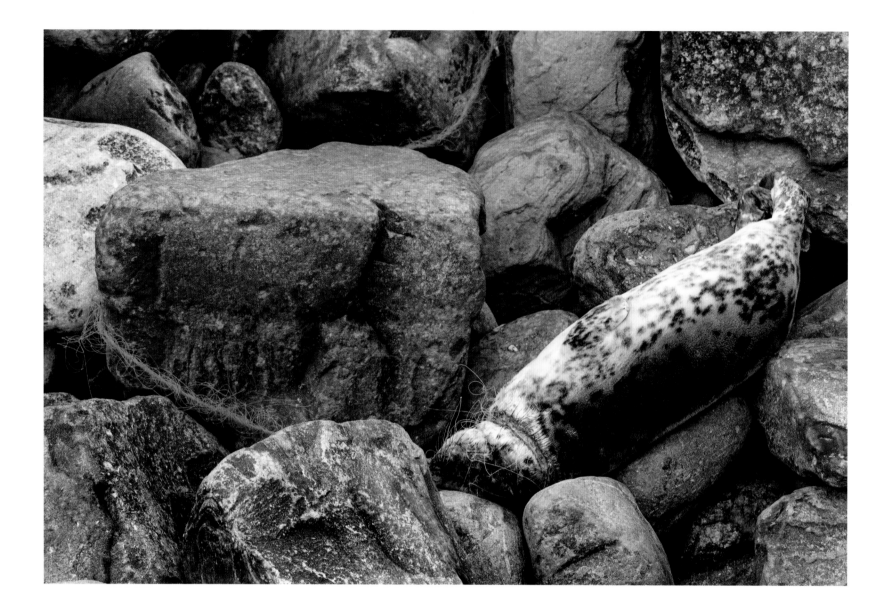

JOHN MONCRIEFF HIGHLY COMMENDED

Help
(Grey seal, *Halichoerus grypus*)
Exnaboe, Shetland, Scotland

I took this shot as I waited for the Hillswick Wildlife Sanctuary to come and free the poor seal. I had found the seal the previous evening – the monofilament net was twisted like rope, and caught among rocks – pulling the seal under as the waves came in. I wanted the subject tight in the frame to reflect how the seal was trapped by the net. Fortunately, this story had a happy ending.

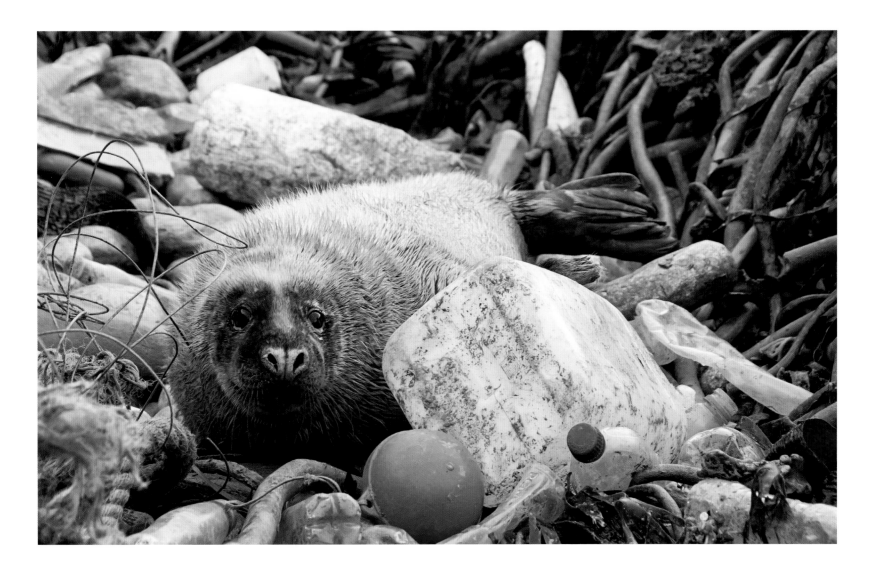

JOHN MONCRIEFF HIGHLY COMMENDED

Dunna Chuck Bruck
(Grey seal, *Halichoerus grypus*)
Garths Ness, Shetland, Scotland

I found this seal pup among a pile of plastic junk washed up on a remote pupping beach in Shetland. This is where the Braer oil tanker ran aground in 1993. 'Dunna Chuck Bruck' is Shetland's version of 'Keep Britain Tidy'.

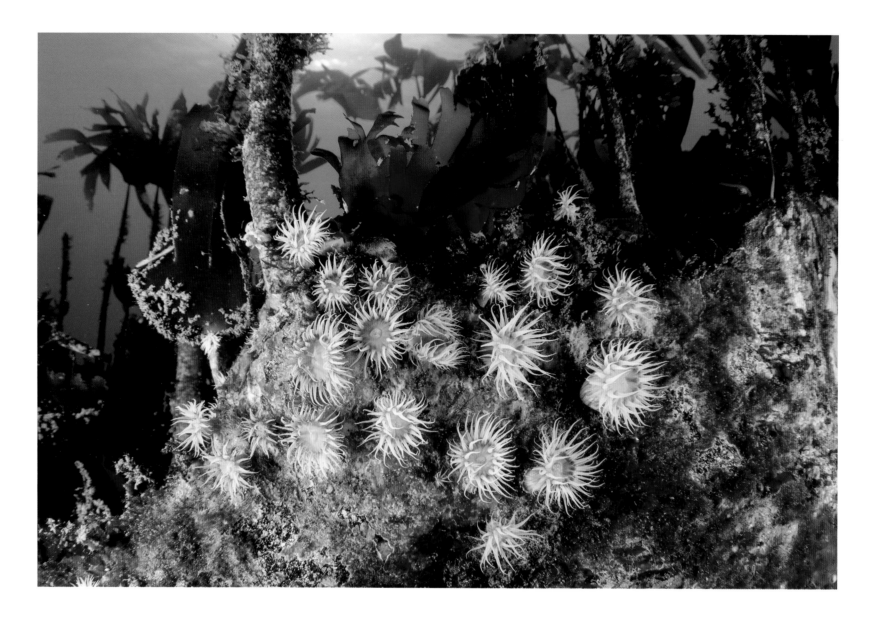

RICHARD SHUCKSMITH ∧

Underwater Garden
(White striped anemone, *Actinothoe sphyrodeta*)
North Rona, Scotland

This rocky habitat is full of surprises, with kelp growing on the top of the rocks and the vertical rock faces full of invertebrates. This scene just looks wonderful to me, with the rock covered in red encrusting algae, the anemones and the kelp above. It really shows off how wonderful the seas are around the UK.

MARK N THOMAS >

Shanny Trio
(Shanny, *Lipophrys pholis*)
Criccieth, Gwynedd, North Wales

These inquisitive little fish can be found hiding in the nooks and crannies on the breakwater off Criccieth beach. They often come out to investigate a strange underwater intruder and last summer, I was able to get this photo of three individuals peering out at me at the same time.

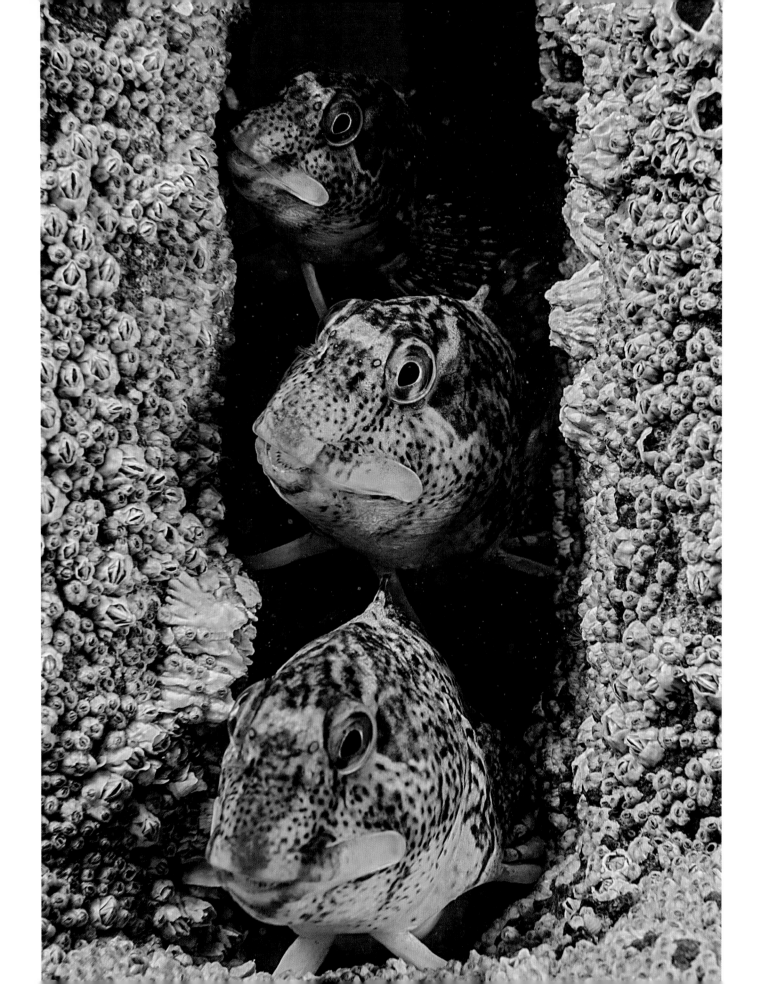

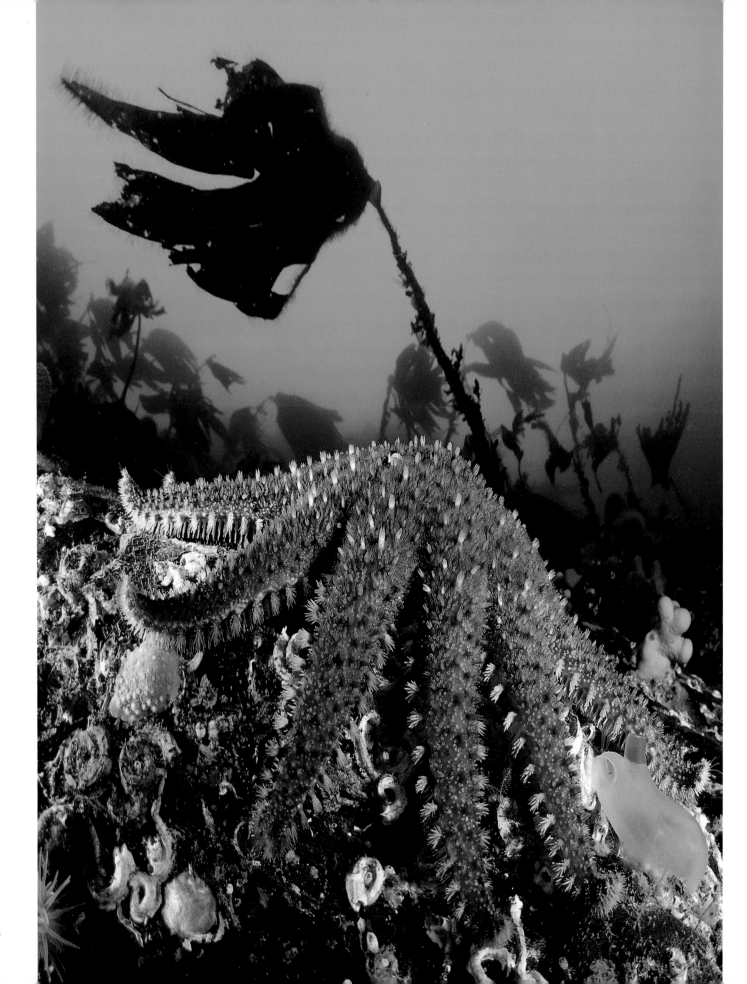

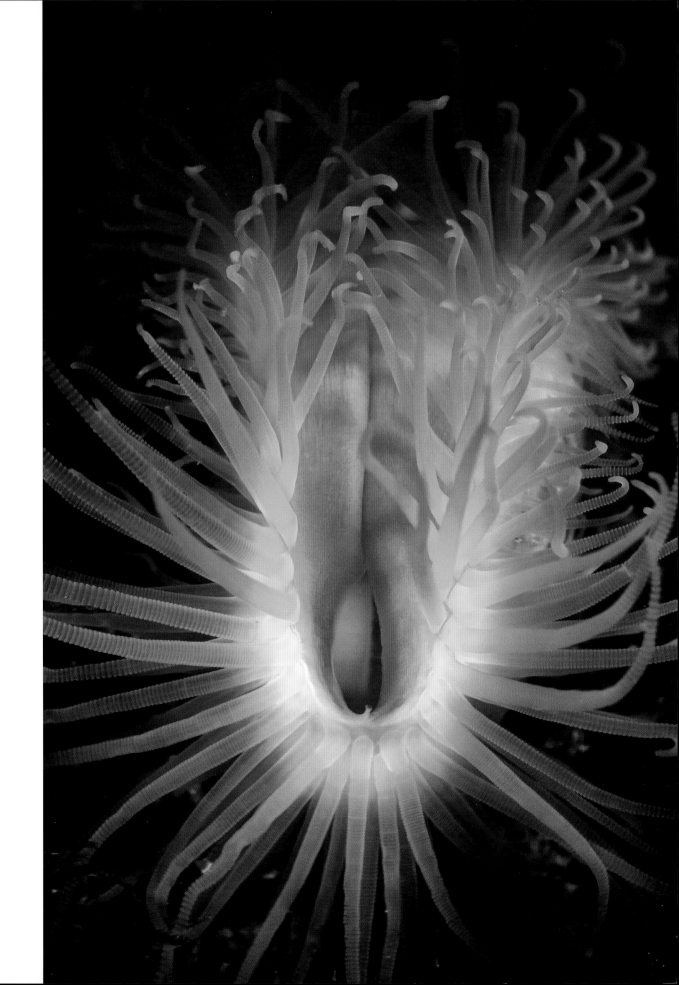

TREVOR REES <

Sunstar and Kelp
(Common sunstar,
Crosaster papposus)
Loch Carron, Wester Ross, Scotland

A close-focusing wide-angle lens
was used to capture the sunstar
against a backdrop of reef and kelp.
A slow shutter speed was used to
maximise the available background
light and artificial strobe light was
added to bring out the red colour
of the sunstar.

DAN BOLT >

Flame Shell
(Flame shell, *Limaria hians*)
Loch Carron, Wester Ross, Scotland

The rare but outlandish flame
shell mollusc is a true wonder
of British nature. Being unable
to withdraw its many tentacles
into the safety of its shell, it is
usually hidden beneath self-made
shelters. This individual seemed
happy to be out in the open,
and indeed had actually swum
into this position, giving me a
great photo opportunity.

WILD WOODS

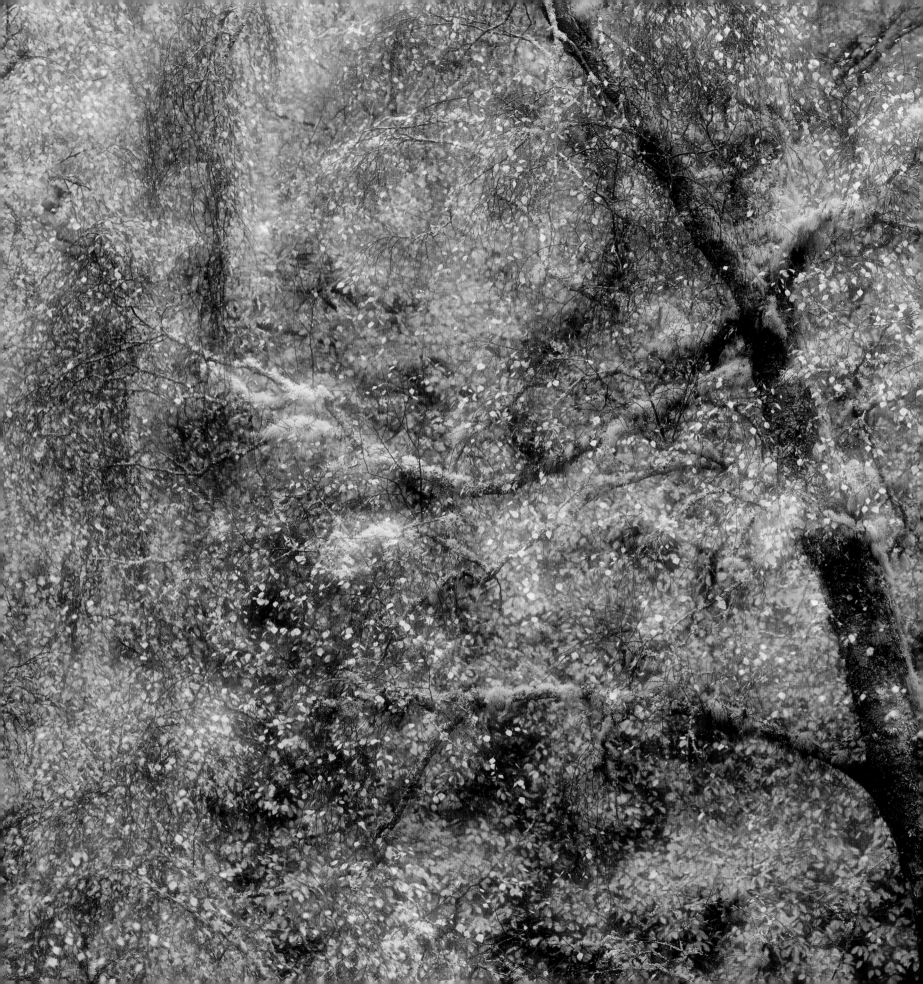

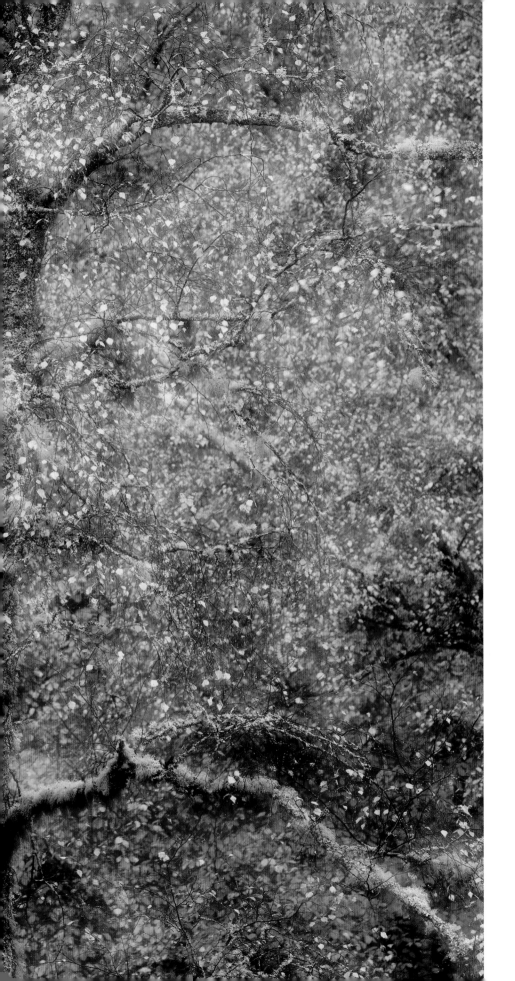

WILD WOODS WINNER

PETER CAIRNS

Autumn Jewels
(Mixed woodland but mainly Beech, *Fagus*)
Cairngorms National Park, Scotland

In wet weather I love exploring the shapes, colours and textures of local native woodland. Here on the shores of Loch Insh, this lichen-encrusted birch stands against a backdrop of rich autumnal colour. A slightly impressionistic effect is created by an in-camera multi-exposure.

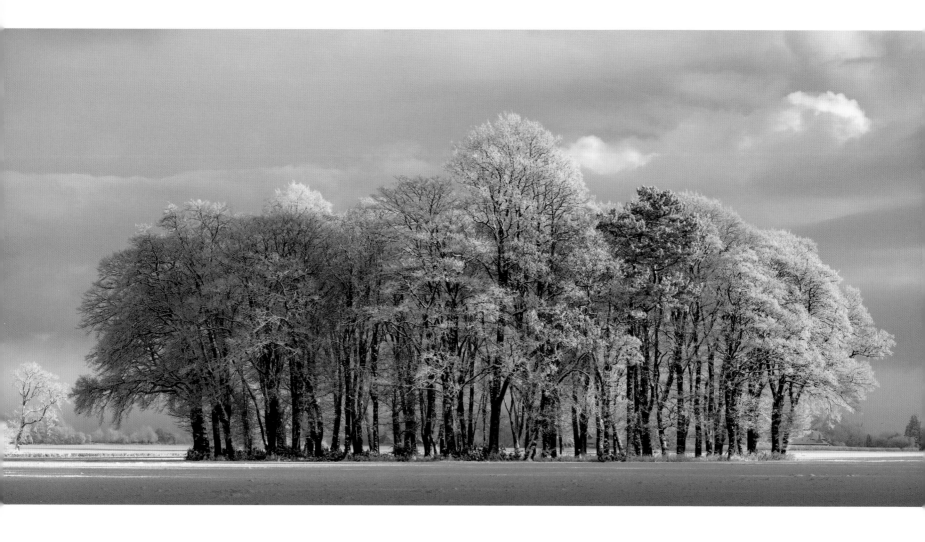

GRAHAM HARRIS GRAHAM HIGHLY COMMENDED

Defiance
(Beech, *Fagus*)
Dunmore, Falkirk, Scotland

I waited six months for this severe hoar frost to enter from the east. It was shot around midday on Christmas Eve at minus 10 celsius. I waited for a gap in the clouds to paint slight warmth onto the stand of frosted trees surrounded by deep snow. The symmetry and positioning of the highest tree in the middle were vital to exaggerate the sense of solidarity.

SIMON PHILLPOTTS HIGHLY COMMENDED

Forest Flyer
(Red squirrel, *Sciurus vulgaris*)
Yorkshire Dales National Park, North Yorkshire, England

I have always admired red squirrels for their athleticism and courage when leaping between trees 60 feet or more above the ground. Having watched and photographed the squirrels jumping to a feeding station for some time, I decided to change the perspective and use a fisheye lens pointing skywards. The intention was to give an idea of what one of these fearless canopy leaps might look like from below, while also showing the squirrels' forest realm.

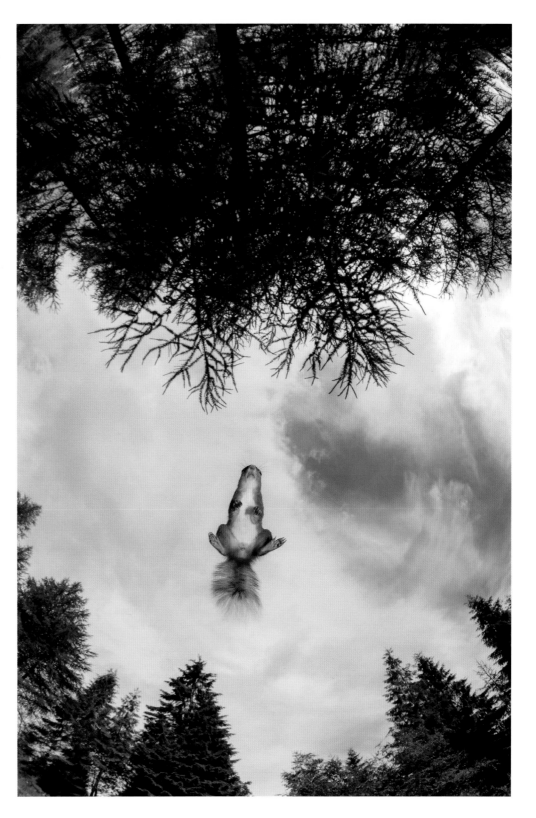

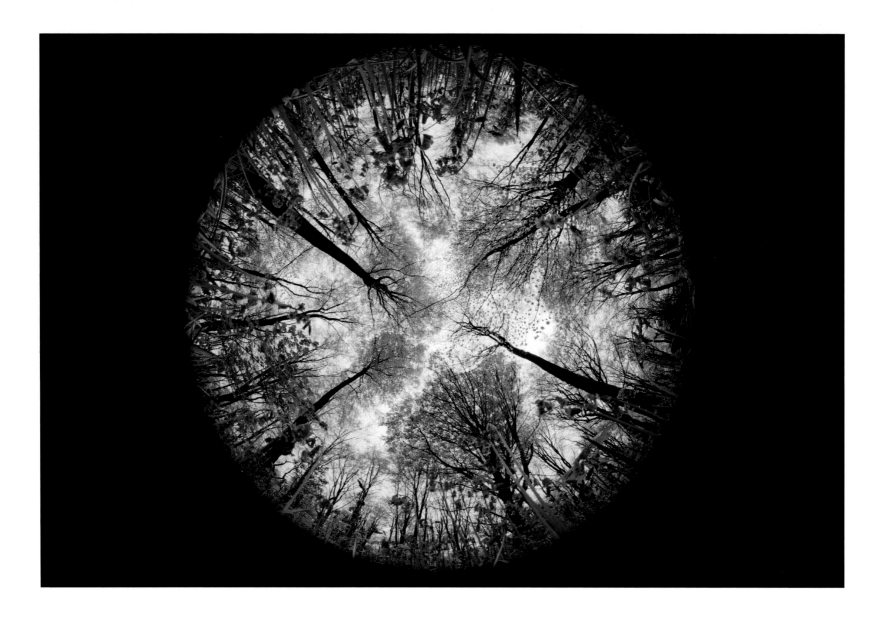

LIAM MARSH HIGHLY COMMENDED

Fisheye Bluebells
(Bluebell, *Hyacinthoides non-scripta*)
Micheldever Woods, Hampshire, England

To get an original photograph of something as popular as bluebells
sometimes requires a new approach. For this shot I lay my camera on
the ground among the bluebells and set the timer running. I then had 10
seconds to run through the trees (avoiding stepping on any flowers) and
duck down in order not to be recorded in the image. I got some strange
looks from other photographers but it was worth it.

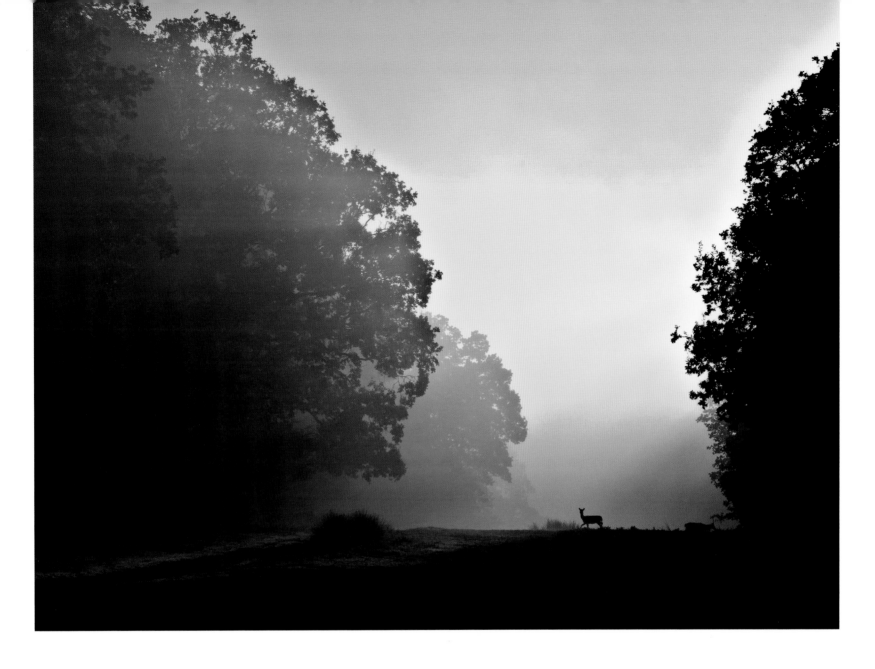

ANDREW WHITMARSH HIGHLY COMMENDED

Deer at Sunrise
(Fallow deer, *Dama dama*)
Richmond Park, Greater London, England

On this morning in Richmond Park, the mist was almost too thick for photography. However, I saw the potential of a photograph looking down this ride, with the mist backlit by the rising sun. I set up position and waited. After about 10 minutes, a female fallow deer emerged from the trees into exactly the right position (a second deer can be just seen further to the right).

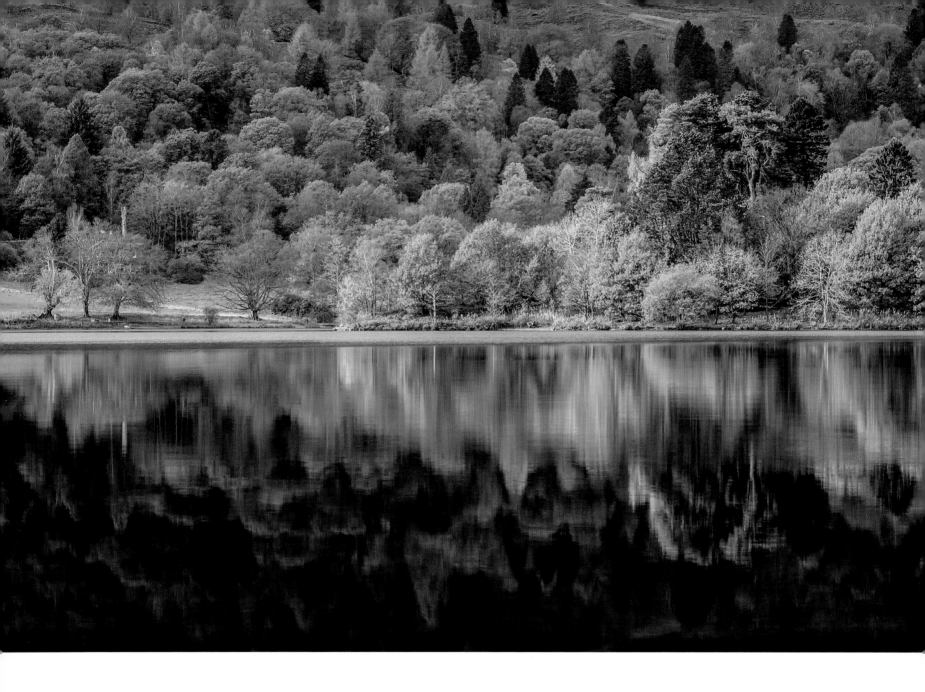

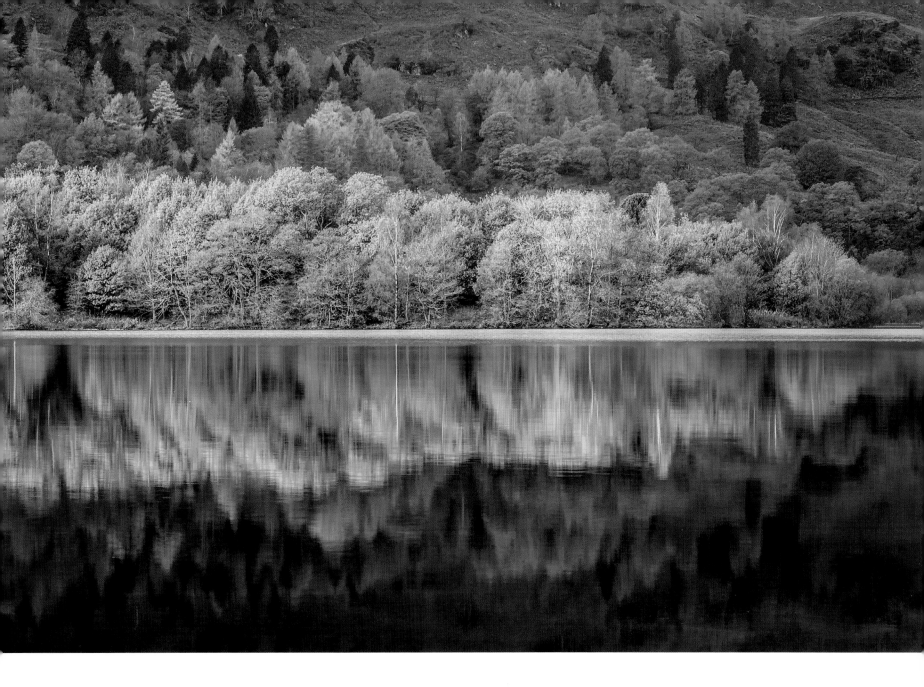

DREW BUCKLEY HIGHLY COMMENDED

Grasmere Island Wood – Reflections in Autumn
Grasmere, Cumbria, England

In autumn, it's hard not to fall in love with the natural wonder that's going on all around you and the Lake District is a particularly special place for me. At this time of year the region is transformed with a stunning natural tapestry of colour all around. I'd waited all week for Grasmere to be still enough to capture this near mirror image; a slight breeze emphasising the divide between land and water.

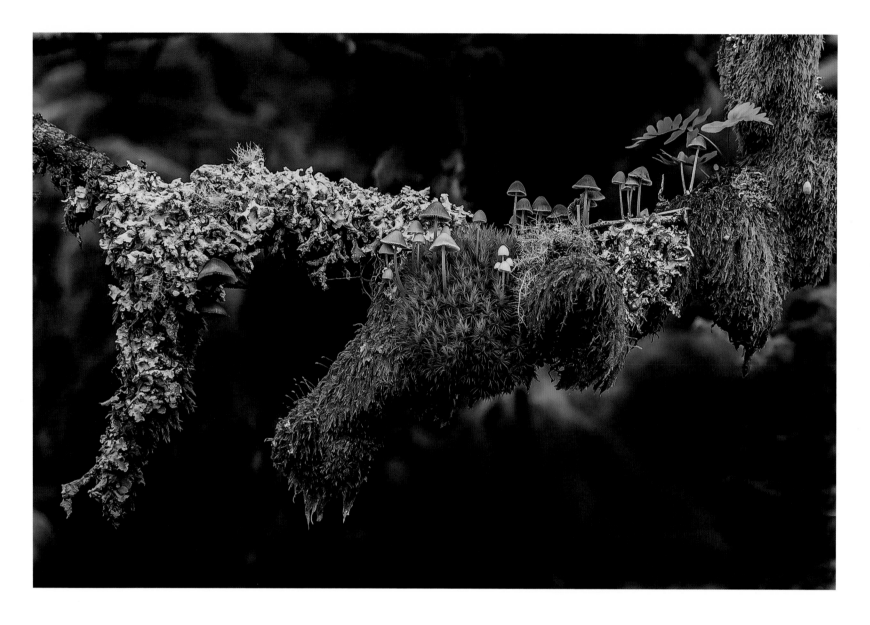

BOB REYNOLDS HIGHLY COMMENDED

Lichen and Fungi – Wistman's Wood

(Fungi, *Mycena speirea*; Lichen, *Hypotrachyna revoluta*)
Wistman's Wood, Dartmoor, Devon, England

I was fascinated by the variety of life to be found on a short length of branch on this ancient oak tree – species of lichen, moss, fungi and fern. A tripod, wide-aperture lens and reasonably fast shutter speed were essential due to the branch moving in the wind and being in shaded woodland. The terrain was slippery moss-covered boulders, so setting up proved difficult, an acceptable image taking 30 minutes to achieve.

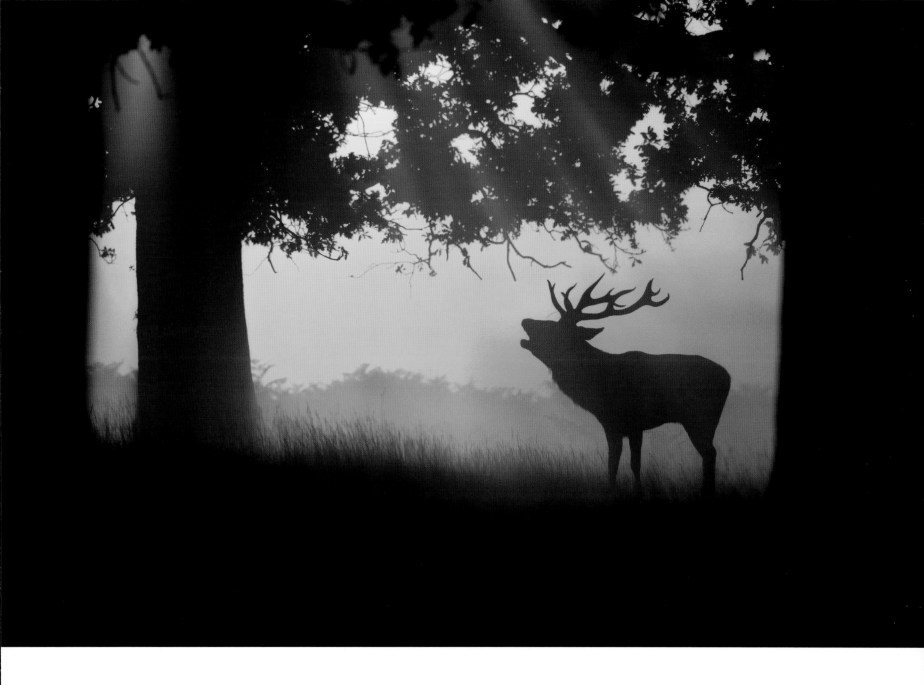

KEVIN SAWFORD HIGHLY COMMENDED

Roaring Stag
(Red deer, *Cervus elaphus*)
Bushy Park, Surrey, England

My early start to beat the London rush hour was rewarded by being in position as the sun broke through the mist and as this stag was roaring during the rutting season. The stag was easy to find through the mist as its bellowing could be heard across the park, so I was able to frame the image in the woodland setting.

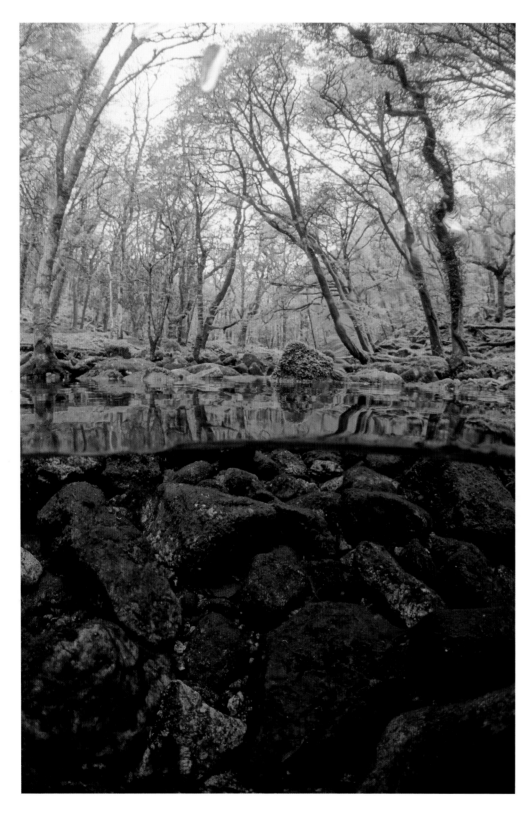

River Meavy and Woods
Dartmoor, Devon, England

On this quiet stretch of the River Meavy I intended to try a split-level image showing the underwater rocks and trees above. The difficulty was getting the exposure right above and below the water. I obtained several images and this was the best one. I was wearing wellington boots at the time.

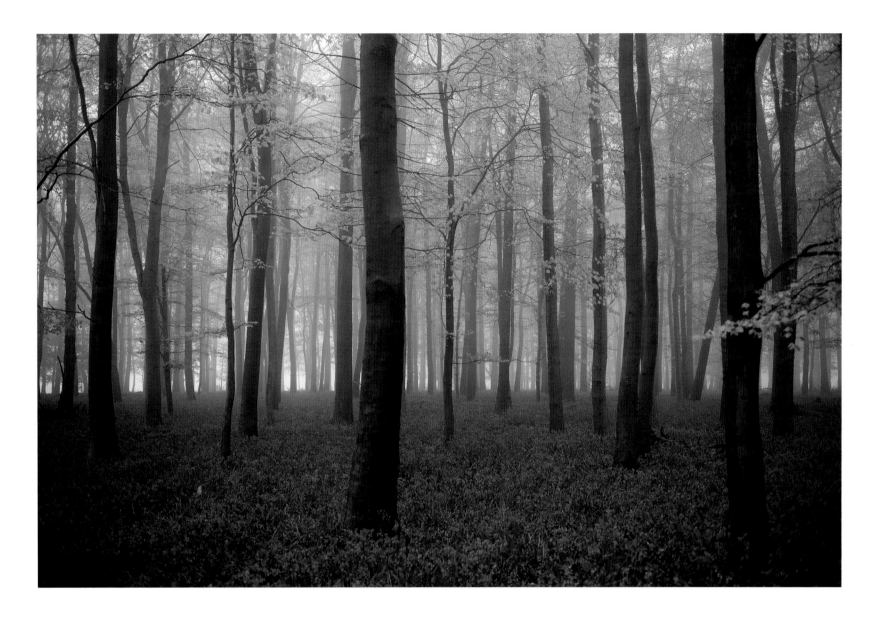

CRAIG CHURCHILL HIGHLY COMMENDED

Misty Bluebells

(Bluebell, *Hyacinthoides non-scripta*)

Ashridge Forest, Ashridge Estate, Hertfordshire, England

This little patch of woodland is set away from the rest and is usually deserted. I'd set off before dawn and a few miles from here I could see that low cloud and mist had enveloped the wood. I've photographed here in the autumn and winter but failed so many times in the spring, but on this day the conditions were just right; misty and overcast with perfect colour.

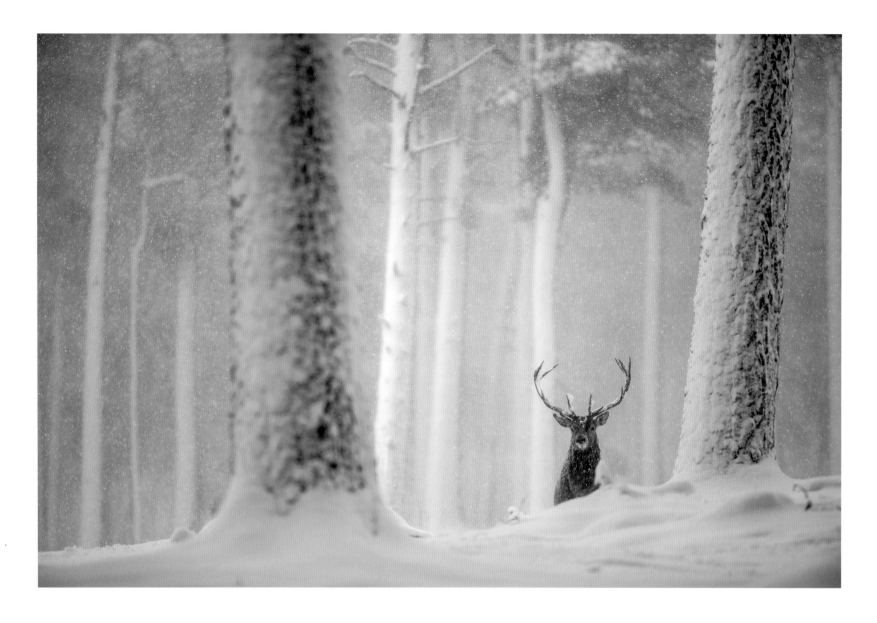

PETER CAIRNS HIGHLY COMMENDED

Red Deer Stag in Blizzard
(Red deer, *Cervus elaphus*)
Cairngorms National Park, Scotland

In many parts of the Highlands, red deer are banished from their natural
pine forest habitat by fencing designed to protect young trees from the
grazing pressure brought about by high numbers. It's a contentious issue,
but putting the politics aside, I was grateful for the stag, the forest and the
blizzard coming together in a scene reminiscent of Narnia.

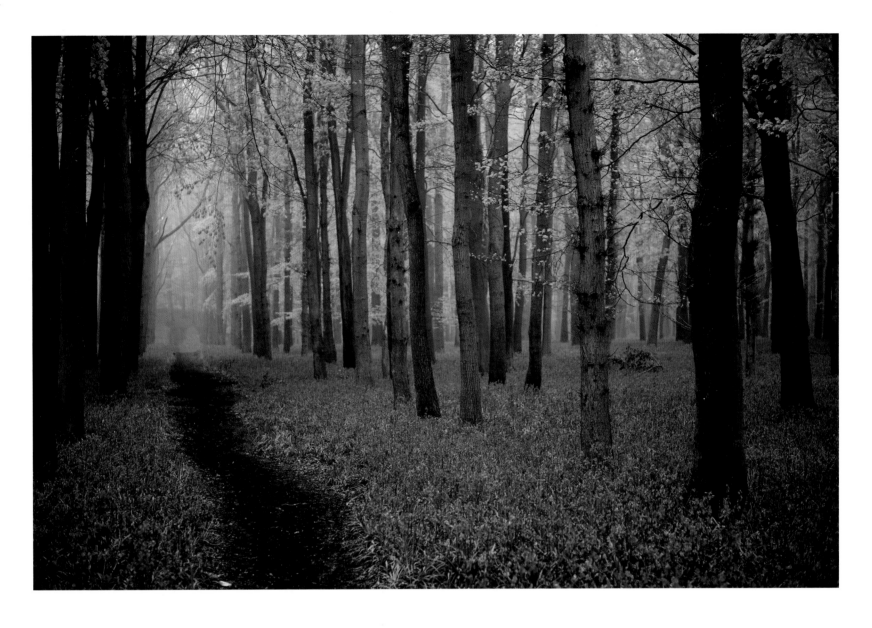

CRAIG CHURCHILL HIGHLY COMMENDED

An Inviting Stroll
(Bluebell, *Hyacinthoides non-scripta*)
Ashridge Forest, Ashridge Estate, Hertfordshire, England

Every year I visit this bluebell wood and every year it's different; it's either a poor year for bluebells and a good year for beech trees or vice versa. This year the timing of both were perfect. A pre-dawn start and a touch of mist provided great conditions, with just me and two other photographers to witness the beauty.

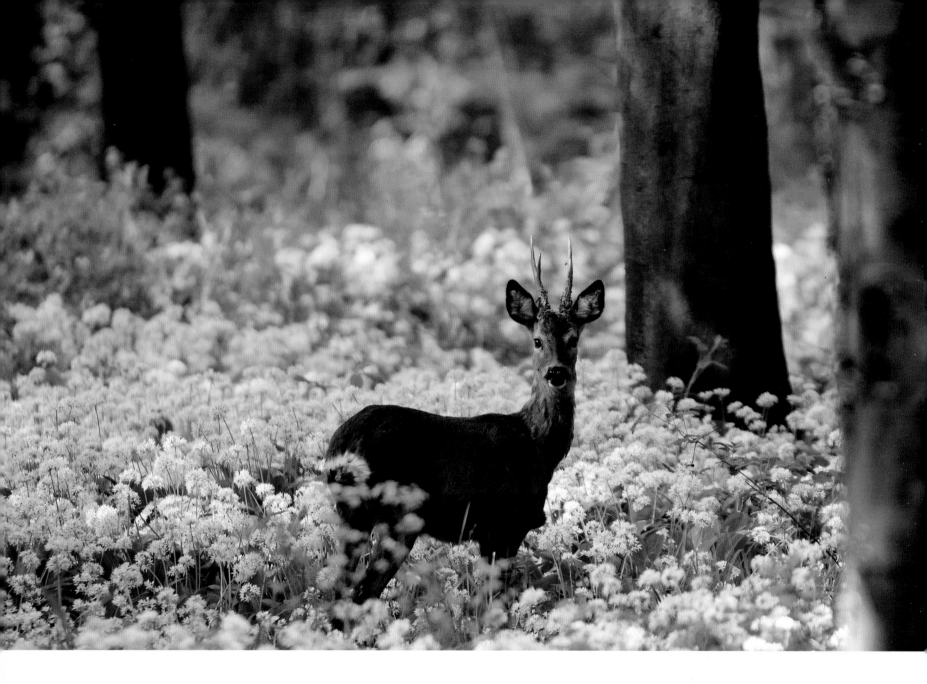

ANDREW WHITMARSH

Roe Buck among the Ramsoms

(Roe deer, *Capreolus capreolus*; Ramsom, *Allium ursinum*)
South Downs, West Sussex, England

This wood had an impressive display of ramsoms in flower. I had already spent several hours there trying to find the best compositions. I was amazed when this male roe deer wandered past, apparently unconcerned by my presence – probably because I was crouched over the camera and barely moving. I frantically changed from my wide-angle to a longer lens, and managed to get this shot as the deer briefly looked back before disappearing.

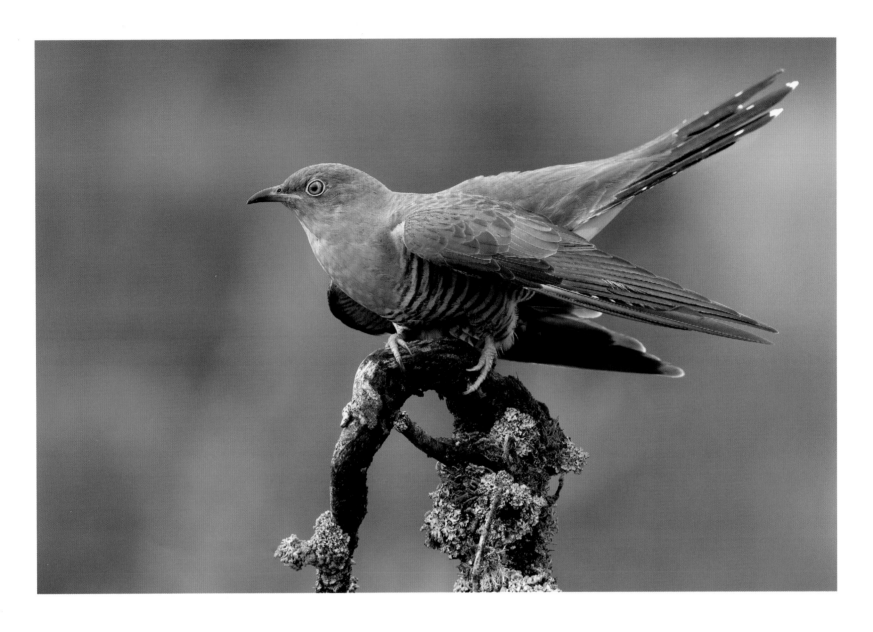

MIKE CRUISE

Resting Cuckoo
(Cuckoo, *Cuculus canorus*)
Kirkcudbright, Dumfries & Galloway, Scotland

This image was taken from a hide erected in an area where cuckoos were frequently seen to perch. The remote, mixed woodland with heather-covered ground provided ideal cover for the chosen host species, which would probably be the meadow pipit. The diffuse late afternoon light helped to give the picture atmosphere and good feather detail.

HABITAT

SPONSORED BY
THE WILDLIFE TRUSTS

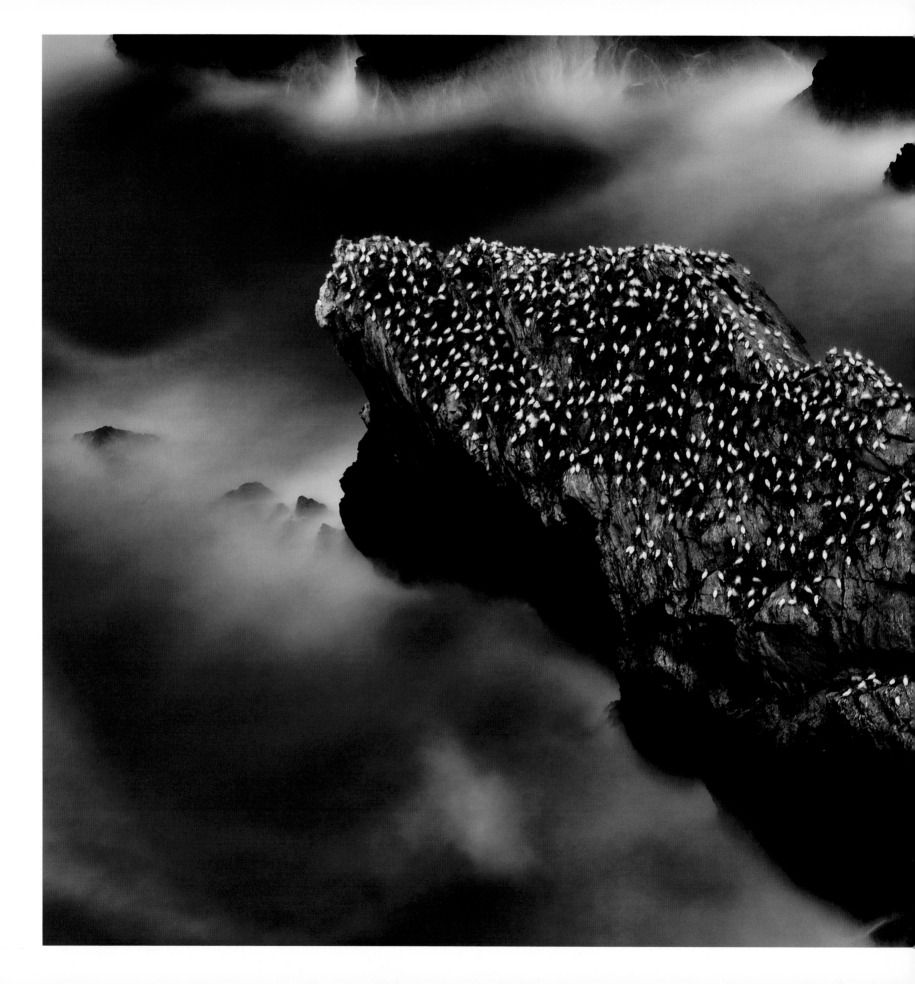

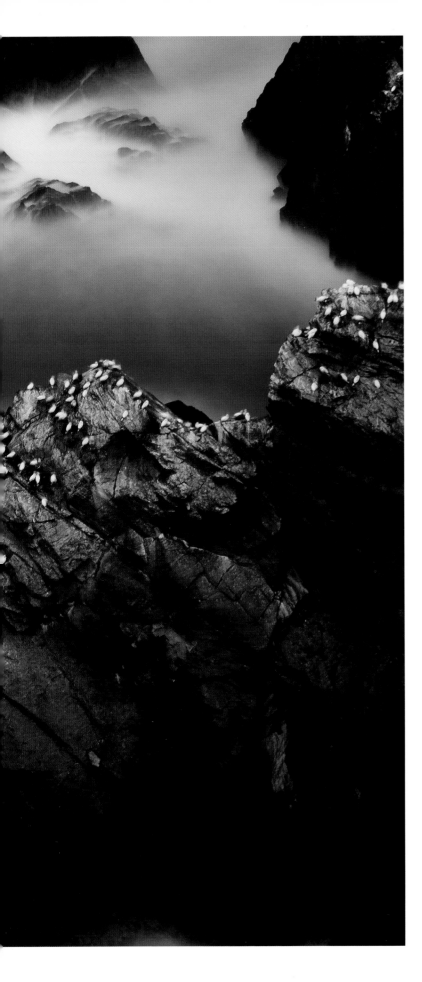

RUTH ASHER

A Life at Sea – Nesting Gannets
(Northern gannet, *Morus bassanus*)
Hermaness, Unst, Shetland Isles, Scotland

I was fascinated by the gannets nesting on this rocky outcrop as they seemed so content while perched in the midst of crashing waves. I wasn't sure how I was going to capture this scene, but with a love for slow shutter speeds I decided to fit my big stopper ND filter to see what happened. I feel the resultant image portrays the ease these birds have with the harsh environment in which they live.

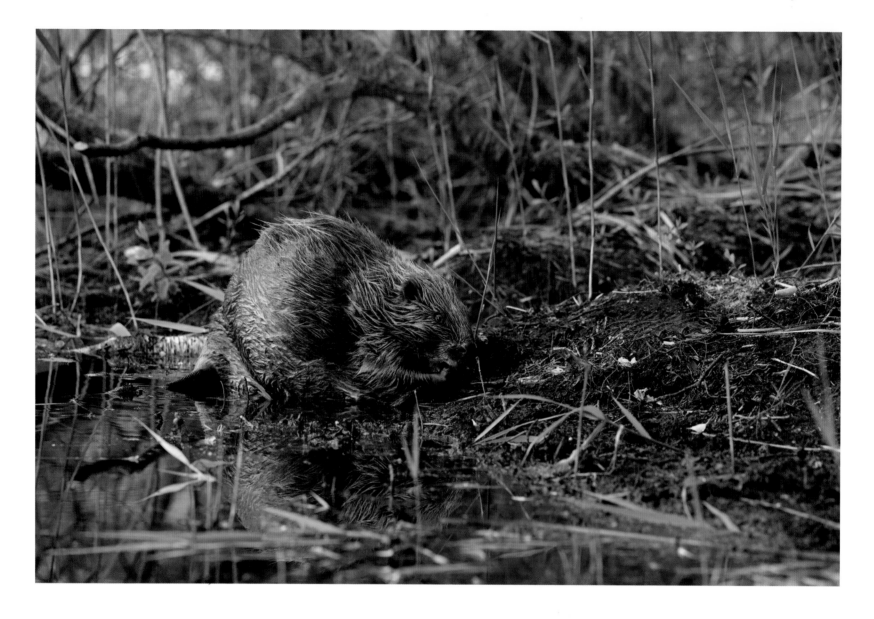

JO McINTYRE ∧ HIGHLY COMMENDED

Female Wild Beaver
(Eurasian beaver, *Castor fiber*)
Scotland

When I had the opportunity to get close to and photograph Europe's largest native rodent, the Eurasian beaver, I jumped at the chance. After sitting on the riverbank quietly for several hours this female beaver appeared. At first she was swimming on the other side of the loch but then she swam towards me and started feeding out of the water. I felt so privileged to photograph her this close; it was just magical.

ALAN BEVIS > HIGHLY COMMENDED

Forest Web
(Orb weaver spider, *Araneidae*)
Bridewell Plantation, Dorset, England

This is a mixed wood plantation a little off the beaten track. On this particular morning sunbeams were highlighting the bracken. One such beam was shining through the almost-perfect spider's web, with attendant spider, which had been woven between two pine trees.

TONY DILGER HIGHLY COMMENDED

Queue for Take-off
(Atlantic puffin, *Fratercula arctica*)
Unst, Shetland Isles, Scotland

An image previously taken by my wife had impressed me with its situation
and compositional possibilities so this shot, taken at the same spot, is really
a combined effort. I wanted to capture not only the group of puffins (who
wouldn't?) but their habitat and that dizzy sense of space you get on a big
sea cliff. The background was the key element in achieving this, hence the
framing. The 'bubbles' in the background are, of course, nesting gannets.

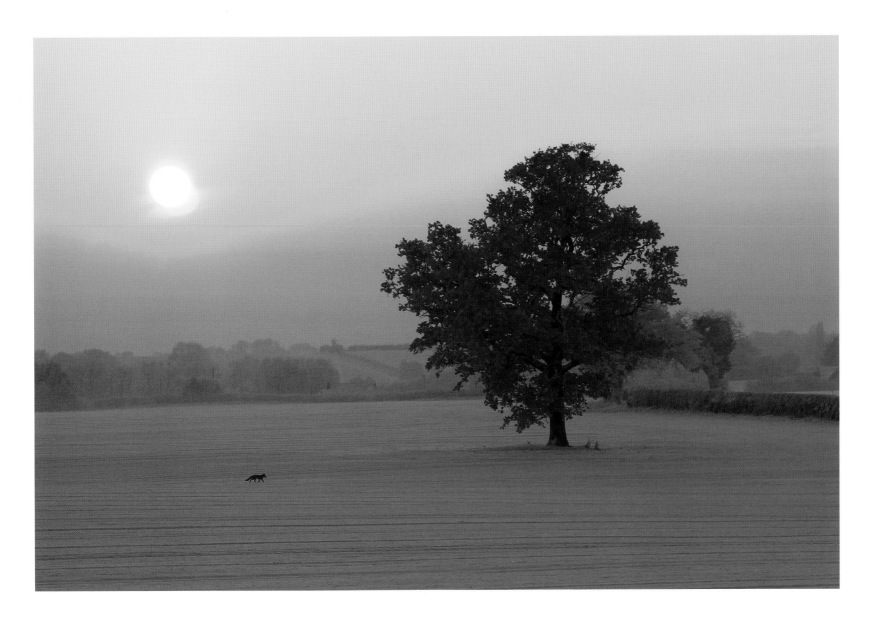

JILL BARROW HIGHLY COMMENDED

Going Home
(Red fox, *Vulpes vulpes*; English oak, *Quercus robur*)
Shropshire, England

It was 3.30pm in the week before Christmas and the sun was setting over the snow-covered field adjacent to my house. It had been one of those hazy winter days which gave the setting sun a special quality. I was in my office upstairs when I saw our local fox moving purposefully towards his earth (out of shot, to the right). He sat for a while beneath the oak tree and then headed out of sight. I chose this shot out of the series as I thought the position of the fox gave the best balance.

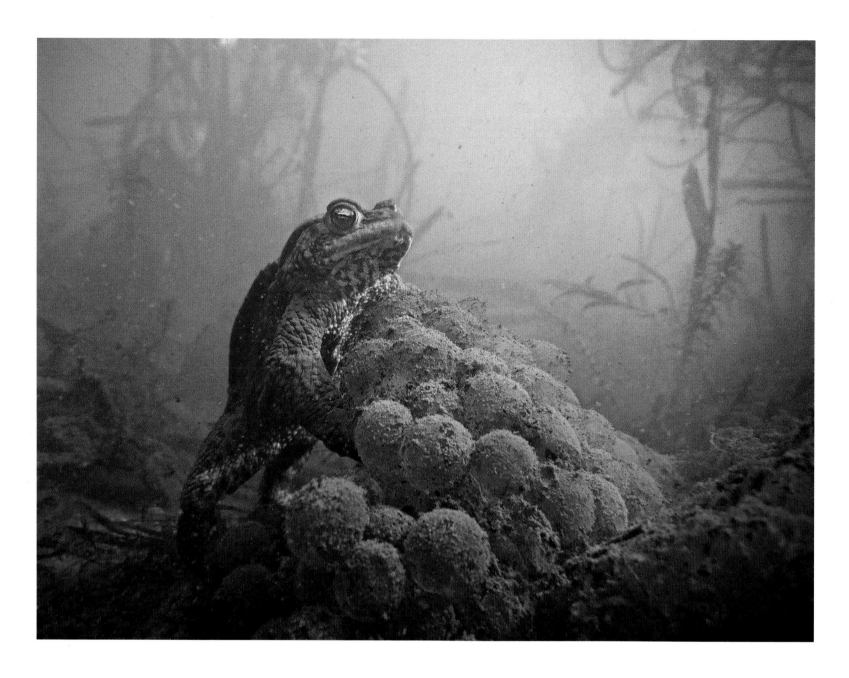

IAN WADE HIGHLY COMMENDED

Waiting for a Mate
(Common toad, *Bufo bufo*)
Bristol, England

I had been waiting patiently all spring for the toads to spawn and kept
missing them at different locations in Bristol. I knew the habitat they liked,
I just needed a little luck. On this day I got lucky. Using my underwater
camera I managed to capture toads mating over two days. At the end of the
second day my arm was really cold, having been in the water for hours.

PETER WARNE HIGHLY COMMENDED

Common Toad Curled up in Brick Bed
(Common toad, *Bufo bufo*)
Copped Hall Park, Epping Forest, Essex, England

Common toads are able to match their skin colour to their surroundings
to provide some protection against would-be predators. There are
several colonies in the gardens of Copped Hall Park, Epping, a historic site
currently undergoing restoration. Some are pale, some mud-coloured but
the example shown is from a colony which inhabits the piles of old bricks
which were once part of the walled garden outbuildings.

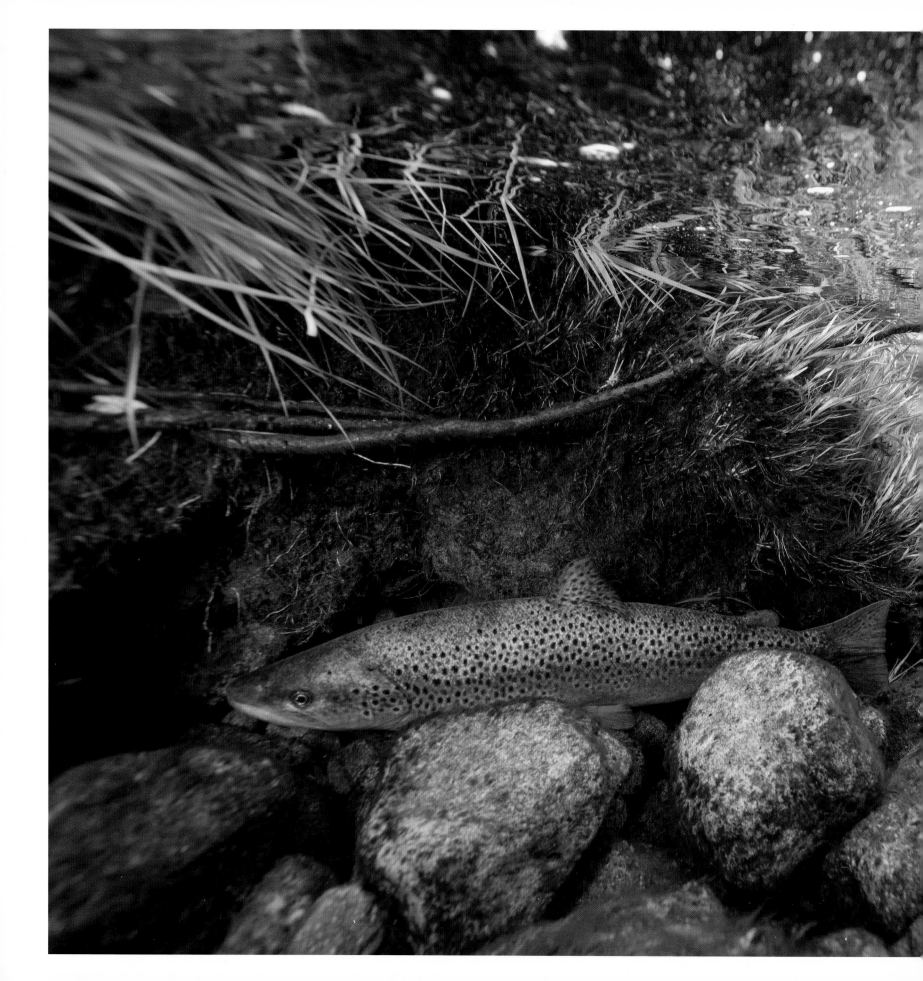

LINDSAY McCRAE HIGHLY COMMENDED

Sea Trout Waiting for Rain
(Sea trout, *Salmo trutta*)
River Duddon, Cumbria, England

It was early September and we'd had our first run of fish up the river. After a week of no rain, the river was running crystal clear and the fish were forced to rest up. In a wetsuit, snorkel and mask and about a foot of water, I slowly approached from downstream until in position.

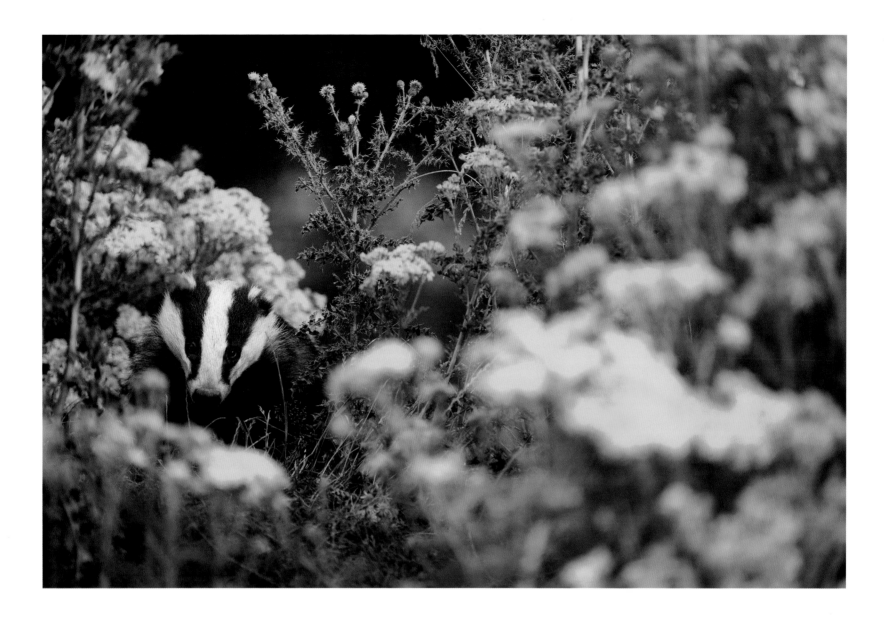

ANDREW PARKINSON HIGHLY COMMENDED

Badger among Summer Flowers
(Badger, *Meles meles*)
Crich, Derbyshire, England

I always prefer to work close to home and this sett is just outside my
village. As the summer progressed so the ragwort began to grow around
the sett and the young badgers gained much confidence from their newly
overgrown surroundings.

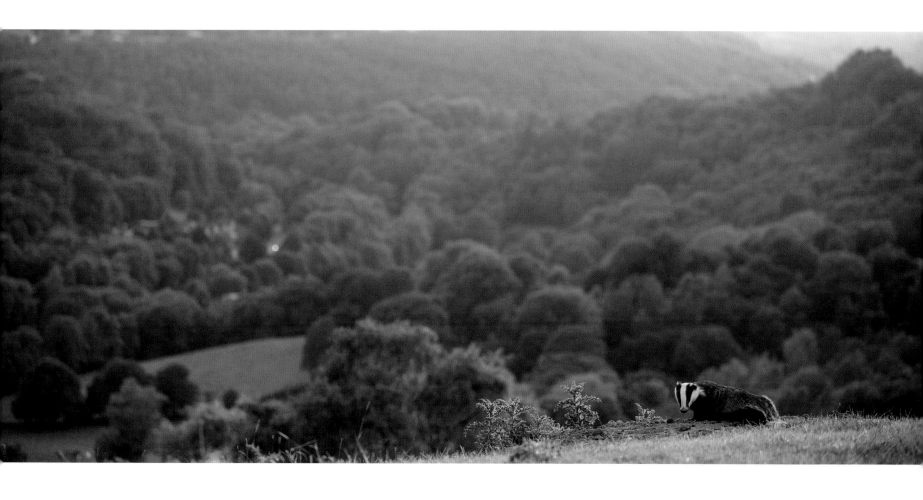

ANDREW PARKINSON HIGHLY COMMENDED

A Sett with a View
(Badger, *Meles meles*)
Crich, Derbyshire, England

This is a new location where I am working with badgers, set against one
of my favourite views of Derbyshire; a view just outside my home village
of Crich. I wanted to show the badger as part of this landscape so I
photographed it using an 80-200mm lens.

ALEX MEEK

Roosting Tawny
(Tawny owl, *Strix aluco*)
Scarborough, North Yorkshire, England

I noticed this owl roosting in our back garden tree while making breakfast one morning. The owl's plumage blends in perfectly with the bark, providing camouflage while it sleeps during daylight hours. Photographing from our decking down the sloped garden gave me the opportunity to shoot at the same level as the owl, providing perfect eye contact with the subject.

BEN HALL

Red Grouse at Dusk

(Red grouse, *Lagopus lagopus*)
Higgor Tor, Peak District, England

I came across this territorial grouse one afternoon when photographing landscapes. I returned the next day just before last light with a wide-angle lens to capture images of this charismatic bird against the beautiful but desolate moorland landscape.

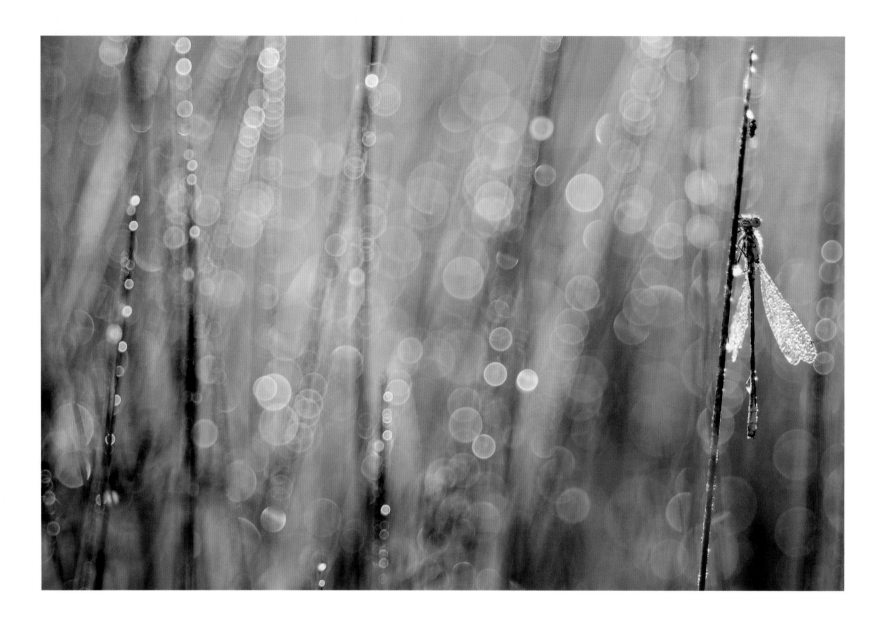

ROBERT CANIS

Dew-spangled Damselfly
(Common blue damselfly, *Enallagma cyathigerum*)
Elmley National Nature Reserve, Kent, England

It was a glorious, still morning which I had spent, prior to sunrise, photographing dragonflies. I had this image in my mind for quite some time and when I came across the situation, while searching among dense scirpus grass, I knew exactly how I wanted to portray it. The steep bank and the threat of stumbling into the deep, watery ditch, however, made the process a little more tricky!

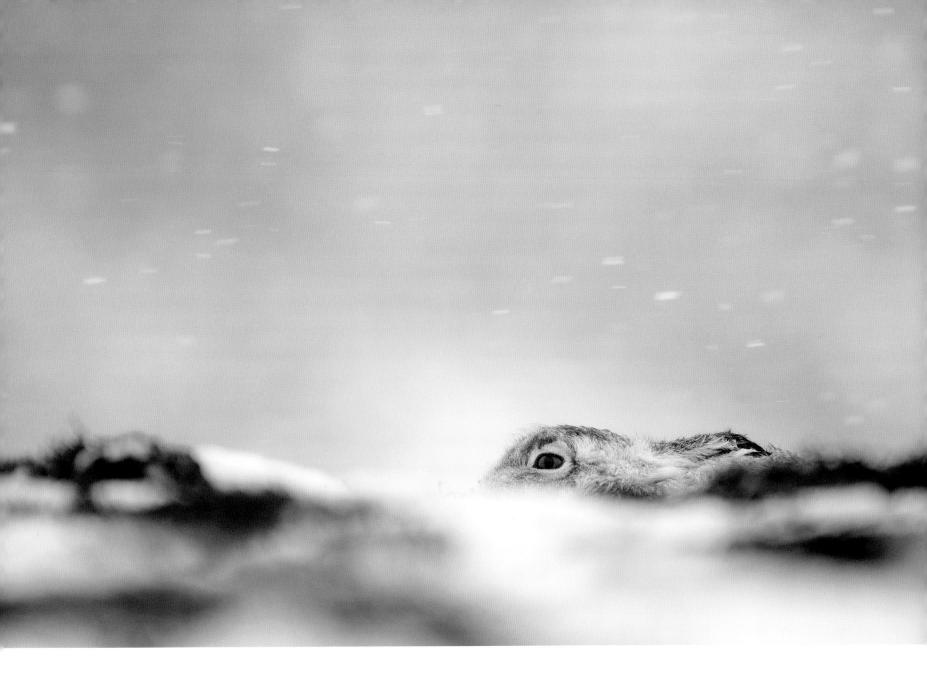

JOHAN SIGGESSON

Laying Low
(Mountain hare, *Lepus timidus*)
Findhorn, Highland, Scotland

Trying to find a white hare in white snow in strong, snowy winds isn't easy. Just as I was about to give up I found some fresh tracks, and after only 20-25 metres I saw the hare laying low, totally confident in its camouflage. Slowly creeping up to it, I tried to capture the behaviour of the animal in this specific habitat.

BOTANICAL BRITAIN

SPONSORED BY
COUNTRYSIDE JOBS SERVICE

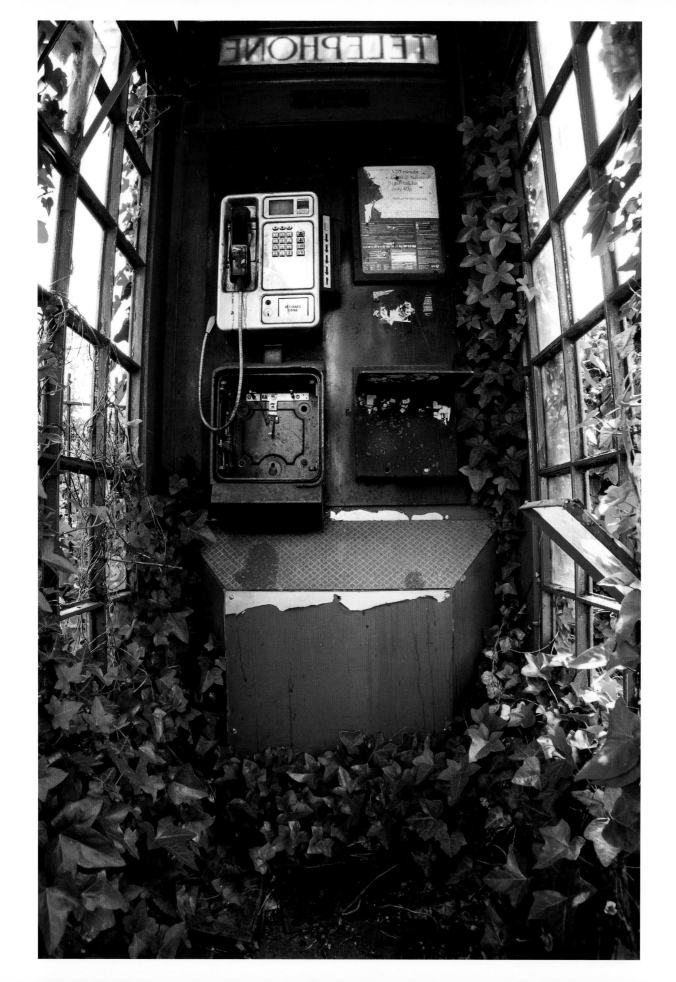

PHILIP BRAUDE <

Green and Red Telephone Box
(English ivy, *Hedra helix*)
South London, England

Ivy creeps through a working telephone box. Some of the glass panes have fallen out, and the ivy has taken advantage of the available space to grow undisturbed. I purposely left the wide-angle lens distortion of the box's straight lines to create a sense of being inside the box, but also of the ivy growing around the viewer.

STUART BROWN > HIGHLY COMMENDED

Branching Out
(Meadow coral, *Clavulinopsis corniculata*)
West Midlands, England

Found on my mother-in-law's lawn, this incredible natural structure was standing proudly above the moss. With my passion for macro photography I felt I had to capture its strange, alien beauty; its shape, colour and texture seemed otherworldly. The Triffids had arrived!

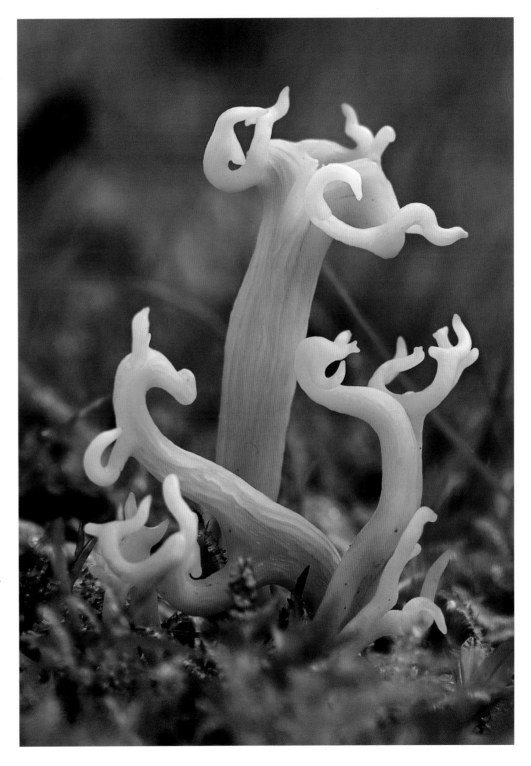

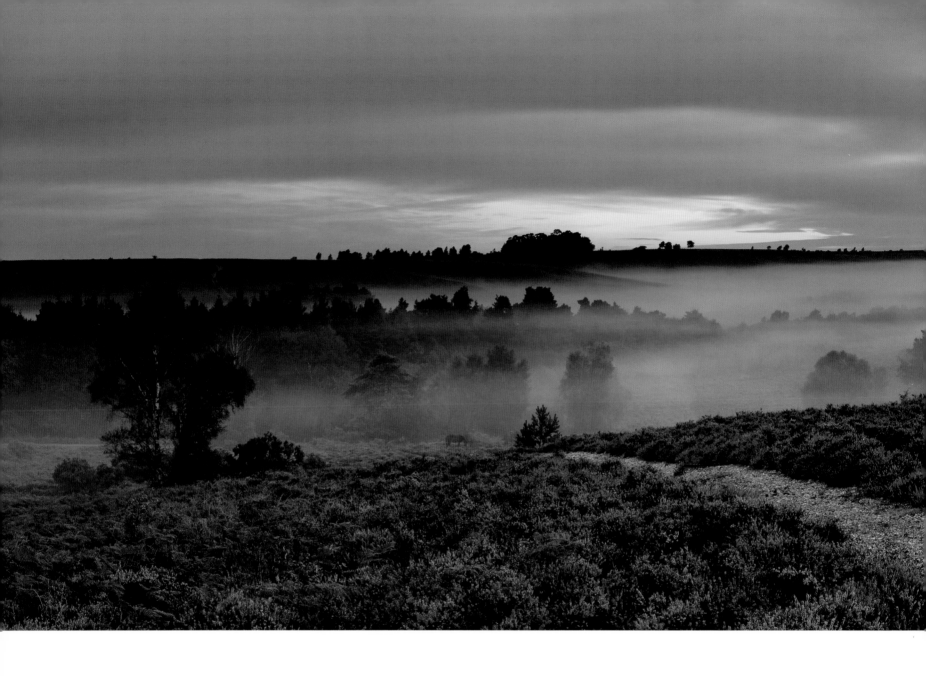

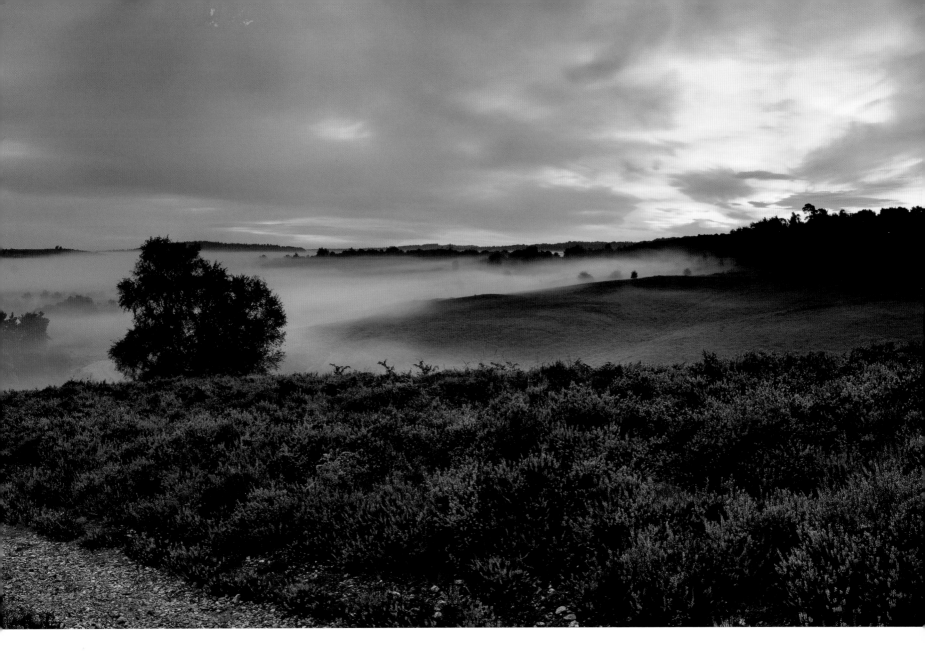

GEOFF KELL HIGHLY COMMENDED

Heather Dawn
(Heather mixture including Ling, *Calluna vulgaris* and Bell heather, *Erica cinerea*)
New Forest National Park, Hampshire, England

The New Forest National Park has some of the largest areas of lowland heath in Europe. It needs the balance of man and grazing animals to maintain this. In summer, it comes alive with the colour purple, formed by various heather species. Before dawn, mist can form in valleys, making a spectacular backdrop for the flowering heath.

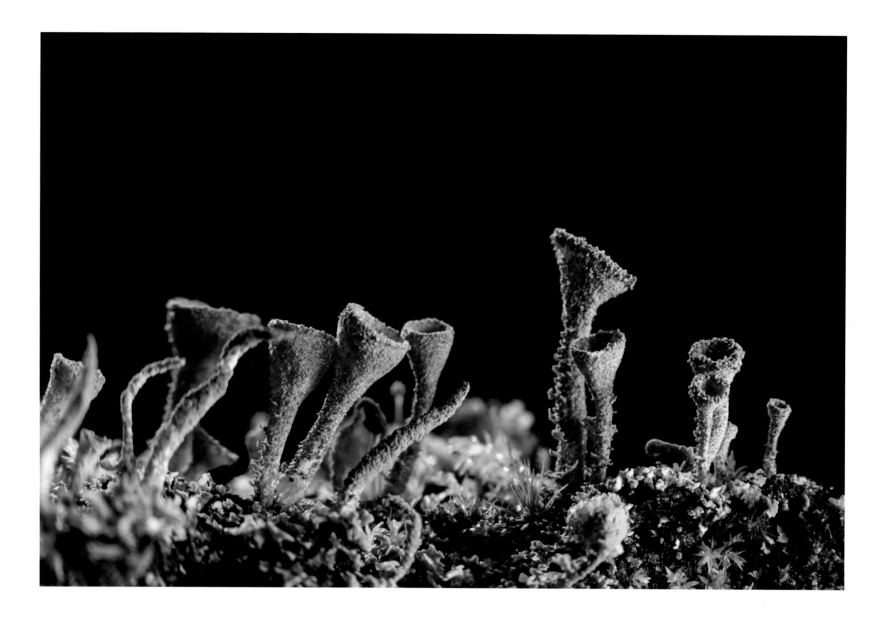

EDWARD MARSHALL HIGHLY COMMENDED

Trumpet Lichens
(Trumpet lichen, *Cladonia fimbriata*)
Shapwick Heath, Somerset, England

In a boggy lowland area in Somerset, a fallen log provided perfect lichen habitat. A broken piece of wood from which they were growing allowed me to position them in order to get low down for the best perspective. The sun provided a natural back-light, my bag the black background and external flash illuminated the front. I love how the combination of light has really brought out the textures of these natural structures.

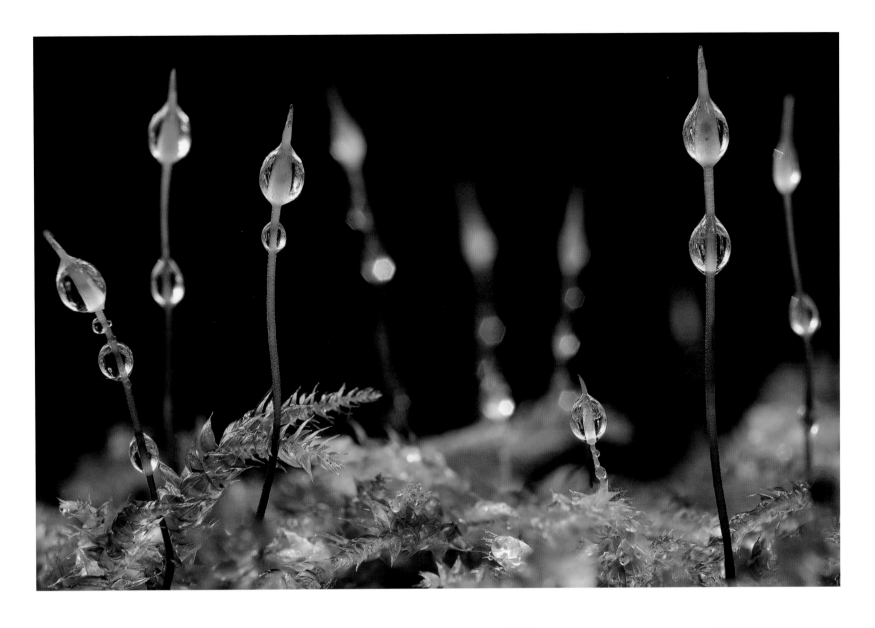

JULIAN PETRIE HIGHLY COMMENDED

The Secret Fairy Garden
(Hypnum moss, *Hypnum cupressiforme*)
Danbury Woods, Essex, England

I originally set out looking for a heavily canopied area to photograph fungi utilising the reverse lens technique, which was new to me. While looking low to the ground I noticed this immature Hypnum moss growing on a fallen tree trunk. The light was perfect after a fine shower and the background suitably dark. I set up and looked through the viewfinder to see a wonderful image of something so commonplace appearing truly beautiful.

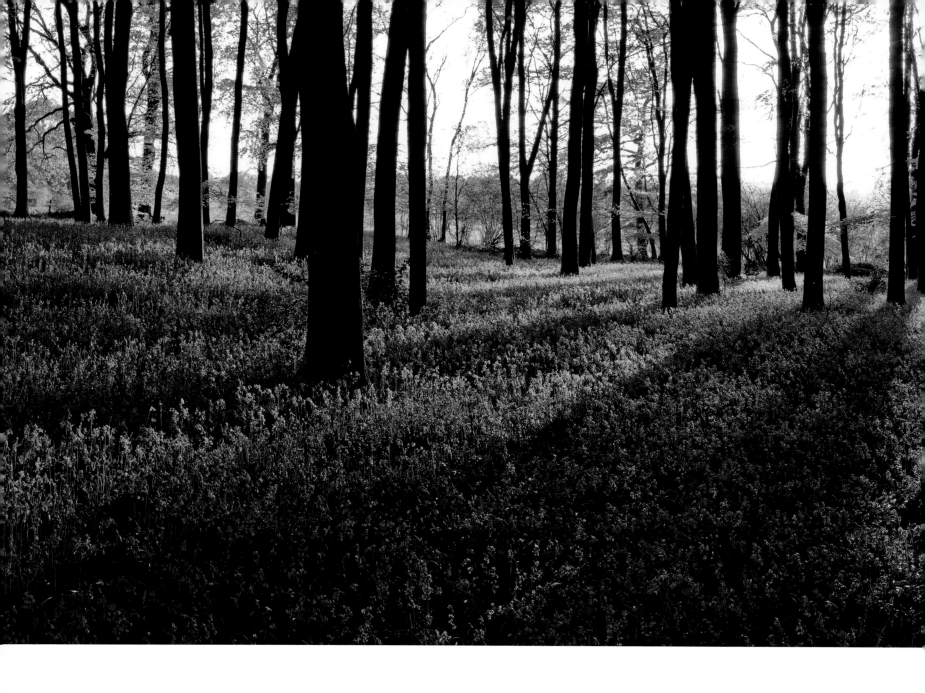

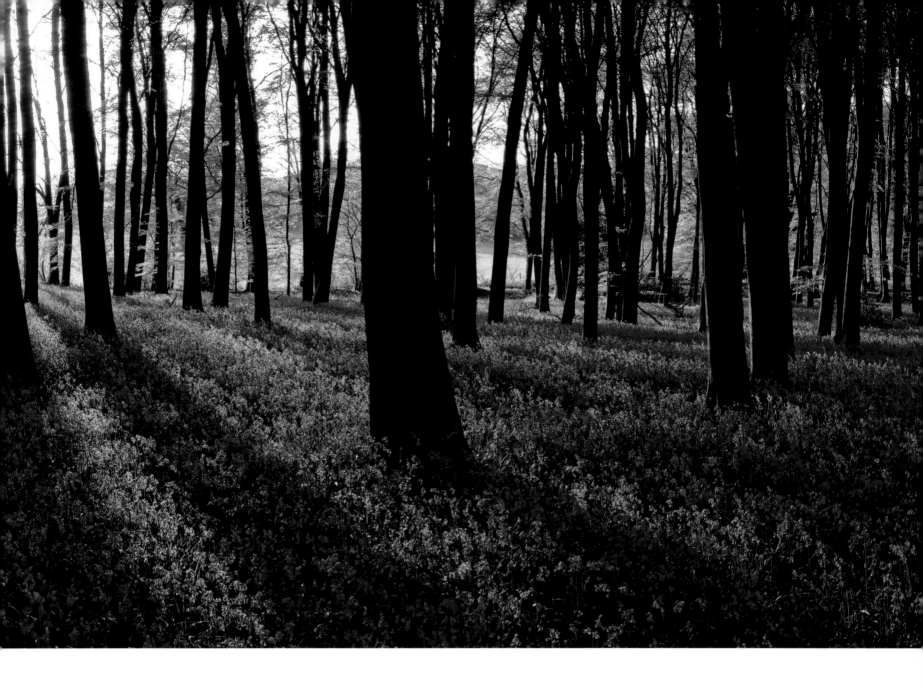

GEOFF KELL HIGHLY COMMENDED

Bluebell Wood, Evening
(Bluebell, *Hyacinthoides non-scripta*)
Micheldever Woods, Hampshire, England

The sight of an English bluebell wood in all its glory is one to behold.
It is estimated that over 25 per cent of common bluebells worldwide
are found in the British Isles, so the preservation of ancient woodland like
this is essential. Being a hyacinth, the smell alone makes it worth visiting.
The evening light and lengthening shadows helped create this panorama.

CLOSE TO
NATURE

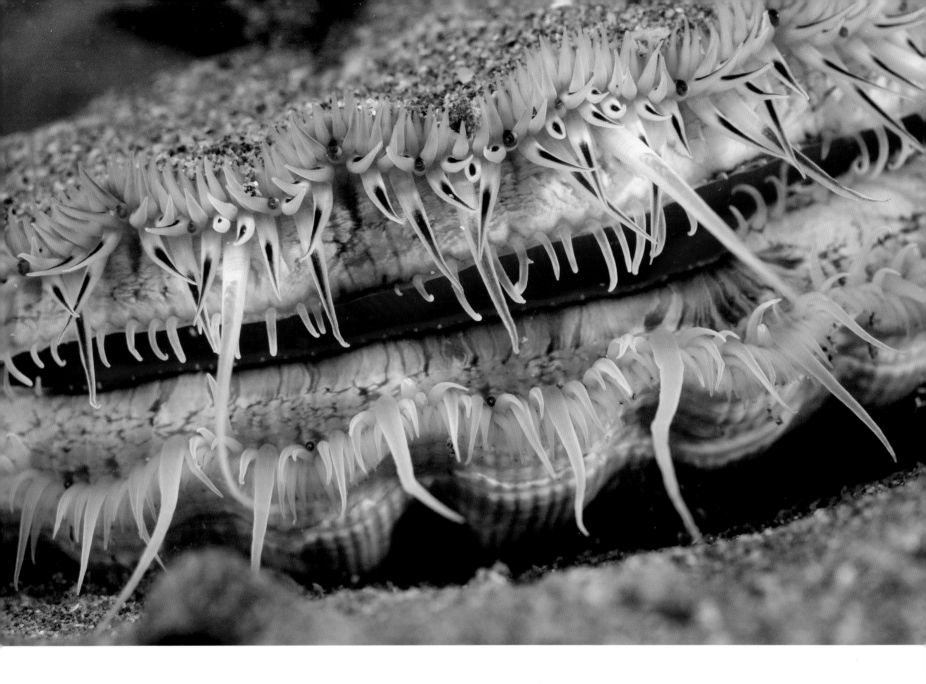

JIM GREENFIELD < HIGHLY COMMENDED

SUE DALY Λ HIGHLY COMMENDED

Grey Seal Claws
(Grey seal, *Halichoerus grypus*)
Public viewing area at Donna Nook, Lincolnshire, England

I was attracted by the lines, markings and surprisingly blue claws on this part-weaned pup. It was snoozing very close to the fence behind which I and hundreds of other visitors were herded. It was lying partly on its side affording a nice square-on view. I had to wait for a moment until I wasn't being jostled and got a handheld shot.

Scallop Eyes
(Scallop, *Pecten maximus*)
Sark, Channel Islands

Scallops live nestled in the seabed beneath a layer of shingle. Their camouflage is perfect until the tide gathers speed and they open to feed on the plankton. Tiny round blue light sensors above and below the beautifully patterned mantle detect movement, causing the scallop to flee or clam shut, but by moving very slowly I was able to capture intricate details of an animal that we're more familiar with on our plates.

DAVID PRESSLAND HIGHLY COMMENDED

Goldwing
(Goldfinch, *Carduelis carduelis*)
Sowerby, North Yorkshire, England

It's a sad fact that the majority of garden birds born each year don't survive long enough to breed. I awoke to find the body of a young goldfinch on my patio without a mark on it and with no indication of how it had died. This gave me an opportunity to explore the incredible colour, detail and intricate structure of one of nature's supreme achievements – a bird's wing.

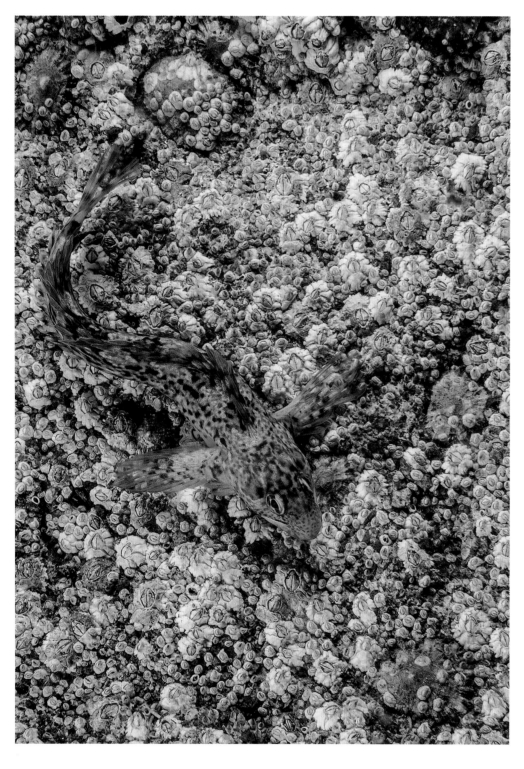

Camouflaged
(Shanny, *Lipophrys pholis*)
Trefor Pier, Gwynedd, North Wales

This common and widespread little fish is often
found out in the open on barnacle-covered rocks,
or in this case, the encrusted walls of Trefor Pier. Its
mottled markings and colouration provides excellent
camouflage. The vertical and horizontal swell close to
the pier proved a challenge when taking this photo!

TREVOR REES > HIGHLY COMMENDED

A Jewel of an Anemone
(Jewel anemone, *Cornactis viridis*)
Plymouth, Devon, England

This particular anemone was photographed growing on
the side of a shipwreck in Whitsand Bay near Plymouth.
Jewel anemones appear in a number of colour varieties
but the purple ones often have the strongest colour.
For many divers they are one of the prettiest anemones
in British seas. At around 2cm across, good macro
technique is a challenge underwater while wearing a
face mask and a bulky diving suit.

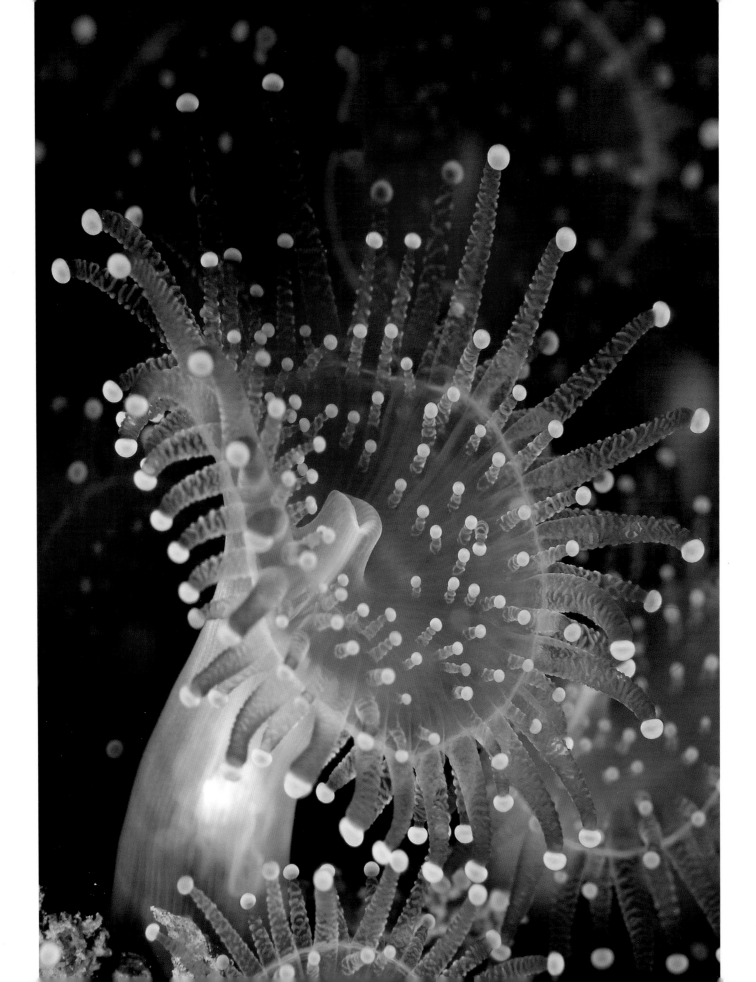

BRITISH NATURE
IN BLACK
AND WHITE

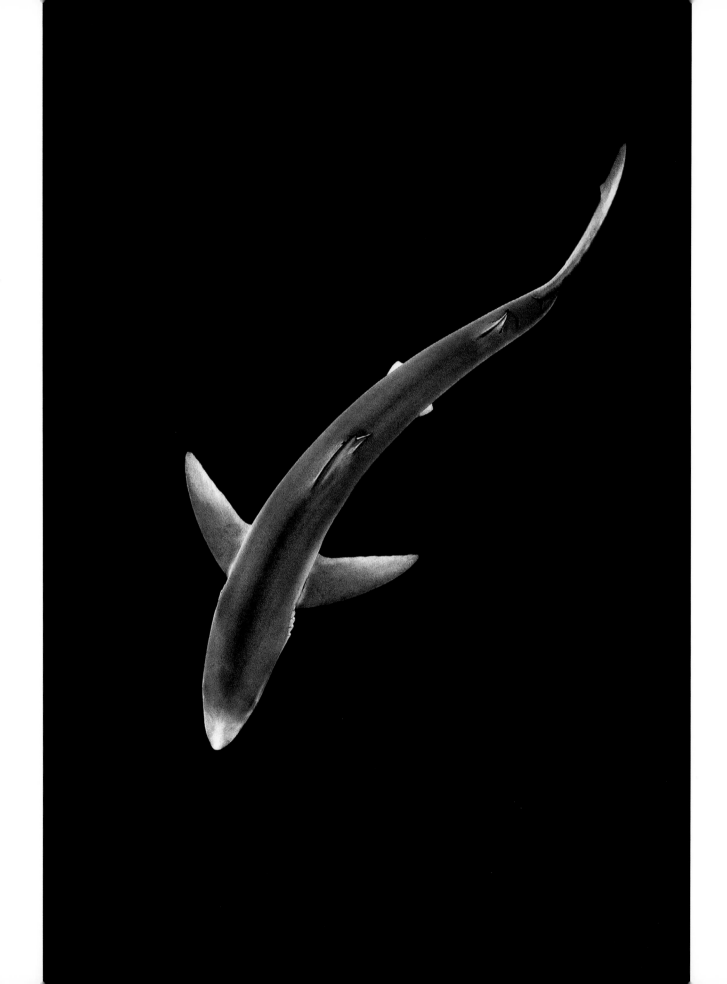

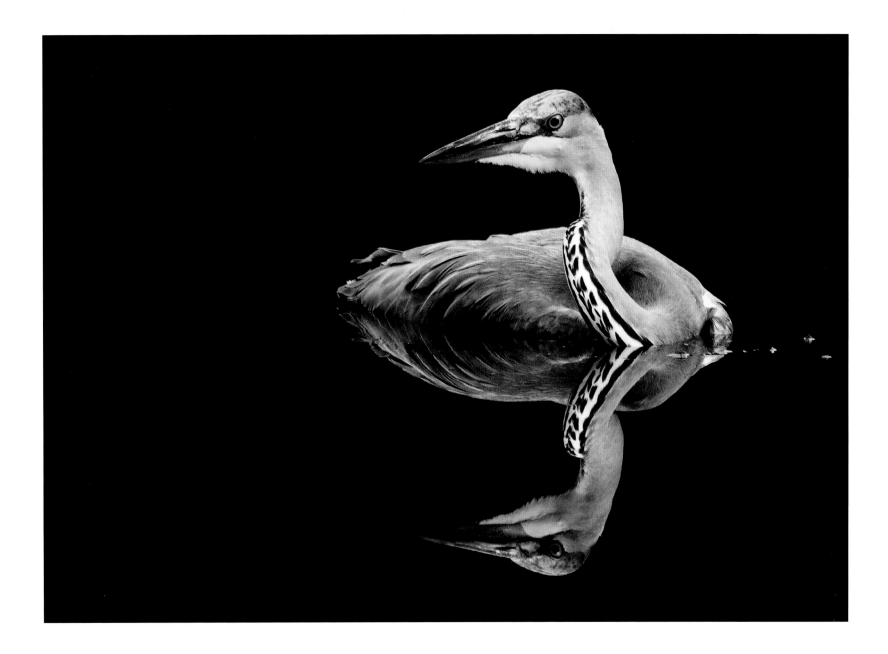

BRITISH NATURE IN BLACK AND WHITE WINNER

ALEXANDER MUSTARD <

Blue on Black
(Blue shark, *Prionace glauca*)
Penzance, Cornwall, England

I wanted to capture the elegant, sinuous shape of this blue shark as it cruised effortlessly through the ocean. The blue sharks of the north Atlantic are one population and regularly cross the ocean between the USA and Europe. This angle shows the efficiency of their streamlined bodies for travelling such distances through water.

JAN GALKO ⋀ HIGHLY COMMENDED

Grey Heron
(Grey heron, *Ardea cinerea*)
Anton Lakes, Hampshire, England

I saw this picture even before I had taken the shot. There was an unusually calm 'mirror' effect and the heron walked without disturbing it. I literally hypnotised it to make it bend its neck into the correct angle. The heron did it, then the next minute it caught an enormous fish.

ALAN PRICE HIGHLY COMMENDED

Little Wool Robbers
(Jackdaw, *Corvus monedula*)
Caernarfon, Gwynedd, Wales

Living in Snowdonia, I am surrounded by wonderful wildlife and plenty of sheep. Each spring the jackdaws, nesting in local chimney pots, look for new nesting material and with so many sheep around they naturally choose wool. Luckily the jackdaws in my neighbourhood use fields that surround my property and boldly approach sheep that are lying down resting. The sheep don't seem to mind and tolerate the birds who go about their business of removing loose wool from the sheeps' coats. This comical routine lasts for several visits and I had plenty of time to set up my gear and wait for the right moment.

ANDREW KAPLAN HIGHLY COMMENDED

Swan in Morning Mist
(Mute swan, *Cygnus olor*)
Loddon Nature Reserve, Twyford, Berkshire, England

I prefer to photograph swans in the morning because of the atmospheric
mist you get after a cool, still night. The other reason is that the usual drying
of wings, after a good morning wash, makes for a great photo.

KAY REEVE HIGHLY COMMENDED

Lines in Nature
(Blood vein moth, *Timandra comae*)
Leamington Hastings, Warwickshire, England

A specimen from my garden moth trap. I enjoyed the pattern of lines
made by the moth on the leaf and converted to monochrome to give the
appearance of night-time, when the moth is active.

NIC DAVIES HIGHLY COMMENDED

Shelf Life
(Robin, *Erithacus rubecula*)
Palmers Green, London, England

Robins built a nest in my shed. I wanted to shoot the well-hidden nest surrounded by all the old equipment and tools without disturbing the birds. The interior was cramped and poorly lit. I placed a small light on a clamp, and used a very high ISO to increase the shutter speed. I cautiously opened the door and took my shots after the adults had left to find food.

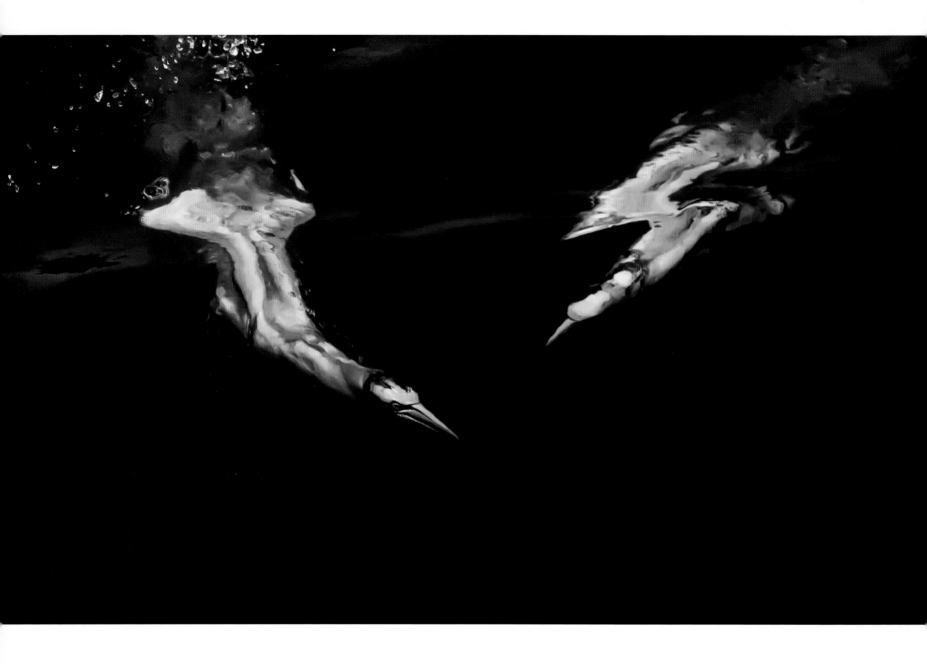

NEIL MacGREGOR HIGHLY COMMENDED

Into the Deep
(Northern gannet, *Morus bassanus*)
Bass Rock, East Lothian, Scotland

Taken on a particularly dreich and misty morning as we approached
the rock. Gannets and gulls were wheeling and diving around the boat,
scrapping for fish. Two gannets were after the same tasty morsel and dived
close to the side of the boat. With a wide-angle lens I managed to capture
the contest as they plunged below the dark water.

ANDREW PARKINSON HIGHLY COMMENDED

Sky Pointing
(Northern gannet, *Morus bassanus*)
Hermaness NNR, Shetland Isles, Scotland

To capture this image I had to descend a 90m cliff and then undergo a treacherous descent along the base of the cliffs to a tidal boulder field. From there it was just a short climb up to the gantry where I could photograph the gannets against a stunning black backdrop of cliffs in shadow.

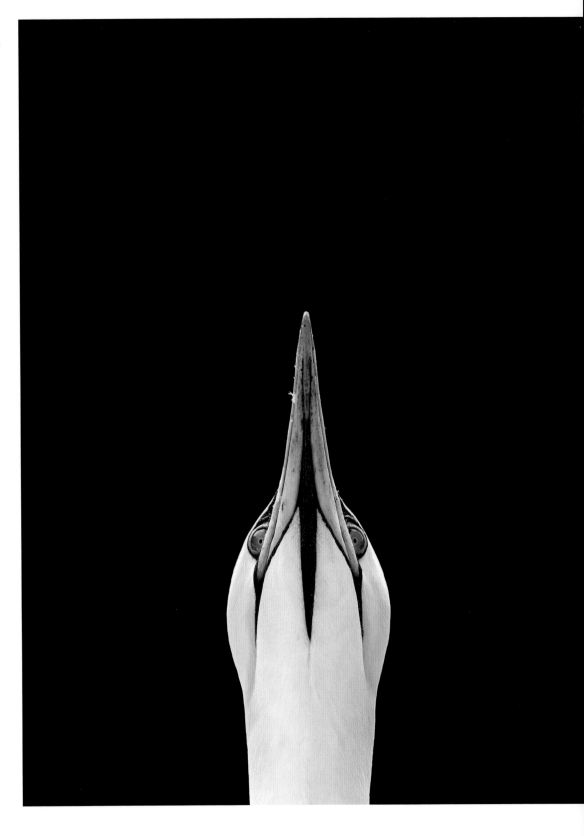

BRITISH
SEASONS

SPONSORED BY PÁRAMO

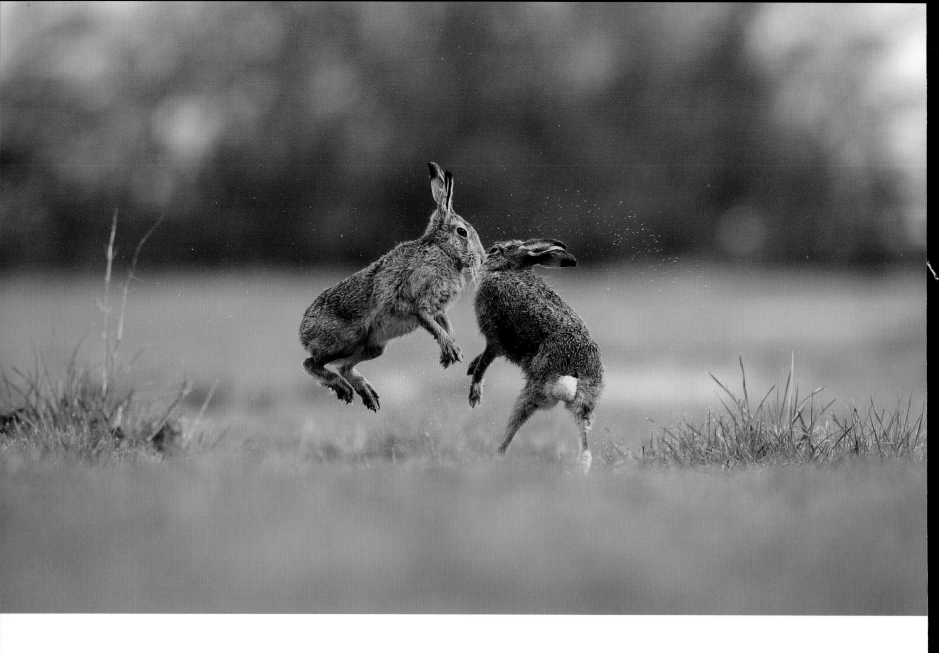

ANDREW PARKINSON

Spring is in the Hare
(Brown hare, *Lepus europaeus*)
Derbyshire, England

Hares have long been a favourite species of mine to work with and catching them boxing is about as challenging a photographic endeavour as there is. On this occasion I had crawled into position several hours before and it was only good fortune that the hares decided to box right in front of me.

Summer Newborn

From a distance I watched through binoculars as the mother gave birth to this single leveret while the male sat dutifully close by. It was a truly remarkable thing to witness and so I stayed hidden in a hedgerow about 100 metres away. After a few hours the parents moved off and I was able to approach the leveret, take a couple of images from downwind and then leave it to its new surroundings.

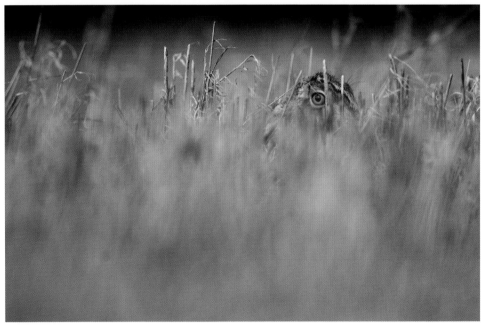

Aware Hare in Autumn

I had seen this hare concealed in a field of crop stubble and spent several hours crawling towards it. The hare was aware of my presence but by approaching slowly and respectfully I made sure that it was content to sit, but keep a close eye on, the strange clicking creature that was sharing its field.

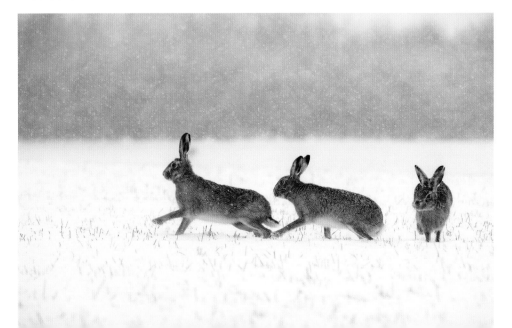

Winter Pursuit

I had been watching the hares in this field for quite a while when the female suddenly got up and started running straight towards me, hotly pursued by two eager males. As they got closer they paused and I was able to capture this image of them in the falling snow.

JAMES YAXLEY
HIGHLY COMMENDED

Silver-studded Blue on Purple Bell Heather

(Silver-studded blue, *Plebejus argus*)
Buxton Heath, Norfolk, England

A silver-studded blue butterfly rests on purple bell heather covered in dew drops. During the summer months the heath is covered with pink and purple heather but the colours of summer are not always rich. In this image the sun is very low and the scene is still in shade, ensuring that the colours are nicely saturated. A clump of pink bell heather provided a diffuse and muted background of rhubarb and custard.

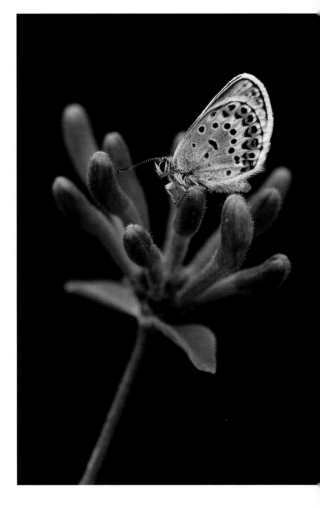

**Summertime Blues –
Chalk-hill Blue at Sunrise**
(Chalk-hill blue, *Polyommatus coridon*)
Warham, North Norfolk, England

A chalk-hill blue butterfly warms up on
a head of grass. I positioned myself to
maximise the rim lighting that illuminates
the feathery edges of its wings and the
fine hairs on the butterfly's body. The rich
light of sunrise makes the grass look like a
ripened head of wheat and has transformed
the stalk into a square rod of antique gold.
This contrasts with the cold colours of its
underexposed wings.

**Summertime Blues –
Chalk-hill Blue at Dawn**
(Chalk-hill blue, *Polyommatus coridon*)
Warham, North Norfolk, England

A chalk-hill blue butterfly, cold and sleepy,
rests on a cornflower head. It is backlit against
a deep orange sky synonymous with the
warmth of summer. I positioned myself to
capture the silhouette, reducing the image to
its basic elements to highlight the relationship
between the butterfly, the flower and the sun.

**Silver-studded Blue on
Wild Honeysuckle**
(Silver-studded blue, *Plebejus argus*)
Buxton Heath, Norfolk, England

A silver-studded blue butterfly rests on
wild honeysuckle buds. The butterfly and
honeysuckle are illuminated by the early
morning light and set against the deep
shadows of a wood where the sun had not
yet penetrated. I exposed for the highlights,
to underexpose the background and show
off the beauty of this delicate blue butterfly
and fragrant summer flower.

DOCUMENTARY
SERIES

NICK UPTON

Hazel Dormouse Monitoring
(Hazel dormouse, *Muscardinus avellanarius*)
Backwell, Somerset, England

Hazel dormouse numbers have diminished in the UK over the last 100 years due to woodland loss and the decline of coppicing. Backwell Environmental Trust is one of many conservation groups helping this engaging creature to recover, coppicing woodland to create ideal, more open habitat, and setting out nestboxes to offer extra homes. Licensed inspectors monitor the nestboxes to count, sex and weigh the dormice.

1. Gill Brown inspects one of 50 nestboxes set out for hazel dormice in a coppiced wood in Somerset, gently lifting the lid just far enough to see if a nest has been built inside.

2. Even when a nest is visible, it often proves to be an old one, or to belong to woodmice. Fresh leaves, a tight weave and, better still, a glimpse of a dormouse curled up inside are what the team really hope for.

3. If a nest is found, a soft cloth is used to block the entrance hole (which faces the trunk of the support tree) before the nestbox is detached. Here, Gill holds open a plastic sack for Ian Chambers to lower the nestbox into, before they open the box fully to have a closer look inside.

4. These two young dormice jumped out of the nestbox into the plastic sack as Gill and Ian inspected the nest. They were held here briefly before being taken out by hand for close inspection, then retuned to their nestbox for re-attachment to the same tree.

5. A dormouse is weighed in a plastic bag suspended from a spring balance. In this autumn survey, 14 dormice were found. There was a mix of heavy adults, well fattened to around 35 grams for the winter ahead, and lighter, still growing youngsters.

6. Dormice deserve their sleepy reputation, and are often found hibernating in a torpid state. They can be sexed, weighed and returned to their nests without ever waking up. This dormouse had survived a long winter, but its weight had fallen to a mere 18 grams. However, weights and population numbers soon recovered in this well-managed wood.

1.

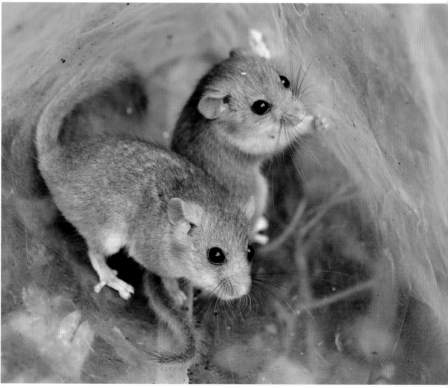

4.

3.

6.

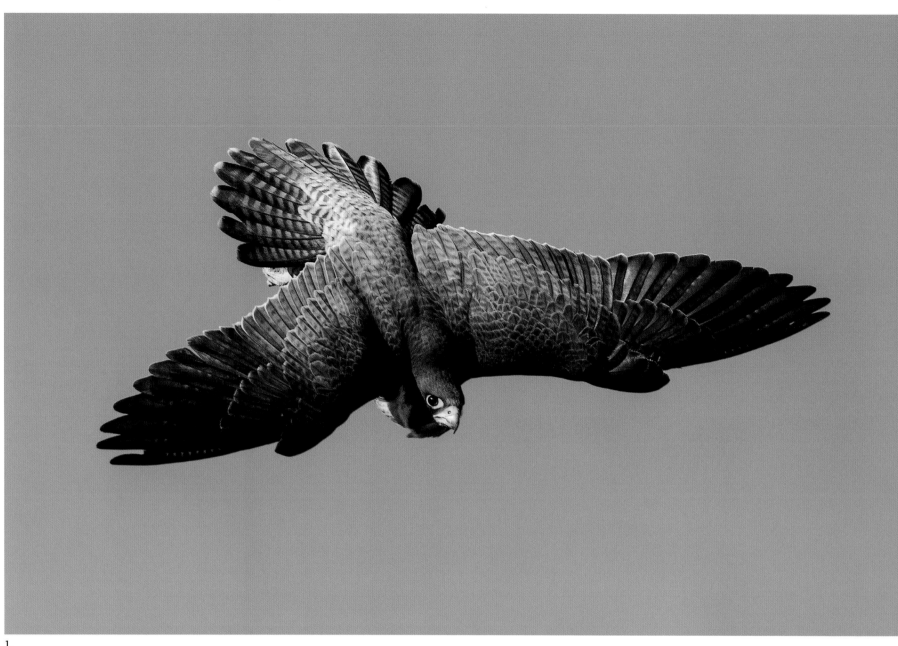

1.

4.

5.

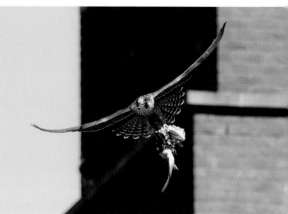

6.

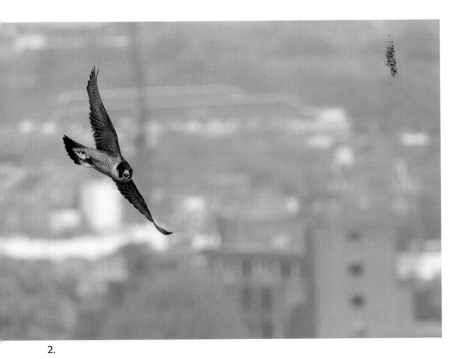

2.

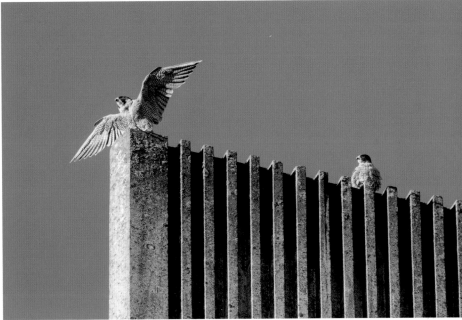

3.

SAM HOBSON HIGHLY COMMENDED

The Urban Peregrine
(Peregrine falcon, *Falco peregrinus*)
London, Bristol and Somerset, England

The rise of the urban peregrine is one of the UK's greatest wildlife success stories. They have found a home in the city, where tall buildings replace crag and cliff and they are relatively sheltered from persecution, with many more eyes to monitor and protect them than their rural counterparts.

1. Aerial Acrobatics
In urban settings we can often get much closer views of natural behaviour than we would ever expect to experience in the countryside. In early spring, this male (tiercel) peregrine falcon starts his year by showing off to the female (falcon), hoping to impress her with flight display and gifts of food. Here, he is banking just before stooping towards a jackdaw.

2. Penthouse Peregrine
These wild falcons will inhabit even the most urban of locations. This female's territory is in the heart of London, where feral pigeons are a year-round food source, and the city's residents have provided her with a sheltered high-rise nestbox where she can safely rear her young.

3. Peregrine Partnership
Once a pair have bonded, they will hold territory together all year round, choosing the tallest buildings from which to look out for intruders and prey.

In winter they use city lights to hunt nocturnal migrants, flying over the city under the cover of darkness, and when spring arrives they are fit and healthy in preparation for the nesting season.

4. Colour Ringing
Many urban peregrines are ringed with alpha-numeric colour rings, which can be read from a distance. This project is providing valuable scientific data about the health of the urban peregrine population, including their dispersal and breeding habits. Coordination of the project is on the increase and many areas now have their own coloured rings.

5. Nestlings
Urban and suburban peregrine eyries are often more accessible to ornithologists as nestboxes on buildings can easily be reached. When the ringer cannot get access, a climber will lower the nestlings to the ground where the leg rings are attached and measurements and other data can quickly be recorded. A usual brood size is three or four, and the whole process takes around 15-20 minutes before they are hoisted up and placed back inside the nest.

6. First Success
With tail feathers spread for extra lift, this fledgling takes its first successful flight while carrying the remains of a feral pigeon. A healthy breeding population of urban peregrines could boost future rural populations and perhaps bring about a change in the perception of these magnificent aerial hunters, reinstating them as master of the UK's rural and urban skies.

WILDLIFE
IN HD VIDEO

SPONSORED BY SKY+HD

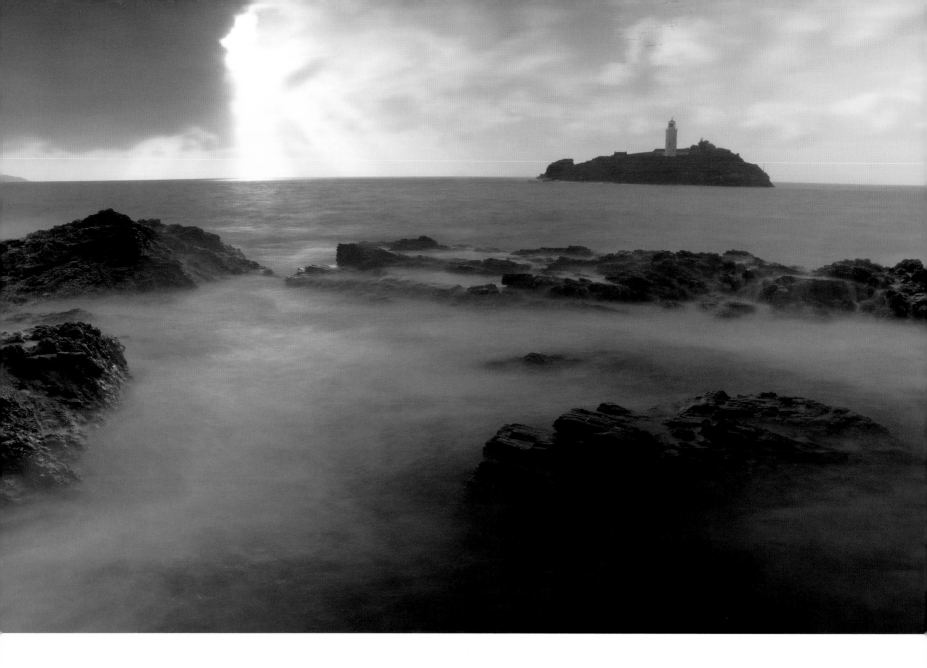

WILDLIFE IN HD VIDEO WINNER

REBECCA PAYNE

Godrevy Lighthouse
(Beadlet anenome, *Actinia equina;*
Atlantic ditch shrimp, *Palaemonetes varians*)
Godrevy, Cornwall, England

This beautiful and dramatic landscape created the perfect setting for my
video story. The wild and windy shores of Godrevy provided a contrast to
the intimate worlds inside the rockpools.

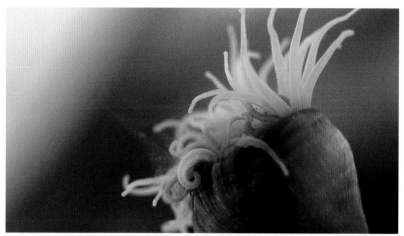

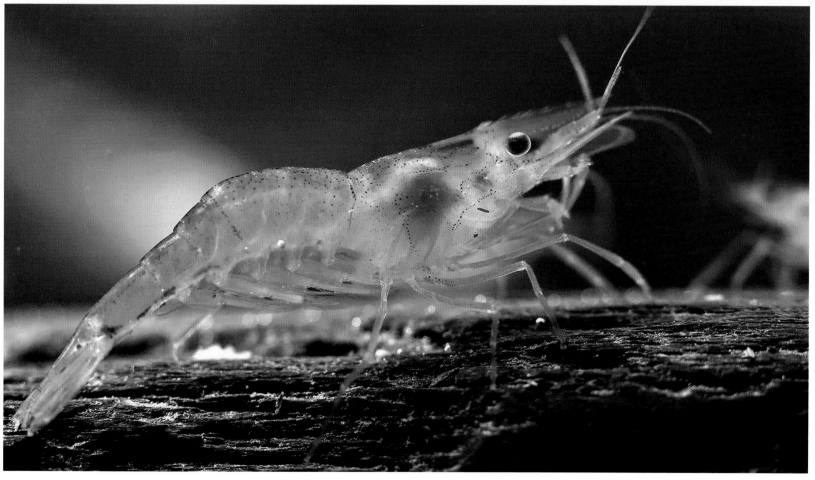

OUTDOOR
PHOTOGRAPHY
EDITOR'S
CHOICE

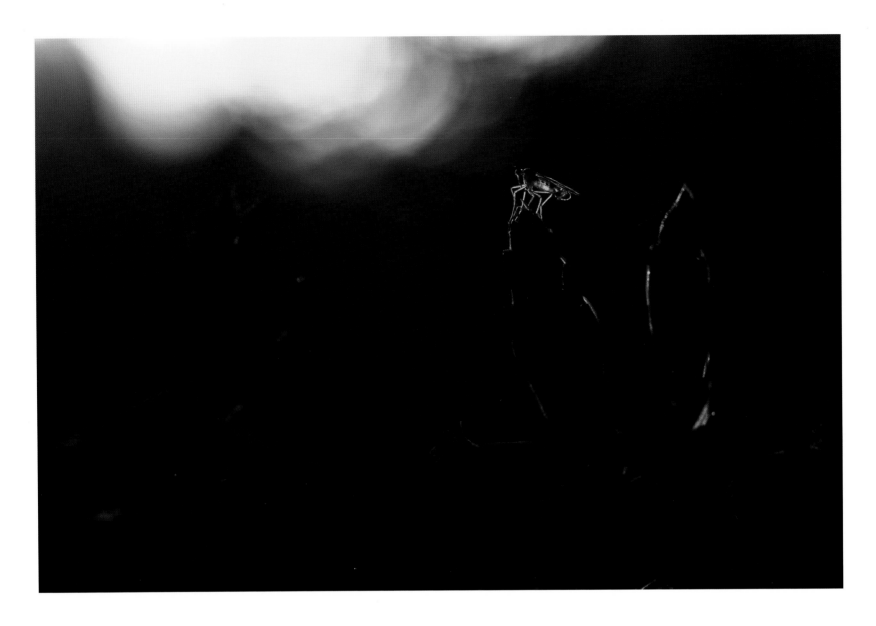

OUTDOOR PHOTOGRAPHY EDITOR'S CHOICE: FEBRUARY

DANIEL TRIM

Fly on a Bluebell
(Dance fly, *Empididae sp.*)
Potton Wood, Bedfordshire, England

It was a little early in the season for the full bluebell display but during a recce visit to a local wood I noticed this small fly resting at the top of a bluebell. I avoided the temptation to get as close as possible, which enabled me to include the second plant in the background and add more warmth from the setting sun. Shooting towards the sun highlighted the fly against the darker plants and background.

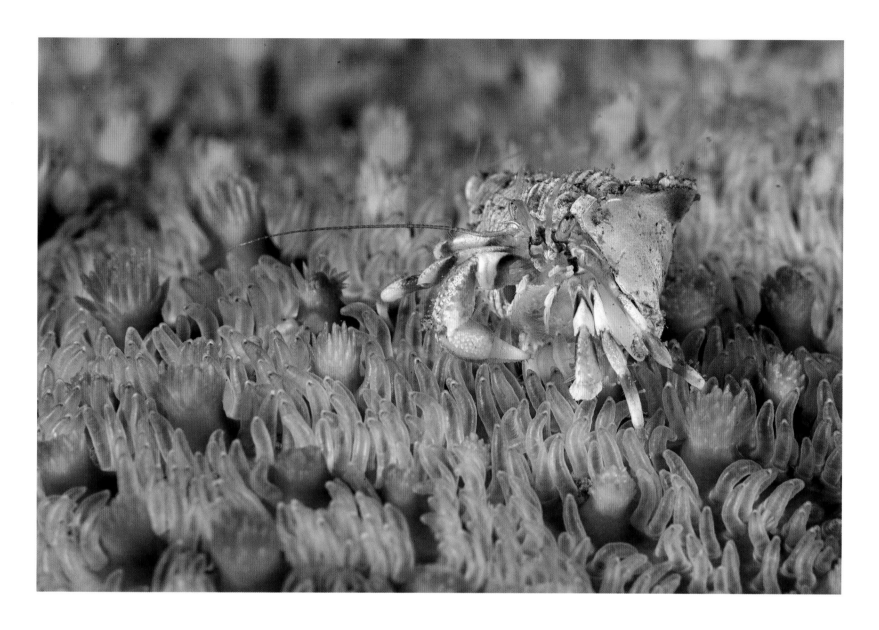

OUTDOOR PHOTOGRAPHY EDITOR'S CHOICE: MARCH

JIM GREENFIELD

Hermit Crab on Common Sunstar

(Hermit crab, *Pagurus bernhardus*; Common sunstar, *Crossaster papposus*)
The Craig, St Abbs Marine Reserve, Berwickshire, Scotland

The colour and detail of the starfish is what first caught my eye but then I saw some sunstars with these tiny crabs apparently hitching a ride. Closer observation showed them to be busily foraging in the crevices of the sunstar. They are difficult to get near and rapidly jump off onto the rock below when 'threatened' with a big camera. I had to work further away than I really wished and rely on modest cropping to get the shot I wanted.

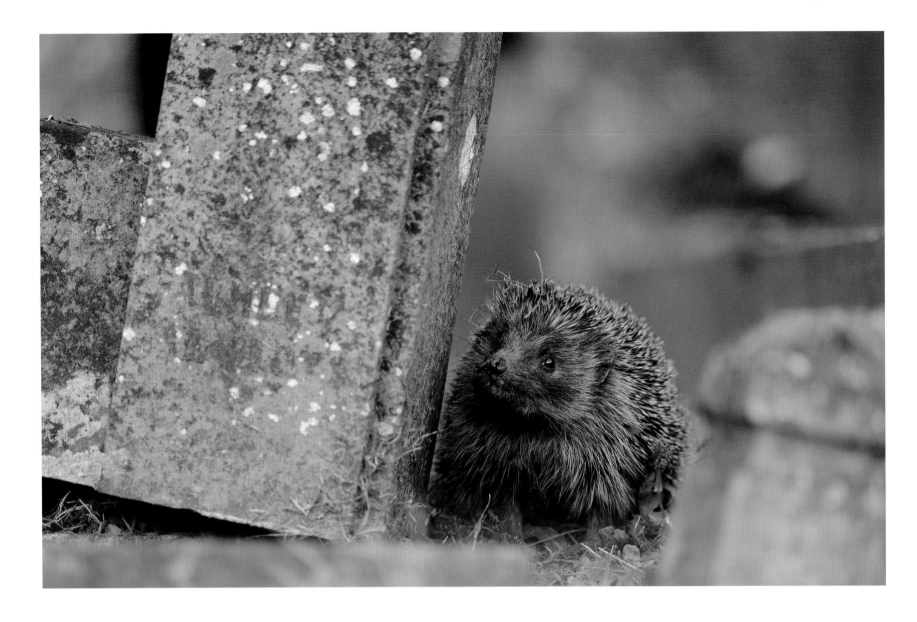

BEN ANDREW

Church Hedgehog
(European hedgehog, *Erinaceus europaeus*)
Tempsford, Bedfordshire, England

Working with a wildlife rescuer I was granted the opportunity to take some photographs of hedgehogs in their release sites, one of which was a church graveyard; a perfect habitat for them with plenty of insect food and little or no human presence.

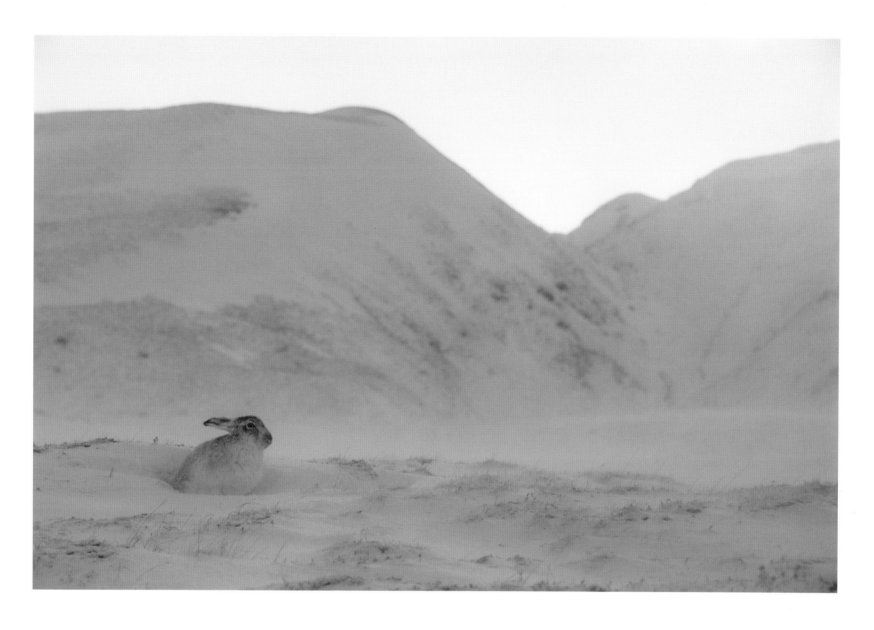

OUTDOOR PHOTOGRAPHY EDITOR'S CHOICE: MAY

MARK HAMBLIN

Mountain Hare in Winter Habitat
(Mountain hare, *Lepus timidus*)
Cairngorms National Park, Inverness-shire, Scotland

I had been photographing this individual over a period of several weeks and it had become quite accustomed to my presence, so much so that I was able to approach it slowly to within a few metres. This opened up other photographic possibilities. The wind was howling, causing spindrift to blow across the hare. By using a shorter lens I was able to capture the spindrift as well as the mountain backdrop to picture the hare as part of its hostile winter environment.

YOUNG PEOPLE'S AWARDS

SPONSORED BY
RSPB WILDLIFE EXPLORERS

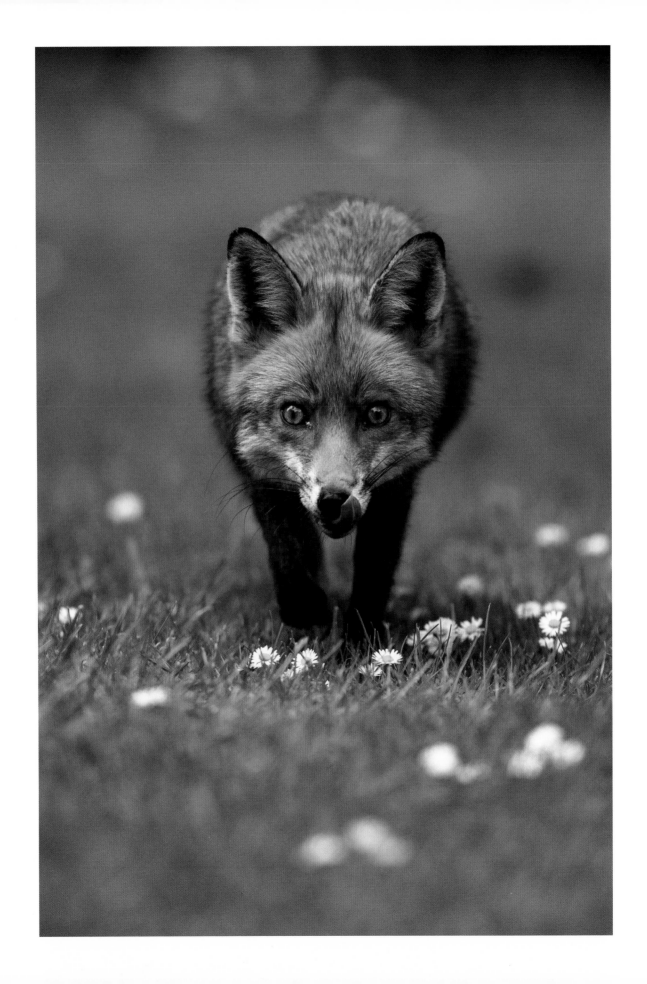

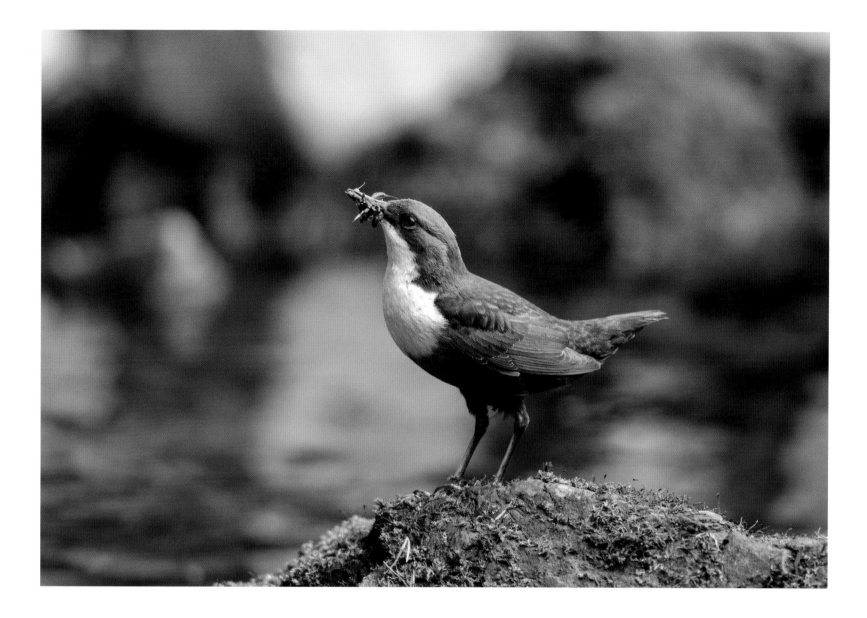

WINNER OF THE 12–18 YEARS CATEGORY

JOSHUA BURCH (AGE 16) <

On the Prowl
(Red fox, *Vulpes vulpes*)
Carshalton Beeches, Greater London, England

For the past month or two I have been working with a vixen that visits our garden most nights in search of food and on occasion just to chill out and take a nap. Through patience I've got to know her character, gaining her trust to the point of her being almost within touching distance of my lens. Occasionally her partner, a one-eyed dog fox, visits, though he is much more cautious. The goal of my project has been to capture the essence of our suburban foxes and present them as the beautiful animals they are and as a contrast to their reputation as a villain and troublesome pest.

WINNER OF THE UNDER-12 CATEGORY

WILLIAM BOWCUTT (AGE 11) ∧

Dipper with Grubs
(Dipper, *Cinclus cinclus*)
Dumfries & Galloway, Scotland

I got up early in the morning during the Easter holidays and had a very special day, sitting on the edge of a fast-flowing stream watching the dippers feeding their chicks. My feet were getting a bit cold by the end, but I didn't mind. There were lots of pictures I liked from the morning, but this was my favourite as the dipper is looking up with a mouthful of yummy bugs. I chose this for the competition because it was one of the clearest pictures from over 400 I took in the morning. Also, I knew I was lucky to have seen the dippers and taken photographs, as they are rare birds.

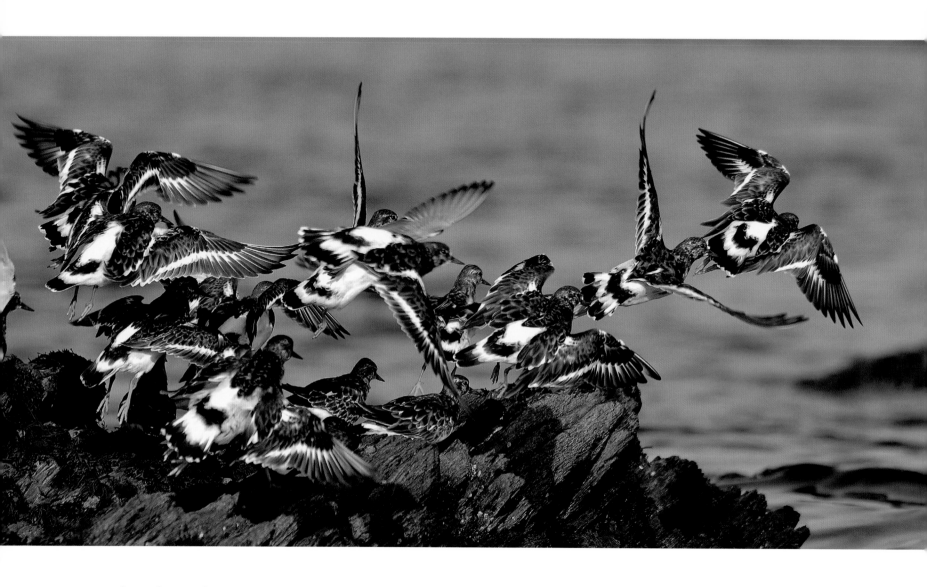

JAMES O'NEIL (AGE 18) HIGHLY COMMENDED

Flock of Turnstones
(Turnstone, *Arenaria interpres*)
Shore of Lough Foyle, Northern Ireland

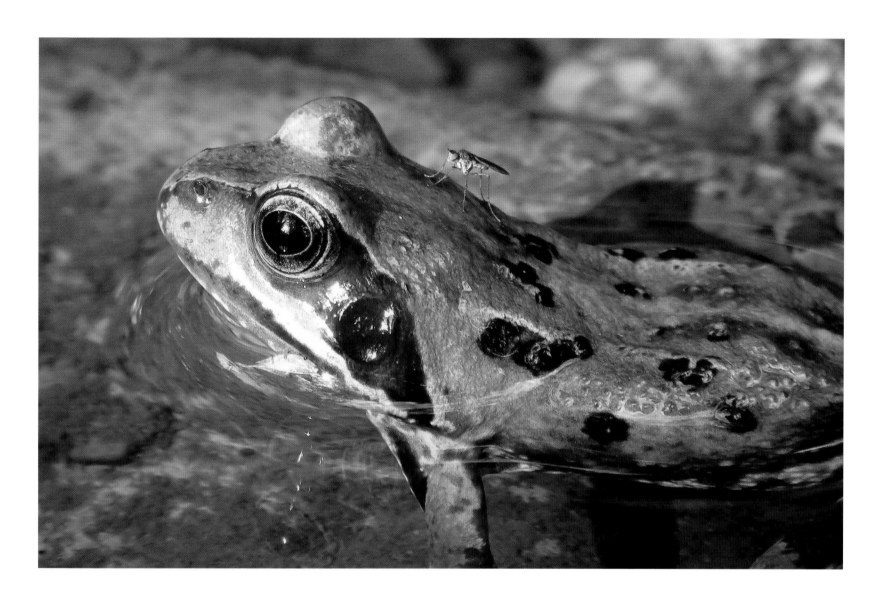

JACK PETTIT (AGE 8) HIGHLY COMMENDED

Long-legged Fly on Frog
(Long-legged fly, *Dolichopodidae*; Common frog, *Rana temporaria*)
Purley, Surrey, England

OWEN HEARN (AGE 15) HIGHLY COMMENDED

Chinese Water Deer Running through Frosty Farmland
(Chinese water deer, *Hydropotes inermis*)
Buckinghamshire, England

IMOGEN HAYDEN (AGE 11)　　　　　　　　　HIGHLY COMMENDED

Coming In
(White-tailed sea eagle, *Haliaeetus albicilla*)
Isle of Skye, Scotland

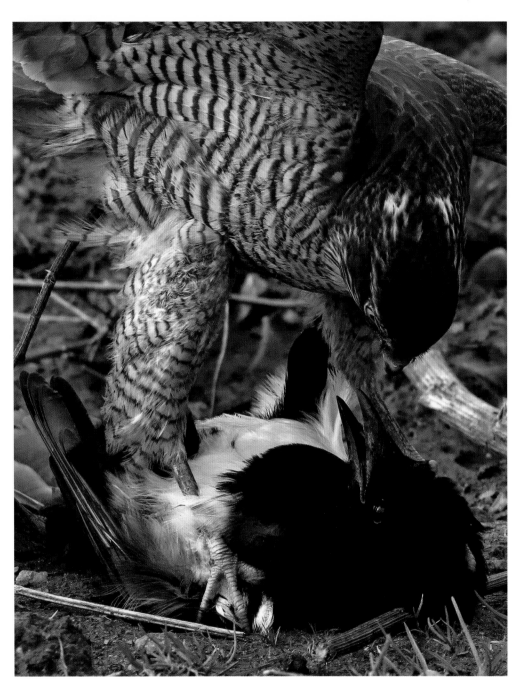

BEN PORTER (AGE 17)
HIGHLY COMMENDED

Death Stare
(Sparrowhawk, *Accipiter nisus*; Magpie, *Pica pica*)
Bardsey Island, Aberdaron, Gwynedd, Wales

TIM BRAMALL (AGE 15)

Grey Heron Landing
(Grey heron, *Ardea cinerea*)
Aviemore, Scotland

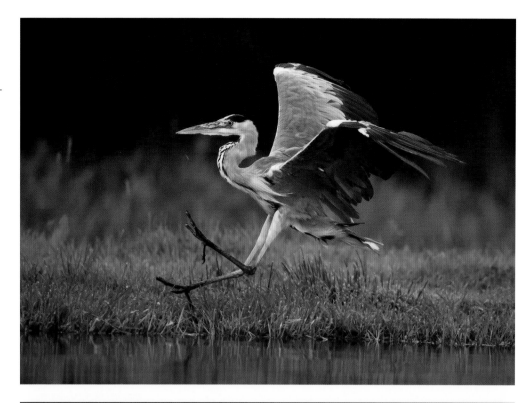

TIM BRAMALL (AGE 15)

Kingfisher Catching the Breeze
(Kingfisher, *Alcedo atthis*)
Near Droitwich, Worcestershire, England

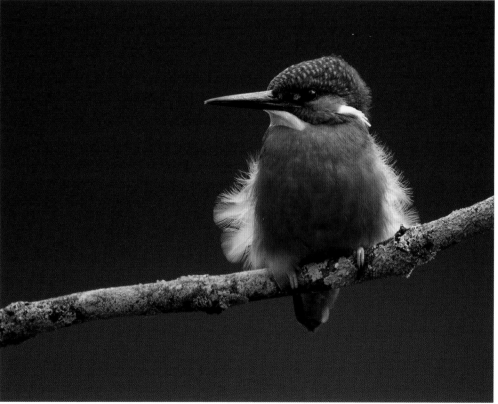

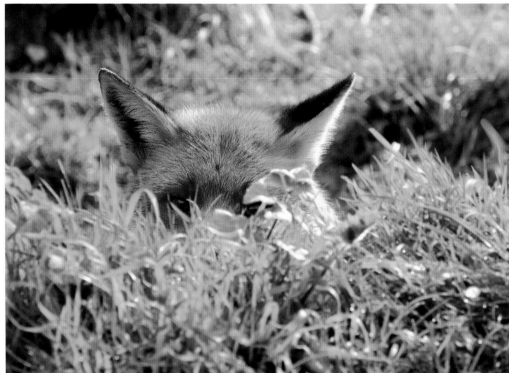

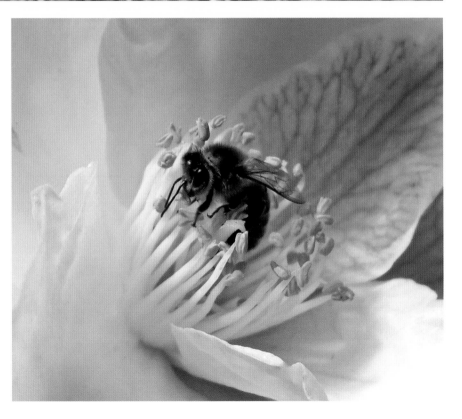

∧ Clockwise from top left

OLIVIA LACEY (AGE 11)

Bumblebee in Bluebell
(Bumblebee, *Bombus sp.*; Bluebell, *Hyacinthoides non-scripta*)
Cardiff, Wales

MYA BAMBRICK (AGE 11)

Hiding Red Fox
(Red fox, *Vulpes vulpes*)
British Wildlife Centre, Surrey, England

ELLA KEEN (AGE 10)

Honey Bee
(Honey bee, *Apis mellifera*)
Westbourne, Dorset, England

THOMAS CONWAY (AGE 15)

Heron in Stream
(Grey heron, *Ardea cinerea*)
Dumfries & Galloway, Scotland

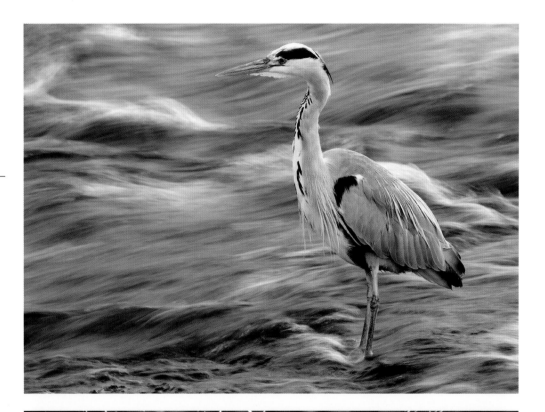

EIRAN DAVID (AGE 14)

Bath Time
(House sparrow, *Passer domesticus*)
Hereford, Herefordshire, England

SCHOOL
BRITISH WILDLIFE
PHOTOGRAPHY
AWARD

SPONSORED BY
YOUNG PIONEERS

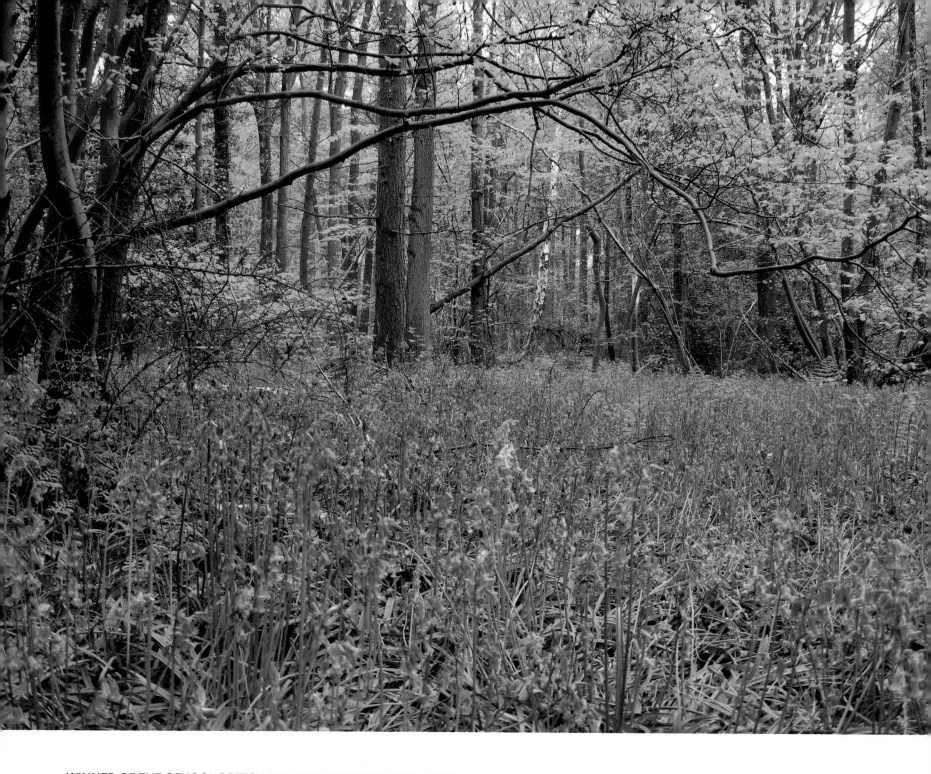

WINNER OF THE SCHOOL BRITISH WILDLIFE PHOTOGRAPHY AWARD

YEAR 5 AND 6 PUPILS, MICHAEL DRAYTON JUNIOR SCHOOL, NUNEATON

Spring Time Glory
Nuneaton, Warwickshire, England

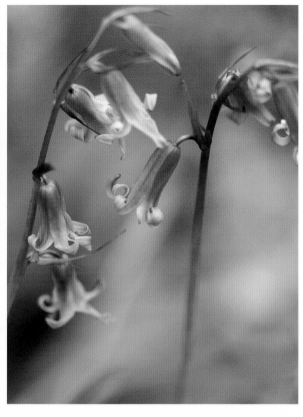
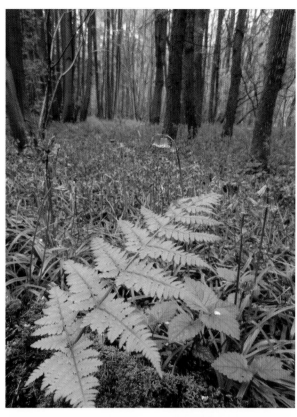
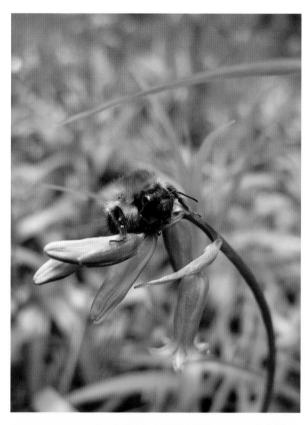

technical information

PRELIMS

TREVOR REES (p.3, 169)
CAMERA: Nikon D80
LENS: Nikkor 60mm micro
SHUTTER SPEED: 1/200
APERTURE: f22
ISO: 100
OTHER: Sea & Sea underwater camera housing together with a single Sea & Sea strobe

KEITH THORBURN (p.5, 29)
CAMERA: Sony A450
LENS: Sigma 18–200mm f5.6
SHUTTER SPEED: 1/320
APERTURE: f13
ISO: 200
OTHER: Yognuo YN – 560 Speedlight flash

JOSHUA BURCH (p.9, 204)
CAMERA: Canon 7D
LENS: 400mm. As the project progressed I've been trying to capture more candid shots using a wide-angle lens and a remote
SHUTTER SPEED: 1/5000
APERTURE: f2.8
ISO: 400
OTHER: Handheld

LEE ACASTER (p.20–1, 74)
CAMERA: Canon 5D MKII
LENS: Zeiss Distagon T* 18mm f3.5 ZE
SHUTTER SPEED: 1/100
APERTURE: f5.6
ISO: 100
OTHER: Circular Polariser, (Canon Speedlight off camera, handheld)

ANIMAL PORTRAITS

STEVEN FAIRBROTHER (p.24)
CAMERA: Canon 550D
LENS: Canon 24–105mm
SHUTTER SPEED: 1/200
APERTURE: f7.1
ISO: 400
OTHER: I used my camera bag for support

JAMIE UNWIN (p.25)
CAMERA: Sony A77
LENS: Sony DT 16–50mm f2.8 SSM
SHUTTER SPEED: 1/640
APERTURE: f2.8
ISO: 200

MATT DOGGETT (p.26)
CAMERA: Canon 5D MkII
LENS: Sigma 50mm macro
SHUTTER SPEED: 1/40
APERTURE: f8
ISO: 200
OTHER: Ikelite housing, twin Inon Z220 strobes

PETER CAIRNS (p.27)
CAMERA: Canon 1DX
LENS: 500mm
SHUTTER SPEED: 1/30
APERTURE: f4
ISO: 400

ANDREW MASON (p.28)
CAMERA: Nikon D4
LENS: Nikon 600mm VR f4
SHUTTER SPEED: 1/1250
APERTURE: f4
ISO: 400
OTHER: Tripod. Photographed at the Red Kite Rehabilitation Centre and Feeding Station at Gigrin Farm

ALEXANDER MUSTARD (p.30)
CAMERA: Nikon D4
LENS: Sigma 15mm and Kenko 1.4x teleconverter
SHUTTER SPEED: 1/250
APERTURE: f9
ISO: 800
OTHER: Subal underwater housing. 2 x Inon Z240 underwater flashes. Chum was used to attract sharks

RADOMIR JAKUBOWSKI (p.31)
CAMERA: Canon EOS 5D II
LENS: Canon EF f5.6 800mm L IS
SHUTTER SPEED: 1/500
APERTURE: f5.6
ISO: 400
OTHER: Gitzo Carbon Tripod + Novoflex Classicball 5

GERARD SEXTON (p.32)
CAMERA: Canon 1D MKIV
LENS: EF 400mm f2.8 L IS USM +1.4x
SHUTTER SPEED: 1/3200
APERTURE: f8
ISO: 800
OTHER: Handheld

ANDREW MASON (p.33)
CAMERA: Nikon D4
LENS: Nikon 200–400mm VR f4
SHUTTER SPEED: 1/800
APERTURE: f5.6
ISO: 400
OTHER: Camera and lens handheld

RUSSELL SAVORY (p.34)
CAMERA: Canon 1D
LENS: 40mm Canon
SHUTTER SPEED: 1/160
APERTURE: f20
ISO: 160
OTHER: Tripod, infra-red remote. Peanuts as bait laid on the other side of the brook

MARK HAMBLIN (p.35)
CAMERA: Canon 1DX
LENS: Canon EF 600mm f4 L IS II USM
SHUTTER SPEED: 1/2500
APERTURE: f5.6
ISO: 1600

ALANNAH HAWKER (p.36–7)
CAMERA: Canon 7D
LENS: Canon 100–400mm f4.5–f5.6 L IS
SHUTTER SPEED: 1/320
APERTURE: f5.6
ISO: 640

AUSTIN THOMAS (p.38)
CAMERA: Canon 1DX
LENS: 400mm
SHUTTER SPEED: 1/1600
APERTURE: f4.5
ISO: 800
OTHER: Camera and lens were mounted to a Gimball head which was on a ground plate placed directly on the ground

LUKE WILKINSON (p.39)
CAMERA: Nikon D800
LENS: Nikon 300mm f4
SHUTTER SPEED: 1/320
APERTURE: f4
ISO: 800

JAMIE HALL (p.40)
CAMERA: Canon 1DX
LENS: Canon 500mm f4.5
SHUTTER SPEED: 1/800
APERTURE: f4.5
ISO: 500

SIMON LITTEN (p.41)
CAMERA: Canon 1DIII
LENS: 500mm
SHUTTER SPEED: 1/640
APERTURE: f9
ISO: 200
OTHER: Tripod, remote release, hide

JACK BREADMORE (p.42)
CAMERA: Nikon D800
LENS: Nikon 105mm f2.8 macro lens
SHUTTER SPEED: 1/800
APERTURE: f4
ISO: 320

MATT BINSTEAD (p.43)
CAMERA: Nikon D300s
LENS: Nikon 70-200mm VRII f2.8
SHUTTER SPEED: 1/500
APERTURE: f3.2
ISO: 800
OTHER: Captive owl flown through woodlands

SIMON HAWKINS (p.44)
CAMERA: Canon 1D MKIV
LENS: Canon 500mm f4 L IS
SHUTTER SPEED: 1/320
APERTURE: f4
ISO: 1000
OTHER: Gitzo monopod. Aigas Field Centre Scottish wildcat breeding programme. Initiated in 2011 with the objective of releasing offspring from the breeding programme 'into appropriate habitat to help boost the threatened population of this ancient and unique feline predator'

CARL DAY (p.45)
CAMERA: Canon 7D
LENS: Canon 500mm f4 IS
SHUTTER SPEED: 1/640
APERTURE: f5.6
ISO: 800
OTHER: Tripod. Setup (feeding station) using a small feeder with peanuts in. The feeder was moved around occasionally to try for better compositions

RUSSELL SAVORY (p.46)
CAMERA: Canon 7D
LENS: 300–800mm Sigma set at 434mm
SHUTTER SPEED: 1/80
APERTURE: f5.6
ISO: 800
OTHER: Taken from car with beanbag on top of the door. Post positioned near nest site

OLIVER CHARLES WRIGHT (p.47)
CAMERA: Canon 1DX
LENS: Canon 800mm f5.6 L USM
SHUTTER SPEED: 1/640
APERTURE: f7.1
ISO: 1600
OTHER: Handheld

JULIAN PETRIE (p.48)
CAMERA: Canon EOS 7D
LENS: Canon EF 400mm f5.6 L USM
SHUTTER SPEED: 1/800
APERTURE: f6.3
ISO: 400
OTHER: Beanbag

STEVEN WARD (p.49)
CAMERA: Canon 1DX
LENS: Canon 500mm f4 IS L II. Canon 1.4x Convertor MKIII
SHUTTER SPEED: 1/1250
APERTURE: f7.1
ISO: 1600
OTHER: Gitzo tripod & jobu junior head

ANIMAL BEHAVIOUR

RICHARD SHUCKSMITH (p.52)
CAMERA: Nikon D4
LENS: 600mm Nikon f4
SHUTTER SPEED: 1/2500
APERTURE: f4
ISO: 1600

PETER WHITEHEAD (p.53)
CAMERA: Canon EOS 400D
LENS: Sigma DC 17–70mm at 70mm
SHUTTER SPEED: 1/400
APERTURE: f4.5
ISO: 400
OTHER: Handheld

PAUL HOBSON (p.54)
CAMERA: Canon 5D MK3
LENS: 16–35mm
SHUTTER SPEED: 1/100
APERTURE: f20
ISO: 2000
OTHER: Underwater camera bag

MARGARET WALKER (p.55)
CAMERA: Nikon D700
LENS: Nikon 300mm AIS
SHUTTER SPEED: 1/2000
APERTURE: f7.1
ISO: 250
OTHER: Nikon x1.4 converter. Handheld

MARK SMITH (p.56)
CAMERA: Canon EOS 1D MKIV
LENS: Canon EF 17-40mm f4 L
SHUTTER SPEED: 1/30
APERTURE: f4
ISO: 3200
OTHER: 2x Canon Speedlite 430EX II, PocketWizard TT1 & 2x TT5. A half-eaten box of chips had been dropped in the middle of the street so I decided it was as good a place as any and set up the camera and flash units there. There is food but it was already there and is a 'natural' part of the urban environment

FELICITY MILLWARD (p.57)
CAMERA: Nikon D7000
LENS: 600mm
SHUTTER SPEED: 1/500
APERTURE: f5.6
ISO: 500
OTHER: Laid flat on the ground

DAVE BARTLETT (p.58)
CAMERA: Canon 1D MKIV
LENS: Canon 500mm f4 L IS
SHUTTER SPEED: 1/250
APERTURE: f6.7
ISO: 200
OTHER: Tripod

IZZY STANDBRIDGE (p.59)
CAMERA: Canon 5D MKIII
LENS: 500mm f4 + 1.4x tc
SHUTTER SPEED: 1/2000
APERTURE: f6.3
ISO: 8000
OTHER: Lens resting on beanbag on hide window. I put food out for the birds, and it was this food they were battling over

MATT DOGGETT (p.60)
CAMERA: Canon 5D MKII
LENS: Sigma 15mm fisheye
SHUTTER SPEED: 1/80
APERTURE: f16
ISO: 400
OTHER: Ikelite housing, twin Inon Z220 strobes

BEN ANDREW (p.61)
CAMERA: Nikon D800
LENS: Nikon 200-400mm f4 VRII
SHUTTER SPEED: 1/2000
APERTURE: f4
ISO: 400
OTHER: Beanbag

MICHAEL RAE (p.62)
CAMERA: Canon EOS-1D MKIV
LENS: EF 800mm f5.6 L IS USM
SHUTTER SPEED: 1/2500
APERTURE: f6.3
ISO: 2000
OTHER: Tripod, pop-up hide

DAVID WHITE (p.63)
CAMERA: Canon EOS-1D X
LENS: EF 500mm f4 L IS USM
SHUTTER SPEED: 1/1600
APERTURE: f4.5
ISO: 800
OTHER: Beanbag, lying on the ground

TERRY WHITTAKER (p.64)
CAMERA: Nikon D4
LENS: Nikon 300mm f2.8 + 1.4 converter
SHUTTER SPEED: 1/500
APERTURE: f5
ISO: 1600
OTHER: Tripod, angle-finder, waders

OLIVER CHARLES WRIGHT (p.65)
CAMERA: Canon 1DX
LENS: Canon 800mm f5.6 L USM
SHUTTER SPEED: 1/640
APERTURE: f5.6
ISO: 3200
OTHER: Handheld

LIZZIE SHEPHERD (p.66-7)
CAMERA: Nikon D800e
LENS: Nikon AF-S 70-200mm f4 VR ED
SHUTTER SPEED: 1/500
APERTURE: f4
ISO: 1600
OTHER: We hid a couple of nuts in the moss for the squirrels to find. This in turn attracted the pheasant and produced this little encounter!

JOHN R BARLOW (p.68)
CAMERA: Canon EOS 7D
LENS: Canon EF 300mm f2.8 L IS USM
SHUTTER SPEED: 1/2500
APERTURE: f5
ISO: 1000
OTHER: Tripod

KRIS WORSLEY (p.69)
CAMERA: Canon EOS 7D
LENS: Canon EF 500mm f4
SHUTTER SPEED: 1/15
APERTURE: f5.6
ISO: 250
OTHER: -1.3 stop exposure compensation. Beanbag. Midge repellent!

LISA NAYLOR (p.70)
CAMERA: Nikon D2X
LENS: 500mm f4
SHUTTER SPEED: 1/200
APERTURE: f8
ISO: 400

BEN HALL (p.71)
CAMERA: Canon EOS 1D MKIV
LENS: Canon 500mm L IS
SHUTTER SPEED: 1/1000
APERTURE: f4
ISO: 1000
OTHER: Gitzo 3541LS tripod and hide

URBAN WILDLIFE
TERRY WHITTAKER (p.75)
CAMERA: Nikon D4
LENS: Nikon 16–35mm f4
SHUTTER SPEED: 1/125
APERTURE: f13
ISO: 1000
OTHER: Tripod, pocket wizard radios for remote release. 2 flashes. Small amount of apple to attract the vole to the wheel

TOMASZ GARBACZ (p.76)
CAMERA: Nikon D90
LENS: Nikkor 18–105mm VR
SHUTTER SPEED: 1/250
APERTURE: f3.5
ISO: 320
OTHER: Wireless remote control

MARK SMITH (p.77)
CAMERA: Canon EOS 1D X
LENS: Tamron SP 24-70mm f2.8
SHUTTER SPEED: 1/30
APERTURE: f4.5
ISO: 6400
OTHER: Canon Speedlite 430EX II. Pocket Wizard TT1 and TT5. Not baited as the fox wasn't being fed, it was just investigating anything new

TREVOR REES (p.78)
CAMERA: Nikon D90
LENS: Nikkor 10.5mm
SHUTTER SPEED: 1/160
APERTURE: f20
ISO: 400
OTHER: Sea & Sea underwater camera housing with dome port together with two Sea & Sea strobes. The swans present on this town pond are attracted in by frequently being fed bread by the locals. They readily approach looking for a free meal

NEIL PHILLIPS (p.79)
CAMERA: K-5
LENS: Pentax DA*300mm
SHUTTER SPEED: 1/320
APERTURE: f4.5
ISO: 1600

JAMIE HALL (p.80)
CAMERA: Canon 1DX
LENS: Canon 500mm f4.5
SHUTTER SPEED: 1/400
APERTURE: f4.5
ISO: 640

JOHN R BARLOW (p.81)
CAMERA: Canon EOS 7D
LENS: Canon EF 300mm f2.8 L IS USM
SHUTTER SPEED: 1/320
APERTURE: f3.2
ISO: 320
OTHER: Handheld

ALEX STEWART (p.82)
CAMERA: Fujifilm X-E2
LENS: Fujifilm 18–55mm
SHUTTER SPEED: 1/1800
APERTURE: f4
ISO: 200
OTHER: Camera was handheld, crouching

ROBERT BIRKBY (p.83)
CAMERA: Canon 5D MKIII
LENS: Canon 70–200mm f4 IS
SHUTTER SPEED: 1/80
APERTURE: f6.3
ISO: 320
OTHER: Handheld

HIDDEN BRITAIN
SUSIE HEWITT (p.86)
CAMERA: Nikon D7000
LENS: Nikon 105mm f2.8
SHUTTER SPEED: 1/320
APERTURE: f8
ISO: 1600
OTHER: Opportunism

CAROLYNE BARBER (p.87)
CAMERA: Nikon D90
LENS: Sigma 50mm macro lens
SHUTTER SPEED: 1/32000
APERTURE: f3.5
ISO: 320
OTHER: Handheld and using manual focus

DAVID MAITLAND (p.88, 89)
CAMERA: Canon EOS 5D MKII
LENS: Olympus Microscope 10x objective
ISO: 50
OTHER: Differential Interference Contrast lighting. To take the picture, I placed some glass microscope slides in my garden pond onto which the snail eggs were laid. These were brought into my studio to photograph and then returned to the pond

DAWN STEPHENS-BORG (p.90)
CAMERA: Canon 500D
LENS: Tamron AF 90mm Macro
SHUTTER SPEED: 1/60
APERTURE: f2.8
ISO: 200

ED PHILLIPS (p.91)
CAMERA: Canon 5D MKIII
LENS: Canon MP-E 65mm Macro
SHUTTER SPEED: 1/200
APERTURE: f5.6
ISO: 100
OTHER: MP-E lens at 5x magnification. Additional 1.4x Extender and 36mm extension tube to give 8x magnification. Canon MT24-EX Twin Lite Flash. Camera on beanbag

STEPHEN WILLIAMS (p.92)
CAMERA: Nikon D4
LENS: Nikon 200-400mm f4
SHUTTER SPEED: 1/2000
APERTURE: f4
ISO: 400
OTHER: Gitzo GT5542LS tripod with a Wimberly head

TIM HUNT (p.93)
CAMERA: Canon 1DX
LENS: Canon TS-E24mm f3.5 L II
SHUTTER SPEED: 1/100
APERTURE: f11
ISO: 200
OTHER: Single flash with softbox

RADOMIR JAKUBOWSKI (p.94)
CAMERA: Canon EOS 5D III
LENS: Canon f2.8 100mm L IS
SHUTTER SPEED: 1/8
APERTURE: f18
ISO: 200
OTHER: Handheld – panning

STEPHEN DARLINGTON (p.95)
CAMERA: Canon EOS7D
LENS: Canon 100mm f2.8 L
SHUTTER SPEED: 1/250
APERTURE: f11
ISO: 400
OTHER: Diffused fill flash

COAST AND MARINE
ALEXANDER MUSTARD (p.98)
CAMERA: Nikon D4
LENS: Sigma 15mm
SHUTTER SPEED: 1/160
APERTURE: f10
ISO: 800
OTHER: Subal underwater housing. 2 x Inon Z240 underwater flashes. Chum was used to attract sharks

RICHARD SHUCKSMITH (p.99)
CAMERA: Nikon D300
LENS: 10–17mm Tokina fish eye
SHUTTER SPEED: 1/60
APERTURE: f13
ISO: 200
OTHER: Ikelite underwater housing

RICHARD SHUCKSMITH (p.100)
CAMERA: Nikon D4
LENS: 15mm Sigma fish eye
SHUTTER SPEED: 1/250
APERTURE: f14
ISO: 400
OTHER: Nauticam underwater housing. Fresh dead mackerel were used to simulate a fishing vessel discarding fish so that the gannets would dive close to the boat

RICHARD SHUCKSMITH (p.101)
CAMERA: Nikon D300
LENS: 10–17mm Tokina fish eye
SHUTTER SPEED: 1/60
APERTURE: f14
ISO: 200
OTHER: Ikelite underwater housing

CYRIL CHEVILLOT (p.102–3)
CAMERA: Nikon D7100
LENS: Nikkor 10.5 mm
SHUTTER SPEED: 1/250
APERTURE: f8
ISO: 100
OTHER: Hugyfot Housing - 2 Ikelite strobes

TREVOR REES (p.104)
CAMERA: Nikon D90
LENS: Nikkor 60mm micro
SHUTTER SPEED: 1/250
APERTURE: f20
ISO: 200
OTHER: Sea & Sea underwater camera housing with a single Sea & Sea strobe

IAN WADE (p.105)
CAMERA: Fujifilm FinePix XP 50
SHUTTER SPEED: 1/110
APERTURE: f6.3
ISO: 100
OTHER: Flash fired

CAROL DILGER (p.106)
CAMERA: Nikon D700
LENS: 300mm f4 + 1.4x converter
SHUTTER SPEED: 1/8000
APERTURE: f6.3
ISO: 640

COLIN MUNRO (p.107)
CAMERA: Nikon D200
LENS: Tokina 10–17mm
SHUTTER SPEED: 1/200
APERTURE: f4.5
ISO: 200
OTHER: Subal underwater housing with 8" dome port. Camera on shutter priority, exposure compensation -0.7EV. The shark was fast, so I needed a fast shutter speed; rapidly changing light required shutter priority. Blue sharks are wide ranging and thinly distributed. In order to

attract blue sharks to our rigid hulled inflatable a mesh bag with mashed mackerel was hung in the water to create a fish oil slick that would draw the sharks in

JAMIE HALL (p.108)
CAMERA: Canon 1DX
LENS: canon 17–40mm f4
SHUTTER SPEED: 1/200
APERTURE: f11
ISO: 100
OTHER: Manfrotto tripod, elinchrom quadra ranger flash, canon cable release

JANE MORGAN (p.109)
CAMERA: Nikon D300s
LENS: 60mm
SHUTTER SPEED: 1/160
APERTURE: f13
ISO: 200
OTHER: Sea & Sea housing and twin Inon strobes

JOHN MONCRIEFF (p.110)
CAMERA: Nikon D300
LENS: Nikon 300mm f4 afs
SHUTTER SPEED: 1/1000
APERTURE: f5.6
ISO: 1000
OTHER: Camera rested on rocks on overhanging cliff

JOHN MONCRIEFF (p.111)
CAMERA: Nikon D300
LENS: Nikon 18–200mm VR
SHUTTER SPEED: 1/125
APERTURE: f6.3
ISO: 560
OTHER: Shot from prone, rested on rocks

RICHARD SHUCKSMITH (p.112)
CAMERA: Nikon D300
LENS: 10–17mm Tokina fish eye
SHUTTER SPEED: 1/60
APERTURE: f9
ISO: 200
OTHER: Ikelite underwater housing

MARK N THOMAS (p.113)
CAMERA: Nikon D3
LENS: Nikon 60mm
SHUTTER SPEED: 1/80
APERTURE: f22
ISO: 250
OTHER: Sea & Sea housing. Twin Sea & Sea strobes on manual

TREVOR REES (p.114)
CAMERA: Nikon D80
LENS: Tokina 10–17mm zoom
SHUTTER SPEED: 1/6
APERTURE: f11
ISO: 400
OTHER: Sea & Sea underwater camera housing with dome port together with two Sea & Sea strobes

DAN BOLT (p.115)
CAMERA: Olympus E-PL5
LENS: 14–42mm
SHUTTER SPEED: 1/125
APERTURE: f10
ISO: 320
OTHER: Olympus housing, 2x Sea & Sea YS-D1 strobes

WILD WOODS
PETER CAIRNS (p.118–9)
CAMERA: Canon 1DX
LENS: 70–300mm
SHUTTER SPEED: 1/60

APERTURE: f16
ISO: 100
OTHER: Multi-exposure. 3 shots – one sharp, 2 x de-focus

GRAHAM HARRIS GRAHAM (p.120)
CAMERA: Canon 5D MKII
LENS: Canon EF 85mm f1.2 L
SHUTTER SPEED: 1/60
APERTURE: f11
ISO: 50
OTHER: Tripod

SIMON PHILLPOTTS (p.121)
CAMERA: Canon 1DX
LENS: EF 15mm f2.8 Fisheye
SHUTTER SPEED: 1/6400
APERTURE: f8
ISO: 800
OTHER: Tripod, cable release and off-camera fill flash. Squirrel visiting feeding station by leaping from fallen tree

LIAM MARSH (p.122)
CAMERA: Canon 5D MKIII
LENS: Canon 8–15mm fisheye
SHUTTER SPEED: 1/400
APERTURE: f8
ISO: 400
OTHER: Self timer, beanbag

ANDREW WHITMARSH (p.123)
CAMERA: Nikon D7000 DSLR
LENS: Nikkor 18–70mm f3.5 – f5.6
SHUTTER SPEED: 1/250
APERTURE: f16
ISO: 200
OTHER: Manfrotto 055CX3 tripod, Manfrotto 494RC2 tripod head. -2 EV exposure compensation. Basic processing in Adobe Photoshop Lightroom, cropped. Park deer

DREW BUCKLEY (p.124–5)
CAMERA: Canon EOS 5D MKII
LENS: EF 24–70mm f2.8 L USM
SHUTTER SPEED: 1/2
APERTURE: f16
ISO: 100
OTHER: Tripod, ball head, 2-stop soft LEE Graduated neutral density filter

BOB REYNOLDS (p.126)
CAMERA: Sony Nex 7
LENS: Sigma E 30mm f2.8
SHUTTER SPEED: 1/200
APERTURE: f2.8
ISO: 200
OTHER: Tripod – Manfrotto lightweight MK293. Sony remote control

KEVIN SAWFORD (p.127)
CAMERA: Canon EOS 1D MKIV
LENS: 500mm
SHUTTER SPEED: 1/1000
APERTURE: f5.6
ISO: 400
OTHER: Tripod

DAVE PEAKE (p.128)
CAMERA: Sony NEX5 in Nauticam housing
LENS: 16mm with fisheye attachment lens
APERTURE: f11 priority
ISO: 800
OTHER: Handheld camera dipped half in and out of river

CRAIG CHURCHILL (p.129)
CAMERA: Nikon D800
LENS: Nikon 24–70 afs
SHUTTER SPEED: 1/13
APERTURE: f2.8

ISO: 100
OTHER: Gitzo tripod/remote

PETER CAIRNS (p.130)
CAMERA: Canon 1DX
LENS: 300mm
SHUTTER SPEED: 1/500
APERTURE: f2.8
ISO: 500

CRAIG CHURCHILL (p.131)
CAMERA: Nikon D800
LENS: Nikon 24–70mm AFS
SHUTTER SPEED: 1/15
APERTURE: f2.8
ISO: 100
OTHER: Gitzo tripod/remote

ANDREW WHITMARSH (p.132)
CAMERA: Nikon D7000 DSLR
LENS: Sigma 120–300mm f2.8
SHUTTER SPEED: 1/400
APERTURE: f2.8
ISO: 1250
OTHER: Handheld. Basic processing in Adobe Photoshop Lightroom, cropped

MIKE CRUISE (p.133)
CAMERA: Canon EOS 1D MK1V
LENS: Canon EF 500mm f4 IS
SHUTTER SPEED: 1/400
APERTURE: f8
ISO: 400

HABITAT
RUTH ASHER (p.136–7)
CAMERA: Nikon D90
LENS: Nikkor 18–105mm f3.5–5.6
SHUTTER SPEED: 266.3 sec
APERTURE: f16
ISO: 100
OTHER: Lee 10-stop neutral density filter. Manfrotto tripod

JO McINTYRE (p.138)
CAMERA: Canon 1DX
LENS: 300mm f2.8
SHUTTER SPEED: 1/250
APERTURE: f5.6
ISO: 2500
OTHER: Gitzo tripod, jobu tripod head. Apples were placed on the edge of the loch bank encouraging the beavers to approach the side of the loch. However there was no guarantee the female beaver would swim near, or go onto the banking at all

ALAN BEVIS (p.139)
CAMERA: Nikon D7000
LENS: Nikon 16–85mm f3.5–5.6
SHUTTER SPEED: 1/13
APERTURE: f16
ISO: 640
OTHER: Giottos MT934OB Travel tripod with Manfrotto head

TONY DILGER (p.140)
CAMERA: Nikon D3s
LENS: 300mm f2.8 VR
SHUTTER SPEED: 1/4000
APERTURE: f4
ISO: 1400

JILL BARROW (p.141)
CAMERA: Canon EOS-1D MKIV
LENS: EF 24–105mm f4 L IS USM
SHUTTER SPEED: 1/250 +0.33
APERTURE: f5.6
ISO: 200
OTHER: Focal length 105mm

IAN WADE (p.142)
CAMERA: Fujifilm FinePix XP 50
SHUTTER SPEED: 1/90
APERTURE: f3.9
ISO: 100

PETER WARNE (p.143)
CAMERA: Canon 5D MKIII
LENS: Canon EF 100mm f2.8 macro IS USM
SHUTTER SPEED: 1/200
APERTURE: f8
ISO: 800
OTHER: Tripod, off-camera flash(-2ev exposure), manual focus on back-screen, cable release

LINDSAY McCRAE (p.144–5)
CAMERA: Canon 5D MKII
LENS: 16–35mm MKII
SHUTTER SPEED: 1/100
APERTURE: f6.3
ISO: 800
OTHER: Ikelite housing, flash

ANDREW PARKINSON (p.146)
CAMERA: Nikon D3s
LENS: Nikon 200–400mm lens
SHUTTER SPEED: 1/640
APERTURE: f4
ISO: 800
OTHER: I put out a small amount of peanuts during the summer months as supplementary feeding for the young cubs

ANDREW PARKINSON (p.147)
CAMERA: Nikon D3s
LENS: Nikon 80–200mm f2.8
SHUTTER SPEED: 1/320
APERTURE: f2.8
ISO: 800
OTHER: I put out a small amount of peanuts during the summer months as supplementary feeding for the young cubs

ALEX MEEK (p.148)
CAMERA: Canon 5D MKII
LENS: Canon 600mm f4
SHUTTER SPEED: 1/800
APERTURE: f5.6
ISO: 1000
OTHER: Manfrotto Monopod

BEN HALL (p.149)
CAMERA: Canon EOS 1D MKIV
LENS: Canon 17–40mm L
SHUTTER SPEED: 1/50
APERTURE: f8
ISO: 400
OTHER: Gitzo 3541 LS tripod

ROBERT CANIS (p.150)
CAMERA: Nikon D300
LENS: 200mm Micro Nikkor
SHUTTER SPEED: 1/400
APERTURE: f4
ISO: 200
OTHER: Manfrotto 055 tripod with Markins M10 head

JOHAN SIGGESSON (p.151)
CAMERA: Nikon D7000
LENS: Nikon 300mm f2.8 VRII
SHUTTER SPEED: 1/1000
APERTURE: f4
ISO: 800

BOTANICAL BRITAIN
PHILIP BRAUDE (p.154)
CAMERA: Nikon D700
LENS: 18–35mm f3.5–4.5
SHUTTER SPEED: 1/50
APERTURE: f10
ISO: 800

technical information

STUART BROWN (p.155)
CAMERA: Canon 60D
LENS: Canon EF-S 60mm f2.8 USM Macro
SHUTTER SPEED: 1.3 sec
APERTURE: f11
ISO: 100
OTHER: UV lens filter, tripod and shutter release cable, HDR for correct exposure

GEOFF KELL (p.156–7)
CAMERA: Canon EOS 50D
LENS: Canon EF-S 17–85mm lens at 35mm
SHUTTER SPEED: 13 sec
APERTURE: f16
ISO: 200
OTHER: Manfrotto 055CXPRO3 tripod + Manfrotto panoramic head. Lee 0.9ND hard grad. 8 portrait orientated images stitched in Photoshop

EDWARD MARSHALL (p.158)
CAMERA: Canon 550D
LENS: 18–55mm EF-S f3.5–5.6 IS
SHUTTER SPEED: 1/200
APERTURE: f8
ISO: 200
OTHER: 14mm extension tubes, aperture set prior to detaching lens using the camera's depth-of-field preview button, Jessops 360AFD external flash with flash cable, focus stacked composite (2 images). Set up. The piece of wood on which the lichen was growing was positioned in order to get the correct composition and lighting

JULIAN PETRIE (p.159)
CAMERA: Canon EOS 5D MKII
LENS: Canon EF-S 18–55mm f3.5–5.6 IS II
SHUTTER SPEED: 8 sec
APERTURE: f11
ISO: 100
OTHER: Reverse-lens adaptor, macro rail, tripod, cable release, bayonet protector cap, image stacking

GEOFF KELL (p.160–1)
CAMERA: Canon EOS 50D
LENS: Canon EF-S 17–85mm lens at 50mm
SHUTTER SPEED: 0.8 sec
APERTURE: f16
ISO: 100
OTHER: Manfrotto 055CXPRO3 tripod + Manfrotto panoramic head. 9 portrait-orientated images stitched in Photoshop

CLOSE TO NATURE
JIM GREENFIELD (p.164)
CAMERA: Canon 20D
LENS: Canon 300mm f4 IS
SHUTTER SPEED: 1/80
APERTURE: f11
ISO: 200
OTHER: A tripod was out of the question due to the crowds. I used f11 for depth of field, sacrificing shutter speed and relying on the IS to stop movement

SUE DALY (p.165)
CAMERA: Canon EOS 5DII
LENS: 100mm
SHUTTER SPEED: 1/60
APERTURE: f9
ISO: 400
OTHER: Sea & Sea underwater housing and strobe

DAVID PRESSLAND (p.166–7)
CAMERA: Nikon D300
LENS: Sigma 150mm f2.8 macro
SHUTTER SPEED: 1/160
APERTURE: f11
ISO: 200
OTHER: Tripod, off-camera flash. Subject deceased

MARK N THOMAS (p.168)
CAMERA: Nikon D3
LENS: Nikon 60mm
SHUTTER SPEED: 1/60
APERTURE: f25
ISO: 250
OTHER: Sea & Sea Housing. Twin Sea & Sea 110 strobes, on manual

BRITISH NATURE IN BLACK AND WHITE
ALEXANDER MUSTARD (p.172)
CAMERA: Nikon D4
LENS: Sigma 15mm
SHUTTER SPEED: 1/200
APERTURE: f10
ISO: 800
OTHER: Subal underwater housing. Chum was used to attract sharks

JAN GALKO (p.173)
CAMERA: Nikon D7100
LENS: Sigma DG 150–500mm, 1:5–6.3 APO HSM
SHUTTER SPEED: 1/200
APERTURE: f6.28
ISO: 800
OTHER: Tripod: Monfrotto 128 RC

ALAN PRICE (p.174)
CAMERA: Nikon D7100
LENS: Nikon 300mm prime
SHUTTER SPEED: 1/100
APERTURE: f5
ISO: 800

ANDREW KAPLAN (p.175)
CAMERA: Canon EOS 1D MK4
LENS: Canon EF 300mm f2.8
SHUTTER SPEED: 1/250
APERTURE: f5
ISO: 200

KAY REEVE (p.176)
CAMERA: Hasselblad H1/Phase One P20 back
LENS: 110mm
SHUTTER SPEED: 1/30
APERTURE: f32
ISO: 200
OTHER: Tripod. Specimen from garden moth trap. Placed where it would rest comfortably

NIC DAVIES (p.177)
CAMERA: Canon EOS 5D MKII
LENS: Canon EF 24–70mm
SHUTTER SPEED: 1/500
APERTURE: f5.6
ISO: 1250
OTHER: I set up a Plamp with a small LED light to throw more light on the nest. Shot handheld

NEIL MacGREGOR (p.178)
CAMERA: Nikon D3s
LENS: Nikkor 17–35mm f2.8 D
SHUTTER SPEED: 1/6400
APERTURE: f2.8
ISO: 1250
OTHER: Handheld and panning. Converted to mono in Photoshop. On approach to the Bass Rock, the skipper threw fish over the side of the boat

ANDREW PARKINSON (p.179)
CAMERA: Nikon D300s
LENS: Nikon 200–400mm f4 lens
SHUTTER SPEED: 1/800
APERTURE: f7.1
ISO: 250

BRITISH SEASONS
ANDREW PARKINSON (p.182)
CAMERA: Nikon D3s
LENS: Nikon 600mm f4 lens
SHUTTER SPEED: 1/1250
APERTURE: f5
ISO: 1600

ANDREW PARKINSON (p.183 – top)
CAMERA: Nikon D2x
LENS: Nikon 80–200mm f2.8 lens
SHUTTER SPEED: 1/320
APERTURE: f5.6
ISO: 200

ANDREW PARKINSON (p.183 – centre)
CAMERA: Nikon D2x
LENS: Nikon 500mm f4 lens
SHUTTER SPEED: 1/500
APERTURE: f4
ISO: 100

ANDREW PARKINSON (p.183 – bottom)
CAMERA: Nikon D3s
LENS: Nikon 200–400mm f4 lens
SHUTTER SPEED: 1/640
APERTURE: f7.1
ISO: 1600

JAMES YAXLEY (p.184)
CAMERA: Canon 5D MKIII
LENS: 180mm Macro
SHUTTER SPEED: 1/160
APERTURE: f5.6
ISO: 400
OTHER: Manfrotto tripod. Manual focus. Remote shutter release

JAMES YAXLEY (p.185 – left)
CAMERA: Canon 5D MKIII
LENS: 180mm Macro
SHUTTER SPEED: 1/15
APERTURE: f11
ISO: 200
OTHER: Manfrotto Tripod. Manual focus. Remote shutter release

JAMES YAXLEY (p.185 – centre)
CAMERA: Canon 5D MKIII
LENS: 180mm Macro
SHUTTER SPEED: 1/1300
APERTURE: f8
ISO: 200
OTHER: Manfrotto tripod. Manual focus. Spot metering. Remote shutter release. Wimberley Plamp

JAMES YAXLEY (p.185 – right)
CAMERA: Canon 5D MKIII
LENS: 180mm Macro
SHUTTER SPEED: 1/60
APERTURE: f8
ISO: 400
OTHER: Manfrotto tripod. Manual focus. Remote shutter release

DOCUMENTARY SERIES
NICK UPTON (p.188–9)
CAMERA: Nikon D300, D800E
LENS: Nikon 18–200mm, 105mm macro, Sigma 24mm macro
SHUTTER SPEED: 1/60 –1/200
APERTURE: f2.2–f16
ISO: 1000–1600
OTHER: All handheld, some with flash, either fill from built-in flash or lit with Nikon R1 close-up system using two SB-200 flash units. Temporarily captive in nestboxes, plastic sacks and bags during survey work as documented

SAM HOBSON (p.190 – No.1)
CAMERA: Nikon D800
LENS: Nikon 200–400mm
SHUTTER SPEED: 1/3200
APERTURE: f6.3
ISO: 800

SAM HOBSON (p.190 – No.4)
CAMERA: Nikon D300
LENS: Nikon 24–70mm
SHUTTER SPEED: 1/100
APERTURE: f2.8
ISO: 320

SAM HOBSON (p.190 – No.5)
CAMERA: Nikon D300
LENS: Nikon 24–70mm
SHUTTER SPEED: 1/1250
APERTURE: f2.8
ISO: 320

SAM HOBSON (p.190 – No.6)
CAMERA: Nikon D7000
LENS: Nikon 300mm/1.4x Teleconverter
SHUTTER SPEED: 1/2000
APERTURE: f9
ISO: 1000

SAM HOBSON (p.191 – No.2)
CAMERA: Nikon D7000
LENS: Nikon 300mm/1.4x Teleconverter
SHUTTER SPEED: 1/2500
APERTURE: f8
ISO: 800

SAM HOBSON (p.191 – No.3)
CAMERA: Nikon D7000
LENS: Nikon 300mm/1.4x Teleconverter
SHUTTER SPEED: 1/1600
APERTURE: f8
ISO: 1250

***OUTDOOR PHOTOGRAPHY* EDITOR'S CHOICE**
DANIEL TRIM (p.198)
CAMERA: Canon 1D MK4
LENS: Canon 100mm f4 L IS USM
SHUTTER SPEED: 1/160
APERTURE: f4.5
ISO: 320

JIM GREENFIELD (p.199)
CAMERA: Canon 5D MK2
LENS: Canon 100mm macro f2.8 IS
SHUTTER SPEED: 1/200
APERTURE: f18
ISO: 200
OTHER: Aquatica underwater housing plus 2 x Nikonos flashes on full power plus diffusers

BEN ANDREW (p.200)
CAMERA: Nikon D800
LENS: Nikon 200–400mm f4 VRII
SHUTTER SPEED: 1/125
APERTURE: f4
ISO: 640

MARK HAMBLIN (p.201)
CAMERA: Canon 1DX
LENS: Canon EF 70–200mm f2.8 L II USM at 95mm
SHUTTER SPEED: 1/800
APERTURE: f8
ISO: 800

YOUNG PEOPLE'S AWARDS
WILLIAM BOWCUTT (p.205)
CAMERA: Nikon D7000
LENS: Nikon 300mm f4 prime
OTHER: Small pop-up hide, so as not to disturb the birds

LEE ACASTER www.leeacaster.com

BEN ANDREW www.benandrewphotography.co.uk

RUTH ASHER www.ruthasherphotography.co.uk

CAROLYNE BARBER www.carolynebarberphotography.co.uk

JOHN R BARLOW www.jrbarlow.co.uk

DAVE BARTLETT www.dbnaturephotos.com

MATT BINSTEAD www.britishwildlifecentre.blogspot.co.uk

ROBERT BIRKBY www.robertbirkbyphotography.co.uk

DAN BOLT www.underwaterpics.co.uk

PHILIP BRAUDE http://www.philipbraude.co.uk

JACK BREADMORE www.jackbreadmorephotos.co.uk

STUART BROWN http://500px.com/Stu-B

DREW BUCKLEY http://www.drewbuckleyphotography.com

PETER CAIRNS www.northshots.com

ROBERT CANIS www.robertcanis.com

CRAIG CHURCHILL www.craigchurchill.co.uk

SUE DALY www.suedalyproductions.com

NIC DAVIES www.pixelenceimages.co.uk

CARL DAY www.carldayphotography.co.uk

CAROL DILGER www.tonydilger.co.uk

TONY DILGER www.tonydilger.co.uk

MATT DOGGETT www.earthinfocus.com/www.mattdoggett.com

STEVEN FAIRBROTHER www.fairbrother.me.uk

JIM GREENFIELD www.oceaneyephoto.com

BEN HALL www.benhallphotography.com

JAMIE HALL www.jamiehallphotography.co.uk

MARK HAMBLIN www.markhamblin.com

GRAHAM HARRIS GRAHAM www.ghgraham.com

ALANNAH HAWKER www.alannahhawker.com

SIMON HAWKINS www.simonhawkinsphotography.com

SAM HOBSON www.samhobson.co.uk

TIM HUNT www.timhuntphotography.co.uk

RADOMIR JAKUBOWSKI www.naturfotocamp.de

ANDREW KAPLAN www.andrewkaplan.co.uk

SIMON LITTEN www.simonlitten.com

DAVID MAITLAND www.davidmaitland.com

LIAM MARSH www.liammarsh.co.uk

EDWARD MARSHALL www.edmarshallwildimages.co.uk

ANDREW MASON www.andrewmasonphotography.co.uk

JO McINTYRE www.gjwildlifephotography.co.uk

ALEX MEEK www.alexmeekphotography.co.uk

JOHN MONCRIEFF www.johnmoncrieffphotography.com

JANE MORGAN www.janemorganphotography.com

COLIN MUNRO www.colinmunrophotography.com

ALEXANDER MUSTARD http://www.amustard.com

LISA NAYLOR http://lisanaylor.zenfolio.com/

ANDREW PARKINSON www.andrewparkinson.com

ED PHILLIPS www.edphillipswildlife.com

NEIL PHILLIPS www.uk-wildlife.co.uk

SIMON PHILLPOTTS www.wilddales.co.uk

DAVID PRESSLAND www.davepressland.zenfolio.com

MICHAEL RAE www.mikerae.com

TREVOR REES www.trevorreesphotography.co.uk

RUSSELL SAVORY www. russellsavory.com

LIZZIE SHEPHERD www.lizzieshepherd.com

RICHARD SHUCKSMITH www.ecologicalphotography.co.uk

JOHAN SIGGESSON www.johansiggesson.com

MARK SMITH www.marksmithphotography.net

IZZY STANDBRIDGE www.westwalesbirdphotographyhide.co.uk

ALEX STEWART www.alexstewartphotos.com

AUSTIN THOMAS www.austin-thomas.co.uk

MARK N THOMAS www.marknthomasimages.co.uk

DANIEL TRIM https://www.flickr.com/photos/danieltrim/

JAMIE UNWIN www.JamieUnwin.com

IAN WADE www.ianwadephotography.co.uk

PETER WARNE https://www.flickr.com/photos/14865557@N04/

DAVID WHITE www.dgwhite.co.uk

PETER WHITEHEAD www.landscapeartandimages.com

ANDREW WHITMARSH www.andrewwhitmarshphotography.com

TERRY WHITTAKER www.terrywhittaker.com

KRIS WORSLEY www.krisworsley.com

OLIVER CHARLES WRIGHT www.oliverwrightphotography.com

JAMES YAXLEY www.jamesyaxleyphotography.co.uk